ROOTS
C A N A D A

ROOTSATHLETICS

ROOTS

ROOTS

ROOTS
TUFF
MADE IN CANADA

ROOTS
ATHLETICS

ROOTS
HOME DESIGN

40 Years of Style

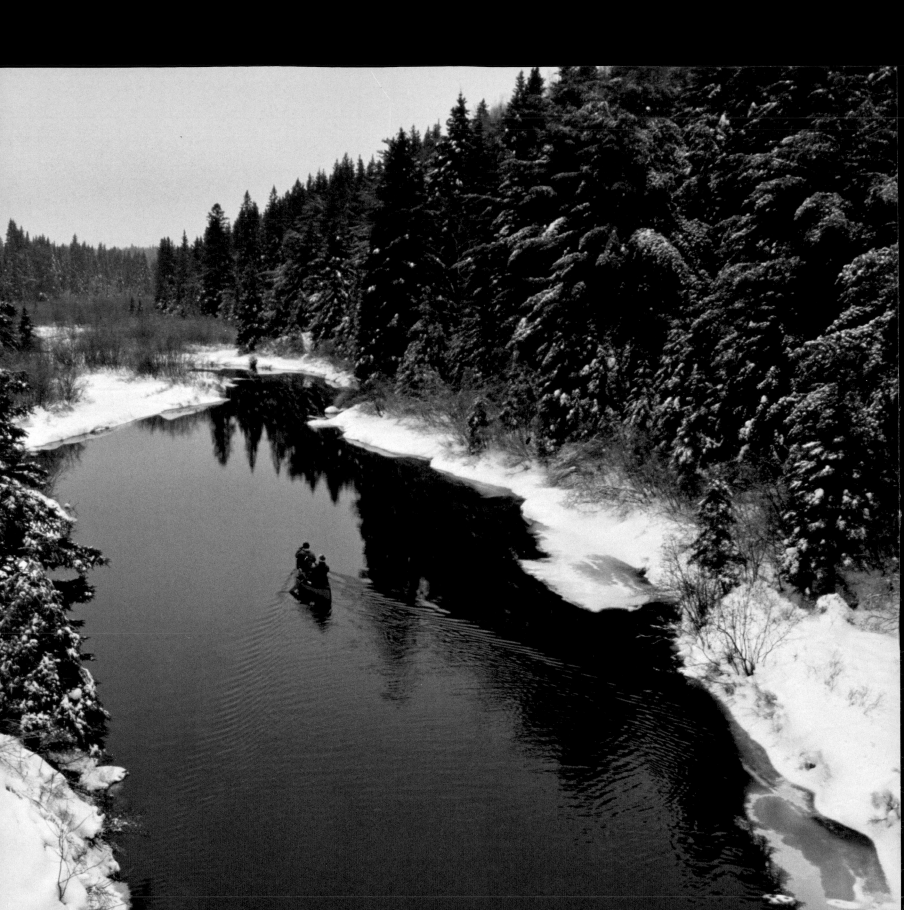

Everyone has roots and values them.

Everyone's roots are distinctly their own.

Roots stands for pride in our origins and history.

Roots represents what is distinctive about ourselves.

Roots: A Fashion Memoir

By Suzanne Boyd

I arrived in Toronto from Halifax via the West Indies in 1982, ostensibly to attend university. On my first day on campus, everyone was talking about a guy I had never heard of named Wayne Gretzky when not slouching toward their classes wearing these grey Roots sweatpants. With their beaver logo, they were more exotic to me than any basic had the right to be.

Back then, there was exactly one nightclub on Richmond Street West, the Twilight Zone, where I spent way too much time, and Saturday nights were the destination for a demimonde of movers, wannabes, and soon-to-bes from the intersecting worlds of art, music, film, and fashion. Patrick Cox, who had a spectacular dancing style, said he was off to London to become a cobbler — he went on to turn the shoe world on its head. Dean and Dan Caten, who would grow up and move to Italy to become Dsquared2 — the acclaimed fashion, denim, and lifestyle brand — had already started to design, and used my sister and me as fit models. And there we'd be, dancing from midnight 'til light wearing vintage cast-offs mixed with labels like Parachute, Leighton Barrett, Cat's Cradle, Zapata, Kansai Yamamoto, Kenzo, Norma Kamali, and Roots. It turned out that the sweatpants were also *de rigueur* on the dance floor.

Some nights Raymond Perkins, the quintessential vibe man and Roots ambassador, would drop by with a band or someone cool in tow. In 1983, he hired me along with my sister and a few other Club Kids to "decorate" the company's tenth anniversary party. It was as if a page from the magazine *Paris Passion*, edited by Robert Sarner (now Roots Director of Communication and Public Affairs) and which Roots co-founders Michael Budman and Don Green dashingly published in France, had suddenly manifested on the corner of Ave and Dav. And

the already legendary persons of architect Andrée Putman, impresarios Steve Rubell and Ian Schrager, and graffiti artist Futura 2000, who created a mural during the event, clubbed the night away amidst a throng of locals.

It was an early lesson in the power of the eclectic scene — an intangible no one leveraged quite the way Roots did or has. The morning after, despite having fallen down some stairs with a tray of champagne that rained broken glass on the dance floor, stopping the party cold as it was mopped up, I was invited to the Roots store to be gifted a pair of desert boots for my troubles. The store was packed, and shoeboxes were flying around. Everything was selling like hotcakes.

In 1996, after six years at the magazine, I was appointed editor-in-chief of *Flare*, Canada's Fashion Magazine, just in time to take my metaphorical front-row seat at the biggest international success that Canadian fashion had ever seen. It wasn't on the runways of New York, London, Milan, or Paris, where Canadian designers had been attempting to make their mark for years, but at the Minami Nagano Sports Park in Japan in 1998, where the Canadian Winter Olympic team appeared during the opening ceremonies outfitted by Roots, resplendent and, more importantly, fab in their nationalistic red-and-white varsity jackets and backward poorboy caps. Roots had taken a risk and had innovated by bringing a street fashion attitude to the more traditional *Chariots of Fire*-esque formality typical during the Parade of Nations, and it had paid off. The spectacle catapulted Roots into an influential league of its own as the look went viral before viral was a thing.

The groundswell began in the Athletes' Village when competitors from other nations attempted to barter their own uniforms for that of the Canadians. The gotta-have-it phenom built after Vancouver's Ross Rebagliati, who won the first-ever gold medal in Olympic snowboarding, was briefly stripped of it when traces of marijuana appeared in his drug test. By the time the medal was reissued, the newly minted media darling had made umpteen international television appearances during the imbroglio (claiming it was all due to second-hand smoke) in his fetching Roots gear. The charmed circle of high/low hipness, fashion as a global spectator sport, and branding through celebrity was complete when Prince William, presented with the hat and jacket by Budman and Green during a royal tour of British Columbia that year, put them on and spontaneously struck a hip-hop pose. He got it, and so did the cameras of the world's watching press.

Roots has gone on to have many more triumphs, Olympic and otherwise, including achieving this fortieth anniversary year, and I have watched all of it unfold with a profound admiration.

One of my self-imposed mandates for my role at *Flare* was to go beyond simply recording trends and hemlines and show that fashion coverage could have a broader scope; that the clothes were partly a result of design's engagement in culture, in the arts, in the country at large; that Canadian fashion had its own place in that world and in *the* world, for that matter. This included an attempt to help build and energize a Canadian star system that would perhaps inspire national pride and industry. And in that I recognized a synergy between what Roots had achieved and what I envisioned to keep propelling the magazine forward.

In the pure realm of style, I saw an aspirational romance in how Roots had synthesized Canadiana, and believed that this ethos could be visually translated through the prism of a high-fashion lens. The result was what I believe still to be the most extensive sitting in the history of the magazine: a thirty-page shoot photographed by Chris Chapman, which ran in the December 2002 issue. It was called "Prêt-à-Portage," a most fitting title coined by John Gerhardt, at the time the magazine's contributing fashion editor, who functioned as not just the stylist but the creative director on the shoot.

A caravan of models — professionals including the soon-to-be supermodel Daria Werbowy, and "real people" including the Budman and Green families — descended on Algonquin Park, where both the Budmans and Greens have retreats. We photographed the cast of characters relaxing and in celebration, with a narrative arc that pointed to the company's origins — including a shot at Camp Tamakwa, where Budman and Green famously met as teenagers from Detroit — and values, including environmentalism and the importance of family. In fact, the integral contribution of Diane Bald, Michael's wife, and Denyse Green, Don's wife — each couple met romantic-comedy cute at the company's first-ever store — has added much durability, grace, and taste to the soul of the brand. Looking back, "Prêt-à-Portage" holds up as a classic. As a statement of intent, it's a career high.

A couple of years ago, Roots reissued the Negative Heel Shoe, known colloquially as the Earth Shoe, the hot item that started it all in 1973. And if they

reissued those 1983 desert boots today in that luscious sandy shade my pair was, they would be just as covetable now as then. In a world of fast fashion, the company's much vaunted and differentiating commitment to quality gives their product a literal longevity — my Roots duffle is going on twenty years. But it's a design longevity as well, one that imbues the company's wares with a timelessness, keeping their key items constant and relevant through the decades.

The sweats were added in 1979, and today the Roots grey sweatpant — which I discovered during my time as a fashion scribe is officially known as the salt-and-pepper sweatpant — is as much a signifier of a modern type of egalitarian style as the white T-shirt or the blue jean. And Fashion can interpret them in as *au courant* a way as its moment desires. The sweatpants can be athletic, neo-grunge, or easy like Sunday morning when worn with a Breton top and thong sandals by couture devotee and Karl Lagerfeld muse Diane Kruger, captured by paparazzi on the streets of L.A. The look goes suited with the co-ordinating sweatshirt, very "Roots, Rock, Reggae" with a hip-hop swagger when worn as the Bajan superstar Rihanna did, posing after she dropped by a Roots store in Montreal.

The brand MVPs, the leather jackets, are also no strangers to the camera, which loves their deep rich tones and luxe finishes. From logoed Varsities to sleek stealthy Bombers, a Roots leather jacket has been the unofficial uniform of Hollywood North for years, exuding the glamour of cool embodied by Budman and Green themselves. Always impeccably turned out in the elements of style they have codified as Canadian through the years, the Roots Boys, as they are universally known, have always been their own best advertisement. They remain strikingly similar in their appearance today as they are in the branding photographs from the early days of Roots — eternally fit and tanned — a result of their long-term love affair with this country, its ice and its game, its Algonquin Park summers, and a beautifully realized northern lifestyle of camp and canoe.

Suzanne Boyd

Suzanne Boyd
Editor-in-Chief, Zoomer magazine

Behind the Style of Roots

By Michael Budman and Don Green

"Personal style is about having a sense of yourself and of what you believe in."
— Ralph Lauren

Many people might be hard pressed to define style but they know it when they see it. That certainly applies to the style of Roots.

After forty years, it's gratifying to see that Roots style — and everything the brand represents — has stood the test of time. As much as certain aspects of Roots may have changed over the years, its essence has not. Today's world bears little resemblance to that of 1973 and since then, the company has grown in more ways than we could have ever imagined.

Shaping Roots has been a collaborative process. Thousands of people, events, phenomena, and social movements have broadened our horizons. An eclectic mix of sports, music, movies, books, art, travel, and fashion has enriched us and our sense of style. A sense of time and place has also contributed immensly to the look and feel of what we do.

The genesis of Roots style began in our youth in Detroit in the 1950s and early 1960s. It was a golden time for the city, then one of America's leading urban centres and home to a booming auto industry. A business and cultural powerhouse, Detroit was a lively, upbeat place, brimming with promise and possibility.

Detroit was also the epicentre of many musical styles that riveted millions of people. Not only was the city a major jazz centre but the birthplace of Motown

Records, which provided the soundtrack, the soul, and the hipster presence to much of the world. Marvin Gaye, the Temptations, Smokey Robinson, the Four Tops, and many more had a look and an innate coolness that helped define being young, hip, and alive.

The city's sports teams, featuring some of the best and most colourful athletes of the day, had unrivalled success. While we were growing up, Michigan produced some legendary teams — the Red Wings, the Lions, the Tigers, the Spartans, and the Wolverines. They played hard, lived large, and taught us what winning was all about. To witness Gordie Howe, Ted Lindsay, Bobby Layne, Doak Walker, Dick "Night Train" Lane, Al Kaline, and Harvey Kuenn in their prime had a lasting impact on us.

But it was a twelve-hour trip by train, bus, and boat into the heart of Canada's wilderness that would change everything. The destination: a summer camp in Ontario's Algonquin Park, an outdoors paradise — the ying to Detroit's yang. Located three hundred kilometres north of Toronto, Camp Tamakwa is where we first really got to know each other, and learned important lessons about life and nature. The camp's co-founders, Lou Handler and Omer Stringer, were impressive, larger-than-life figures. We were drawn to the values, positive attitudes, skills, and knowledge they shared with Tamakwans, as well as to their rustic clothing, which was authentic, comfortable, and rooted in heritage brands.

Tamakwa and its physical setting also introduced us to another world — Canada. Its pristine, expansive beauty stimulated senses within us that we barely knew existed. The more we discovered about Canada — its nature, people, culture, history, sports, and lifestyle — the more we liked it. In time, each of us would move here. Unquestionably, it was the best decision of our lives.

Roots style had its beginnings in Detroit but it matured in Canada. The early 1970s were a wonderful period in Toronto, as the city and the country itself were coming into their own. In this post-hippie era, amid a growing environmental and health consciousness, the Roots Negative Heel Shoe hit home. Toronto was also a magnet for great talent in the arts including Dan Aykroyd, Gilda Radner, Martin Short, and Catherine O'Hara, who became good friends of Roots while making their names in the local comedy scene.

In the mid-1970s, the success of the Roots Negative Heel Shoe in North America led us to open stores in several European countries, in the process heightening our own awareness of the continent's refined sense of style.

When movie producer Jerry Bruckheimer asked us in 1979 to design foot-wear and leather accessories for Richard Gere's character in *American Gigolo*, we went to Milan to meet with Italian fashion icon Giorgio Armani, who was co-ordinating the wardrobe for the film. At the time, Italian designers were at the forefront of fashion and seeing their work there made a strong impression on us.

In 1981 in Paris, where Roots had two stores and where one of us (Michael) was then based, we helped launch *Paris Passion* magazine with journalist Robert Sarner. It provided an entrée to some of the world's leading creators in differ-ent fields, many of whom we featured in *Passion* and got to know personally — Andrée Putman, Karl Lagerfeld, Yves Saint Laurent, Thierry Mugler, Claude Challe, Jean-Paul Goude, Helmut Newton, Jean Touitou, Bernard-Henri Lévy, and many others. Some, such as Andrée Putman and Jean Touitou, worked on projects with Roots.

In the 1990s, we channelled our love of sport into our involvement in the Olympics. Our aim was to make Canada look hip and cool on the world stage. In 1998, the world watched as the Canadian team, dressed in Roots, entered the stadium in Nagano, Japan — and people loved what they saw. The look was widely celebrated and the poorboy hat became a major sensation. Back in Canada, people were thrilled, proud that a Canadian company had produced the style hit of the Games.

In Salt Lake City, four years later, Roots outfitted the U.S. Olympic team, only months after 9/11. During the opening ceremony, the American ath-letes, wearing their Roots berets and jackets, solemnly carried a tattered flag recovered from the Twin Towers. It was one of the most poignant moments in Olympic history. And from our perspective, when the Canadian men's and women's hockey teams won gold, it was the icing on the cake.

Given all of the above and more, it's little surprise that Roots is unmistakably Canadian and global. Urban and bound to the great outdoors. Contemporary and classic. Moving forward while staying true to its heritage. Popular with the young yet multigenerational in its reach. Roots has clearly come a long way. Today, with one hundred retail stores in Asia, along with a growing online borderless business, more people in more countries are now connecting with Roots style and culture.

If, indeed, style is character, then we owe a lot to our parents, who imbued us with lots of character and helped us in many ways. Our respective mothers,

Helen Budman, a fifty-year veteran of the couture deparment at Saks Fifth Avenue, and Bethea Green, a gifted artist, inspired us and opened our eyes to great style when we were growing up. Credit is also due to our late fathers, Irwin Green and Albert Budman, whose mentorship was critical to our early success. Fortunately, we had the good sense to recognize their business acumen and heed their wisdom. They instilled in us the importance of details and making sure quality reigns in all aspects of Roots. The memory of our parents continues to inspire and guide us every day.

The influence of our wives has been equally significant. Both have been indispensable to the development of Roots. In addition to their incredible support, Denyse Green and Diane Bald, usually far from the limelight, have honed the style of Roots, which they've long understood better than anyone. Each embodies the ultimate Roots woman in their taste, style, and approach to life. Their contributions to the brand, which go back almost to the start of the company, are immeasurable.

Of course, Denyse and Diane have also been partners in a more important achievement: the raising of our respective children. All of our kids — Anthony, Sophie, and Deeva Green, and Matthew and Alex Anne Budman — have not only been a huge source of inspiration for us, but each has also contributed to the style and life of Roots in far more ways than they realize.

Looking back is important but we're more excited about what lies ahead for Roots. Ultimately, the real style of Roots is encapsulated in the immortal words of Albert Budman: "Keep on keepin' on." And that's exactly what we're doing, day after day, true to our roots.

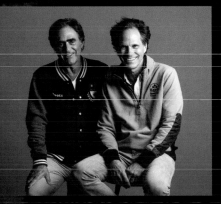

Michael Budman and Don Green
Co-Founders, Roots Canada

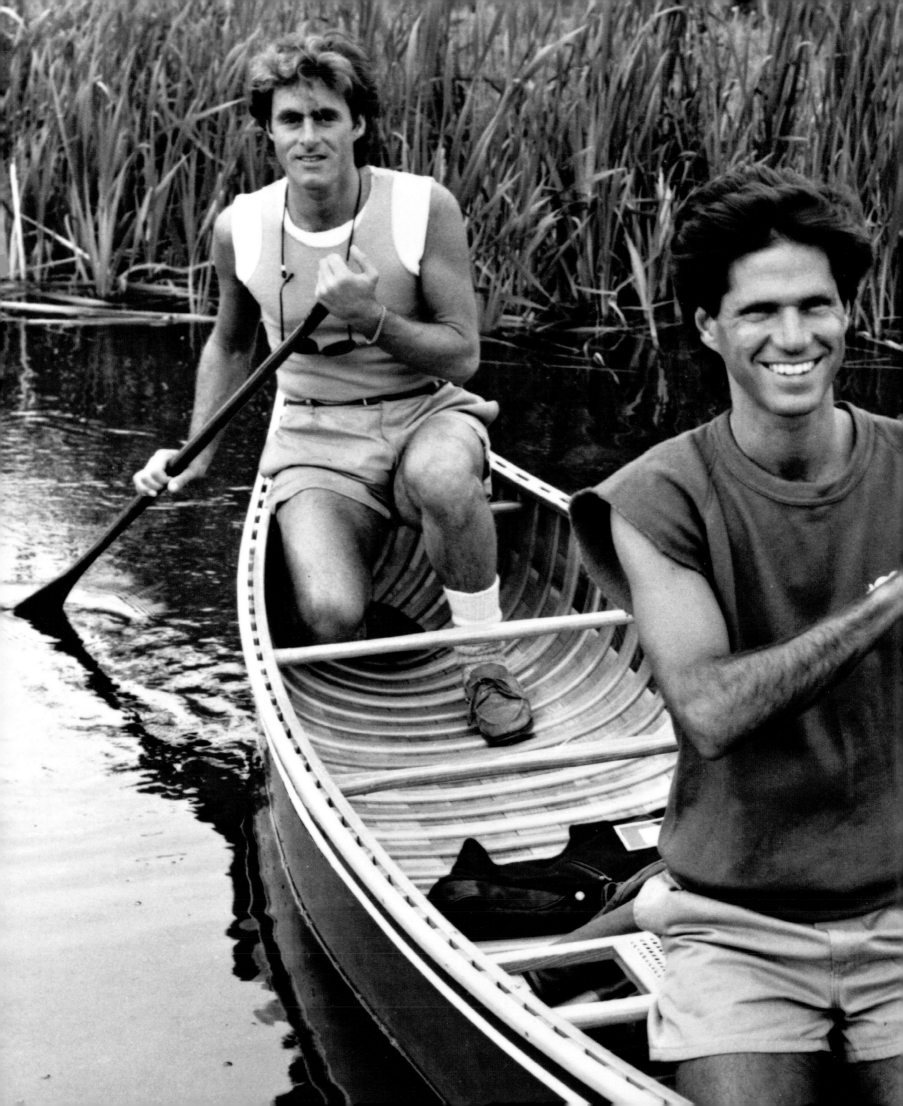

ROOTS
NORTHERN · LAKES

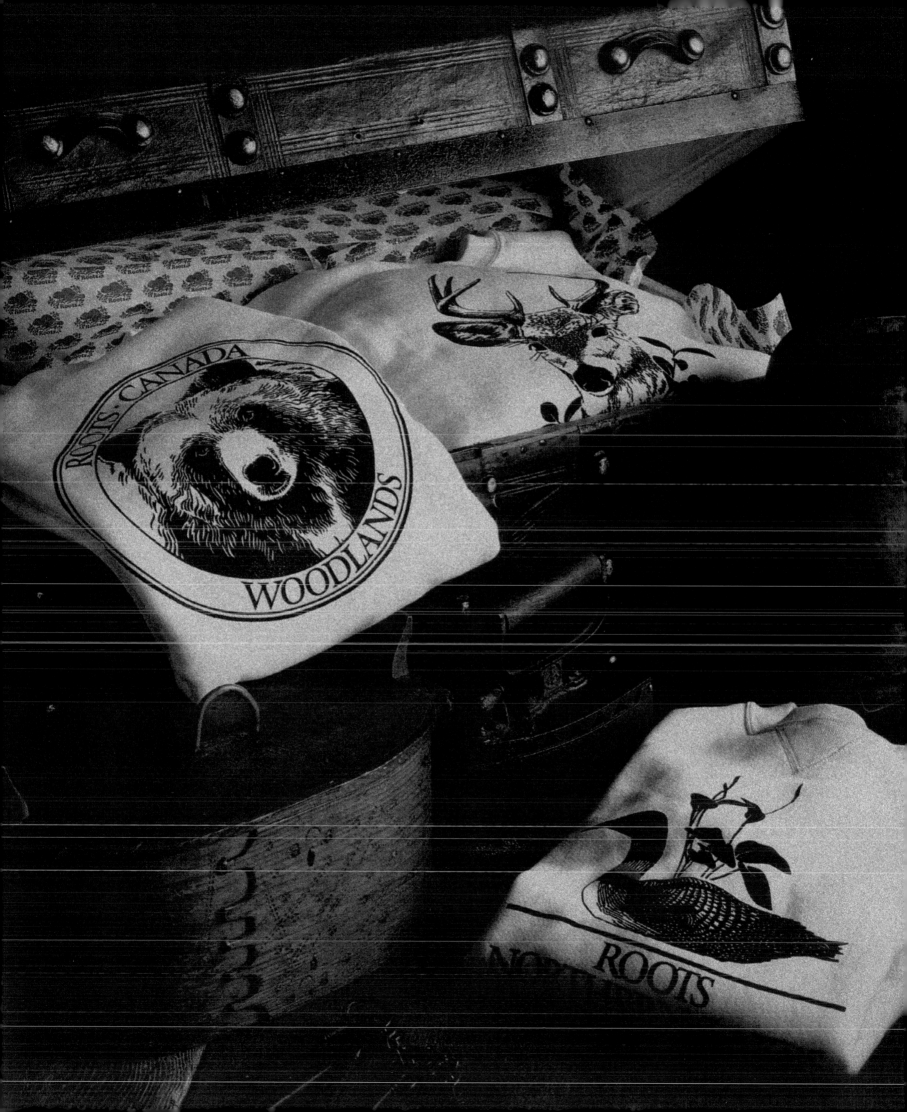

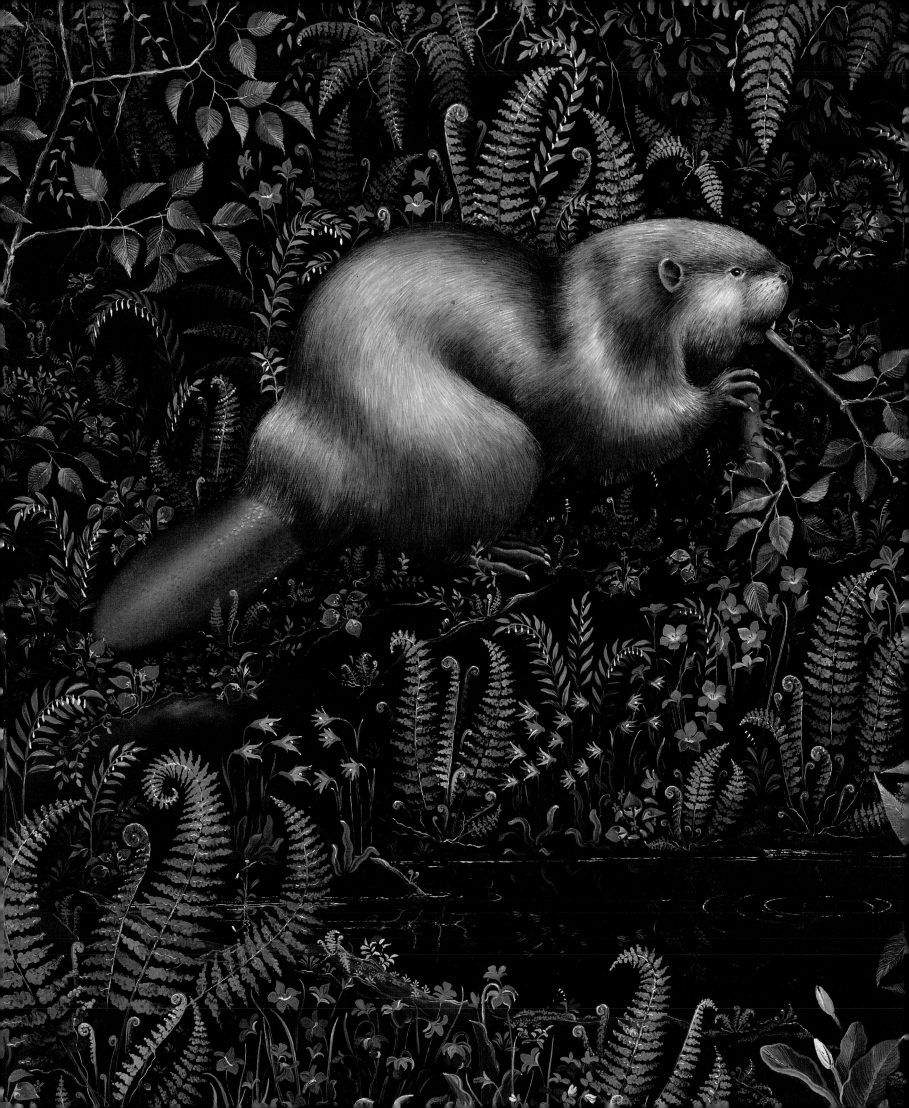

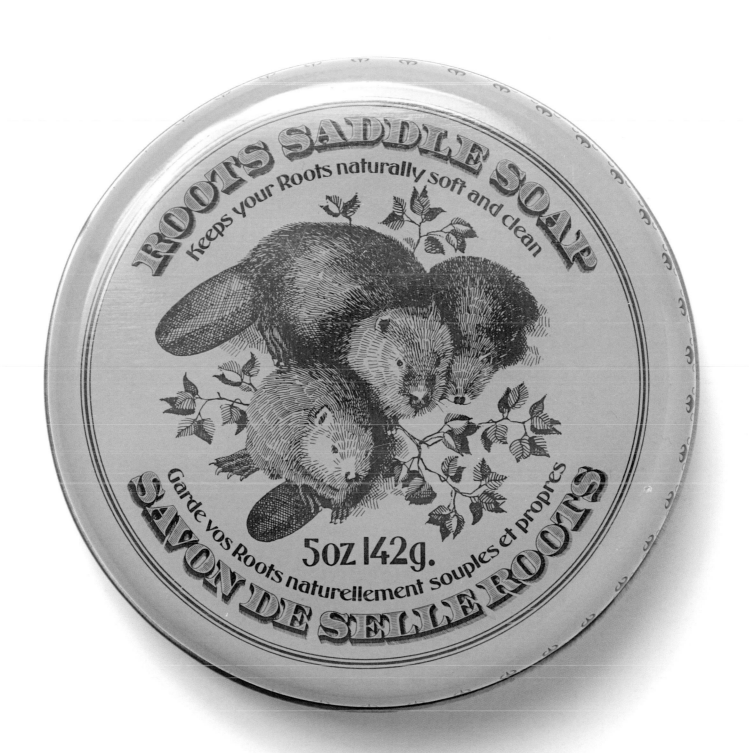

ROOTS SADDLE SOAP

Keeps your Roots naturally soft and clean

Garde vos Roots naturellement souples et propres

SAVON DE SELLE ROOTS

5oz 142g.

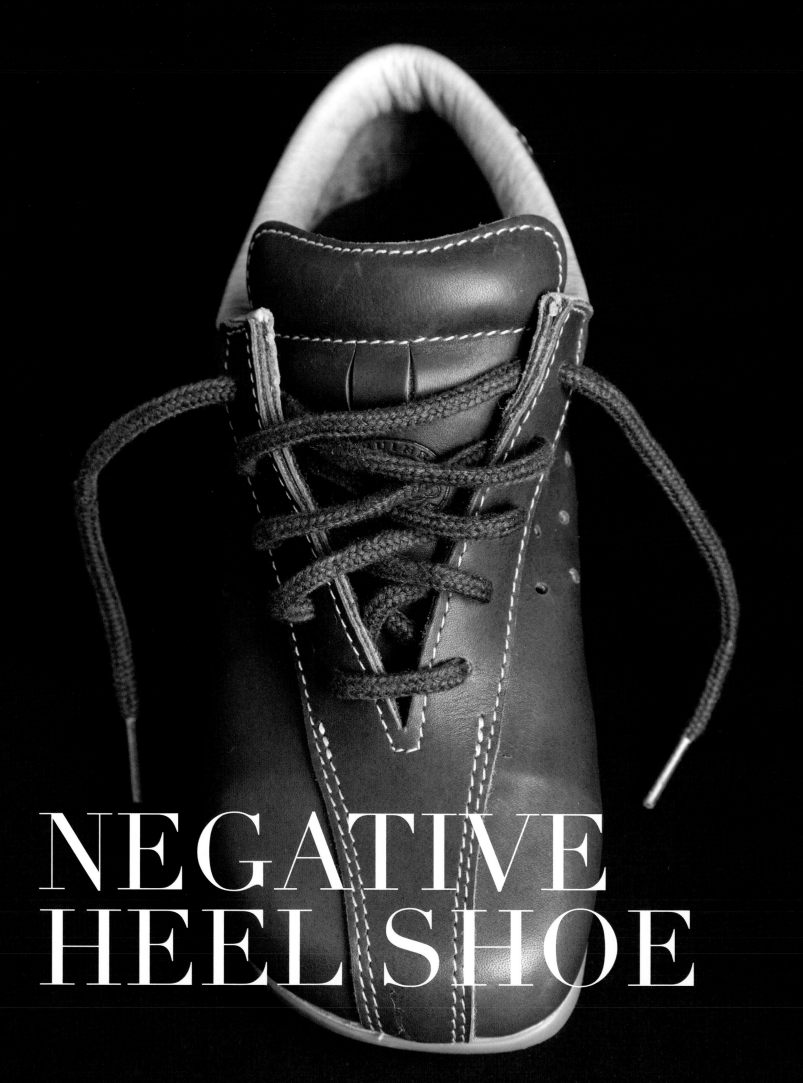

NEGATIVE
HEEL SHOE

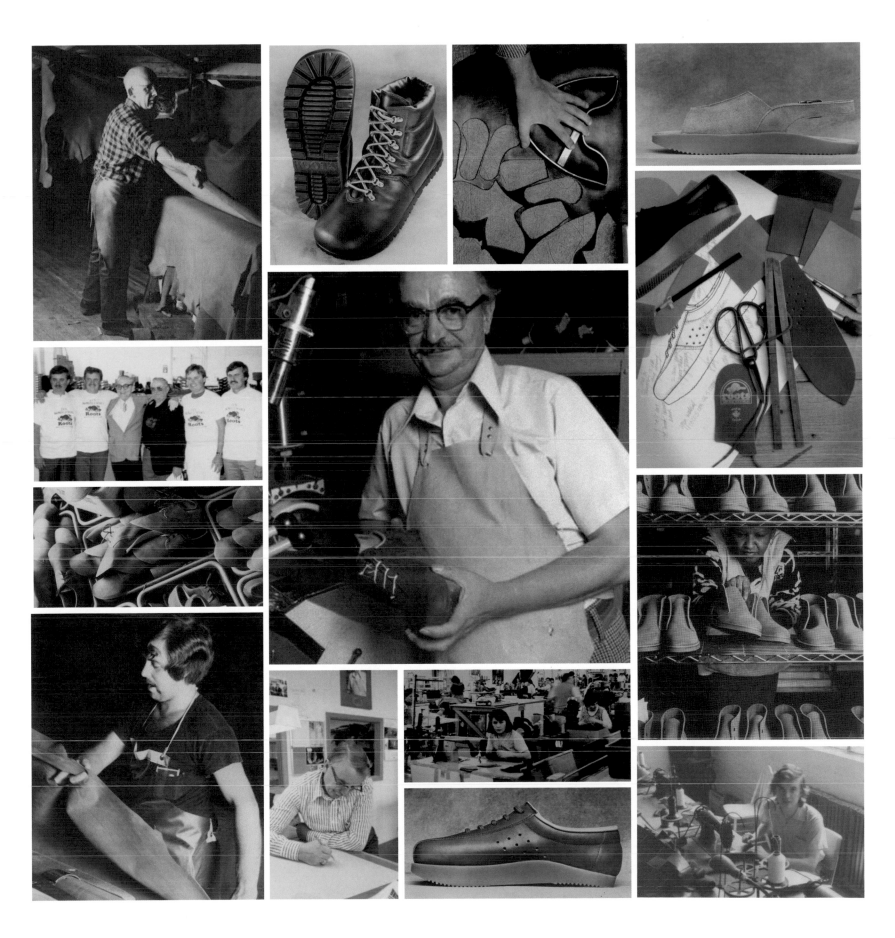

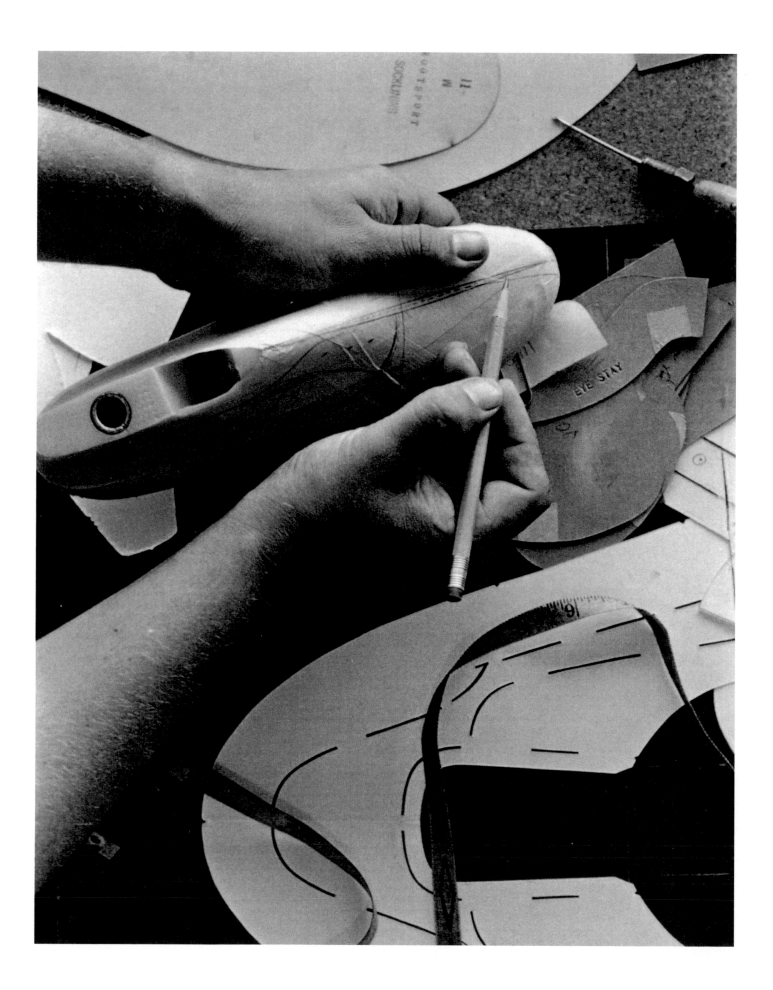

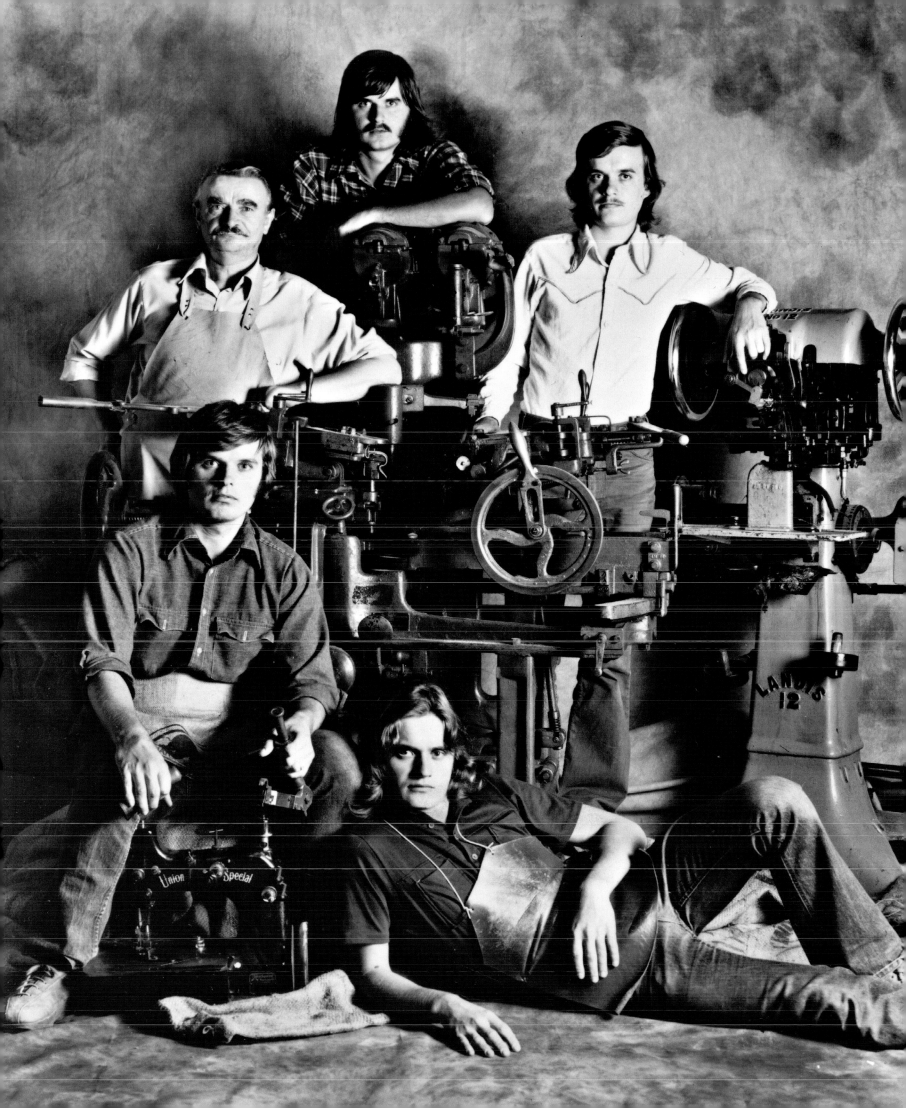

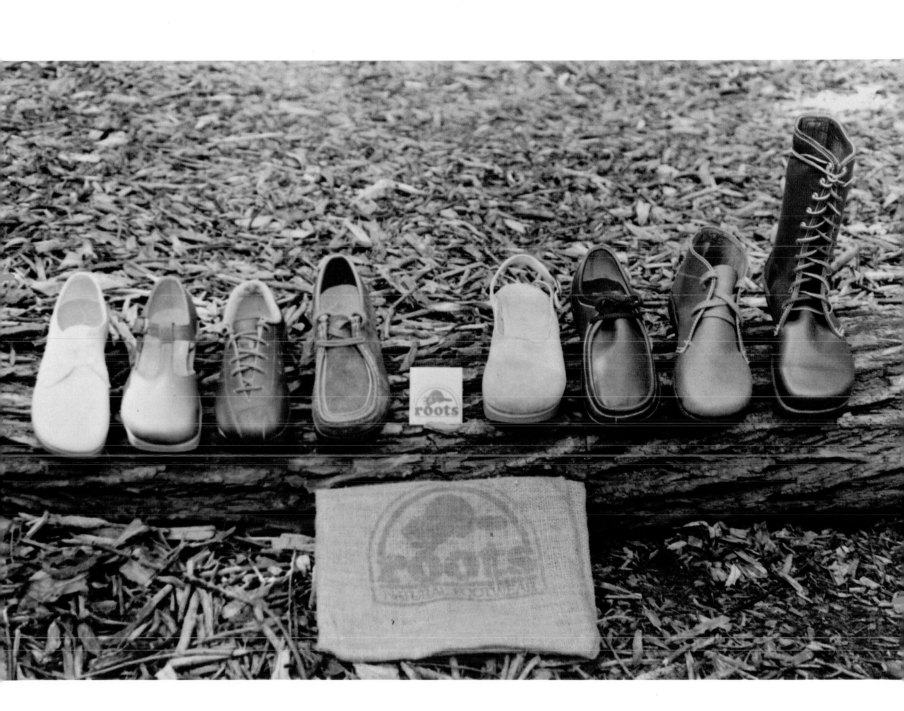

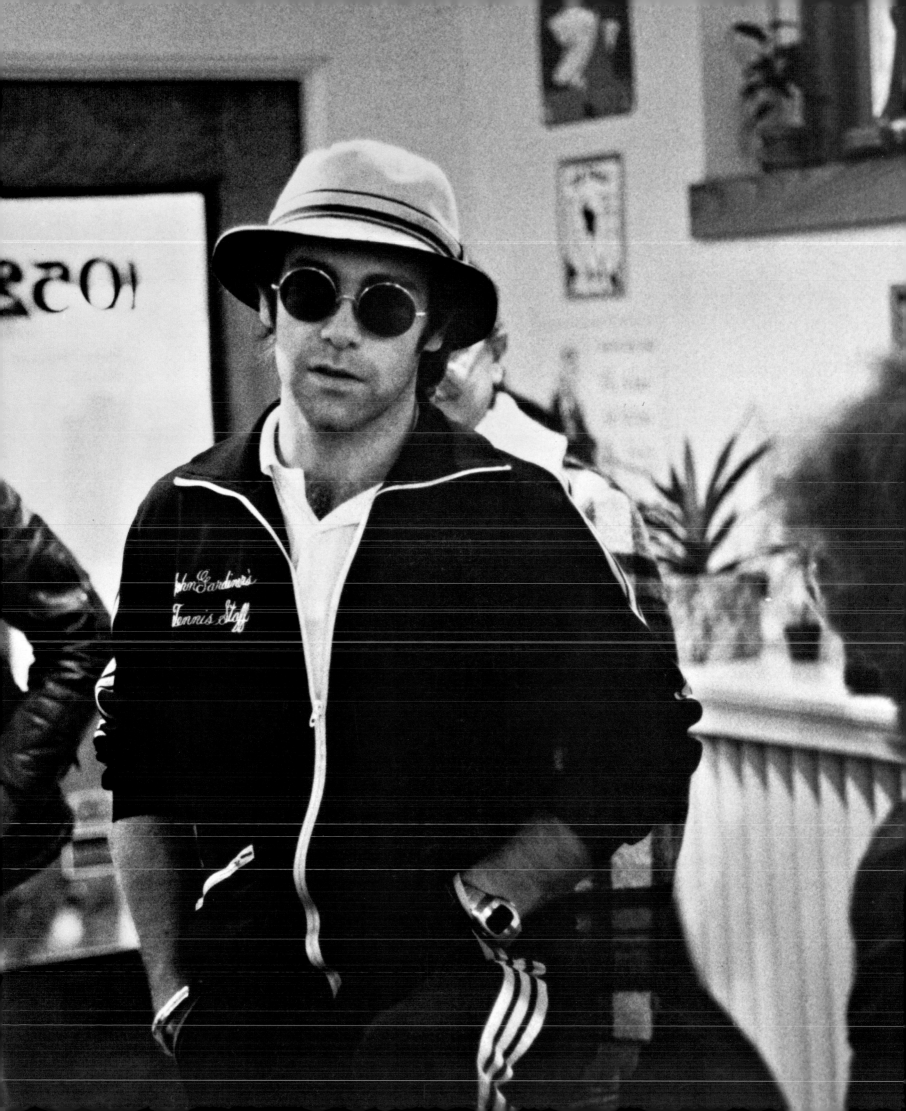

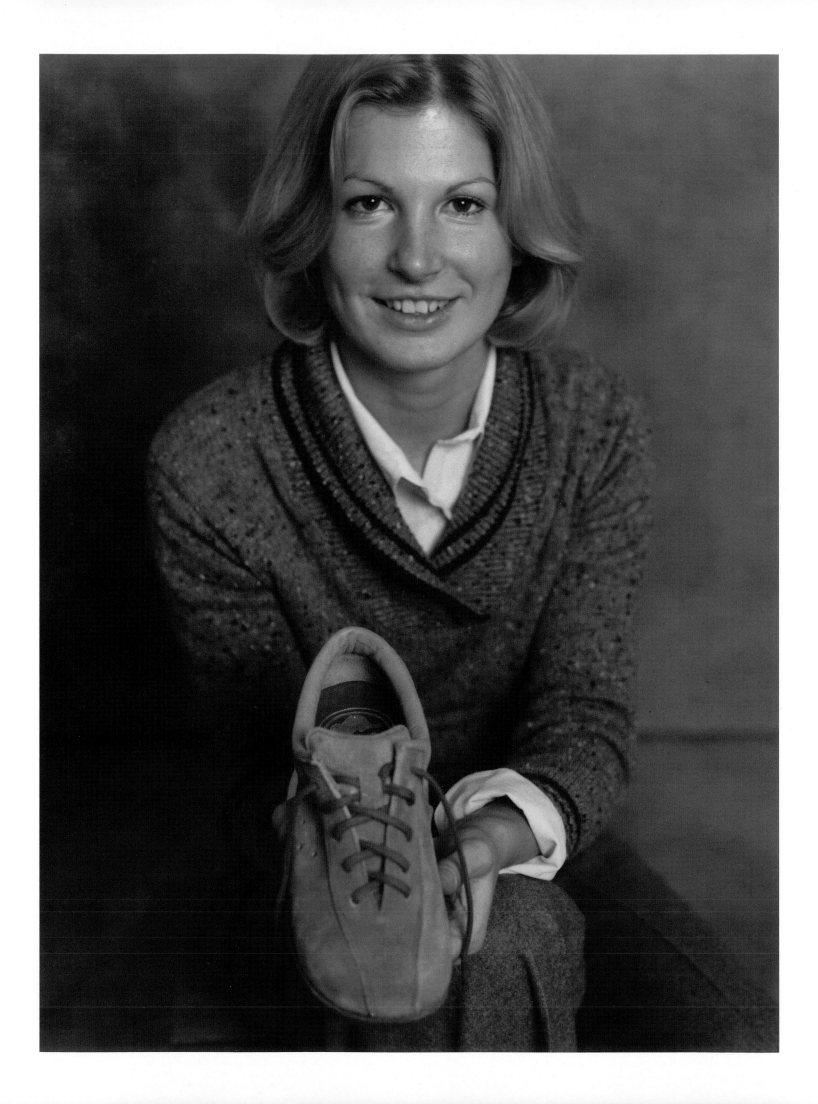

Reasons for Roots.
No. 1. Gently recessed heel.

Helps your posture as your leg muscles develop a little more strength. With no heel to tilt you forward, Roots give you a more natural walk.

The Yukon Root, one of 10 styles.

Sold only at Roots shops. Gift certificates available.

City feet need Roots.

Reasons for Roots.
No. 2. Comfortable arch support.

If you spend a lot of time moving around—or standing around—on hard floors or city sidewalks, your arches need this kind of help.

The Spring Root, one of 10 styles.

Sold only at Roots shops. Gift certificates available.

City feet need Roots.

Reasons for Roots.
No. 3. Rocker Sole.

When you walk, your body weight shifts from your heel down the outer side, across to the big toe for lift-off. Roots sole makes each lift-off less work.

The City Root, one of 10 styles.

Sold only at Roots shops. Gift certificates available.

City feet need Roots.

Reasons for Roots.
No. 4. Naturally shaped toes.

Roots roomy uppers aren't shaped like ordinary shoes. But they are shaped like ordinary feet. Your toes will stay healthfully uncrowded.

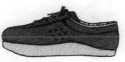

The Sport Root, one of 10 styles.

Sold only at Roots shops. Gift certificates available.

City feet need Roots.

Reasons for Roots.
No. 5. Cool leather lining.

Soft skins inside give your feet just a little extra cushioning, and—since nothing breathes as well as leather—a little extra coolness, as well.

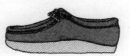

The Main Root, one of 10 styles.

Sold only at Roots shops. Gift certificates available.

City feet need Roots.

Reasons for Roots.
No. 6. Canadian leathers.

All 10 styles of Roots use top-grain hides, finished naturally with no cosmetic cover-ups. The leather pores breathe freely. So do your feet.

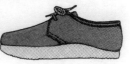

The City Root, one of 10 styles.

Sold only at Roots shops. Gift certificates available.

City feet need Roots.

Reasons for Roots.
No. 7. Craftsmanship.

Two generations of Canadian shoemakers (a father and four sons) guide production. Good work— much of it still done by hand—is a family tradition.

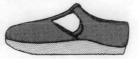

The T Root, one of 10 styles.

Sold only at Roots shops. Gift certificates available.

City feet need Roots.

Reasons for Roots.
No. 8. The Roots Shop.

Roots are available only through Roots shops, where we know our shoes inside and out. Our people do more than stand behind Roots. They stand inside them, as well.

The Portage Root, one of 10 styles.

Sold only at Roots shops. Gift certificates available.

City feet need Roots.

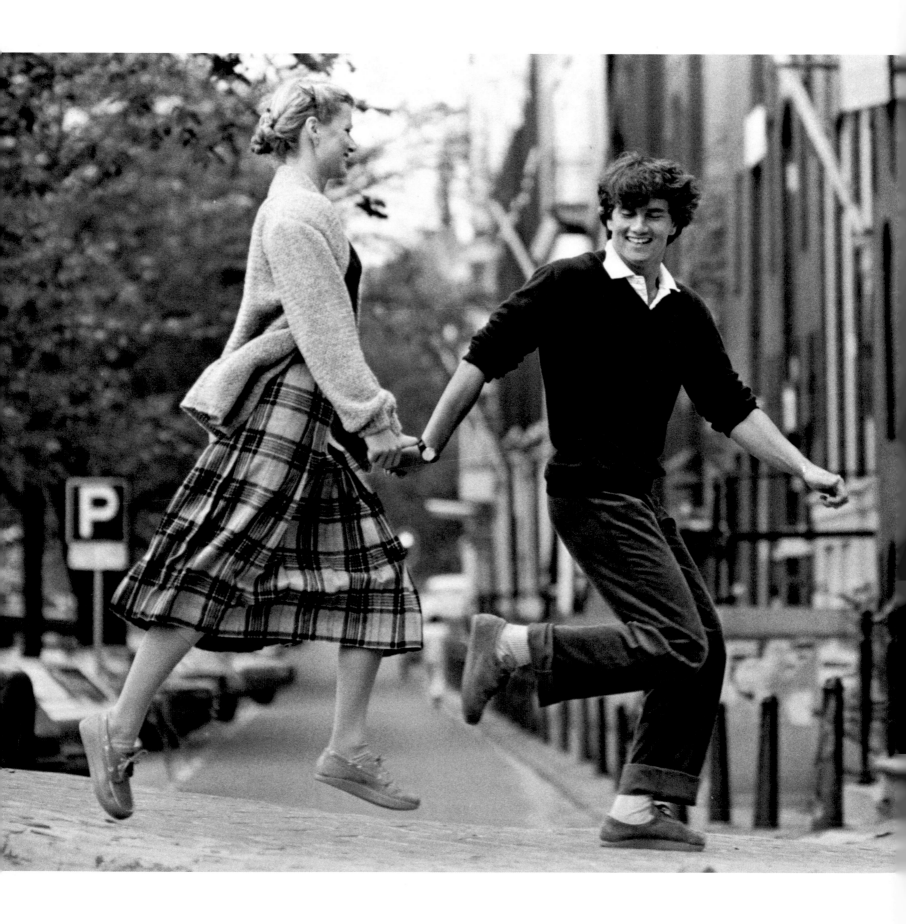

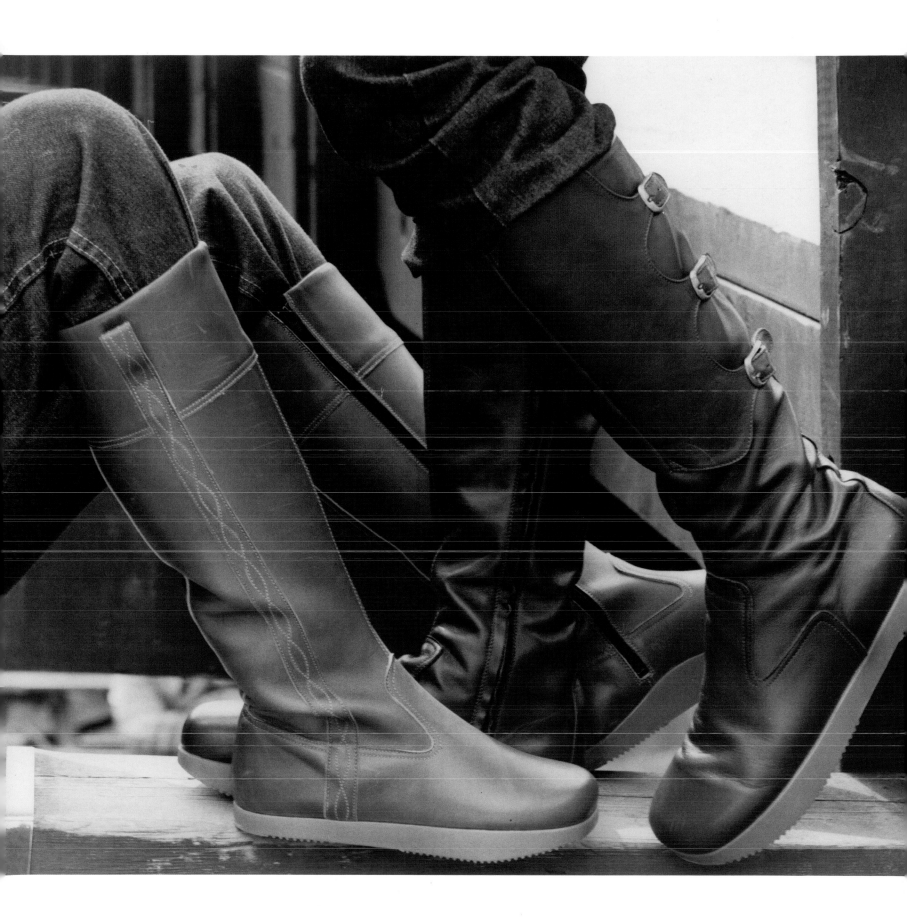

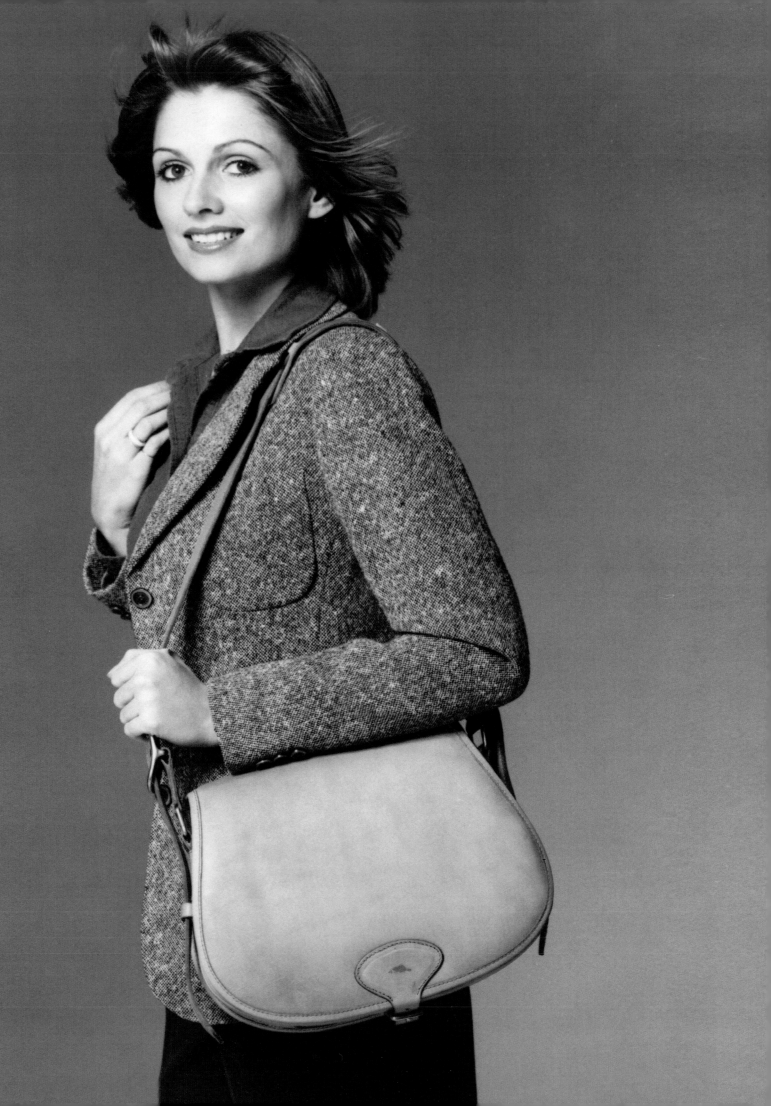

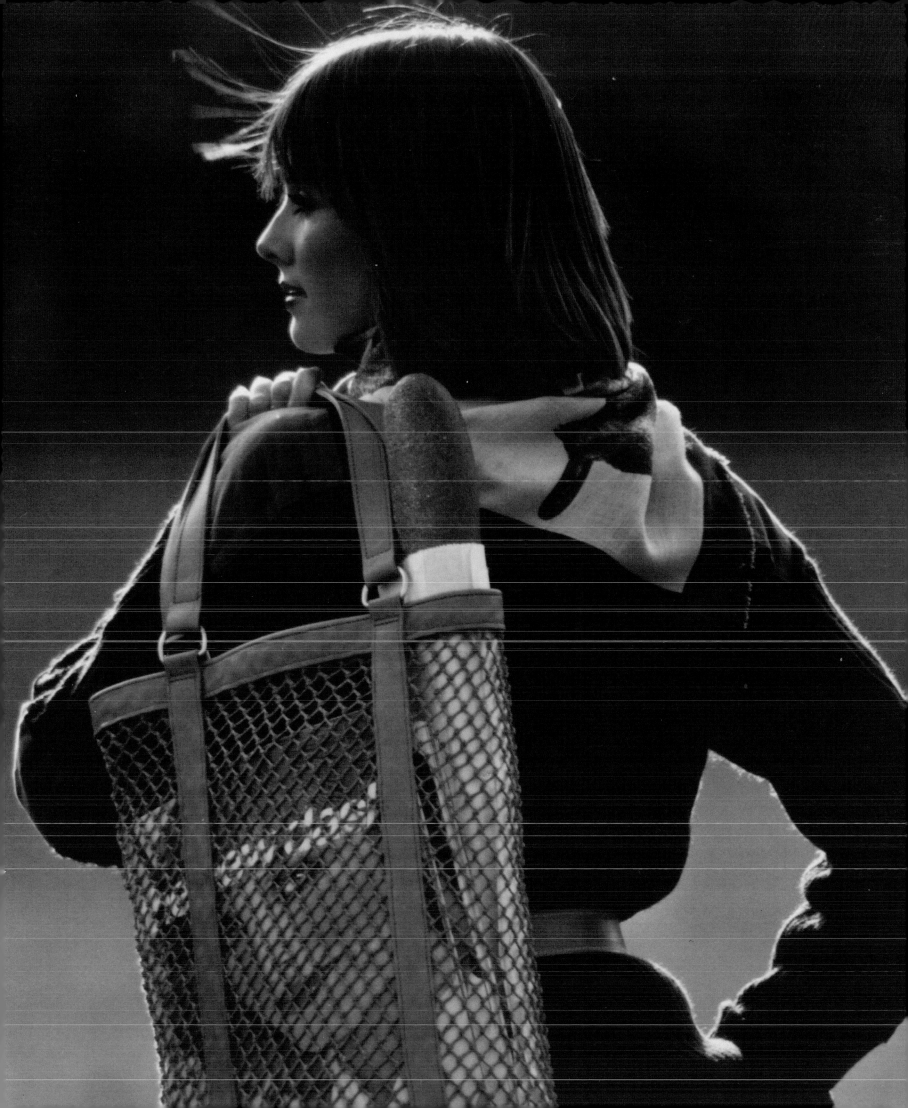

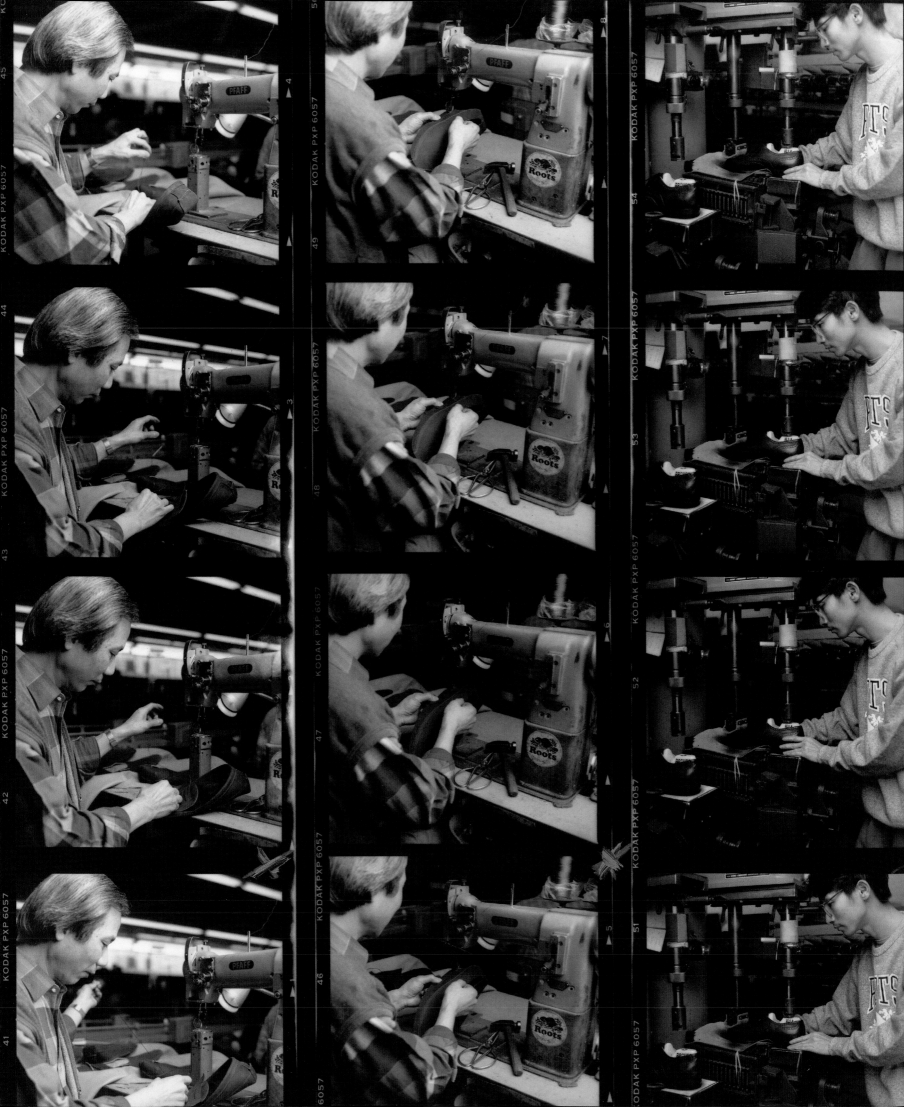

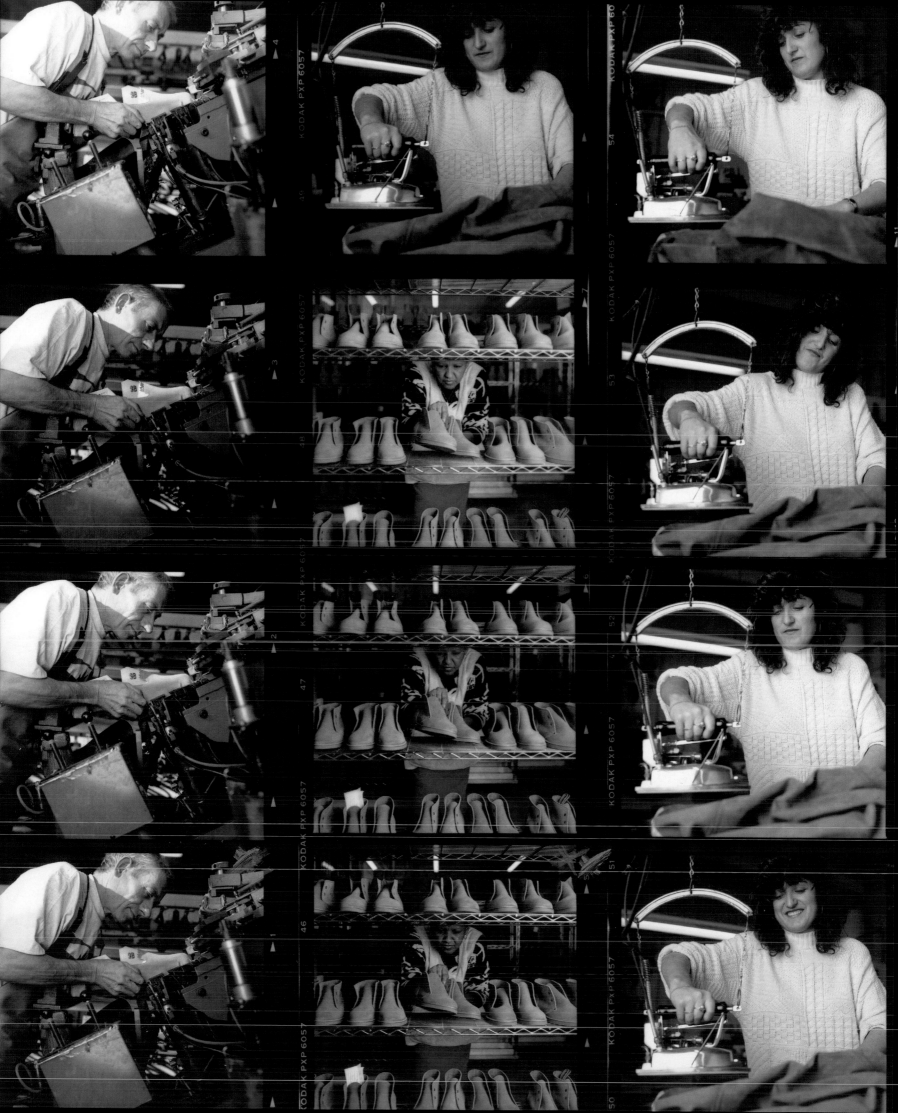

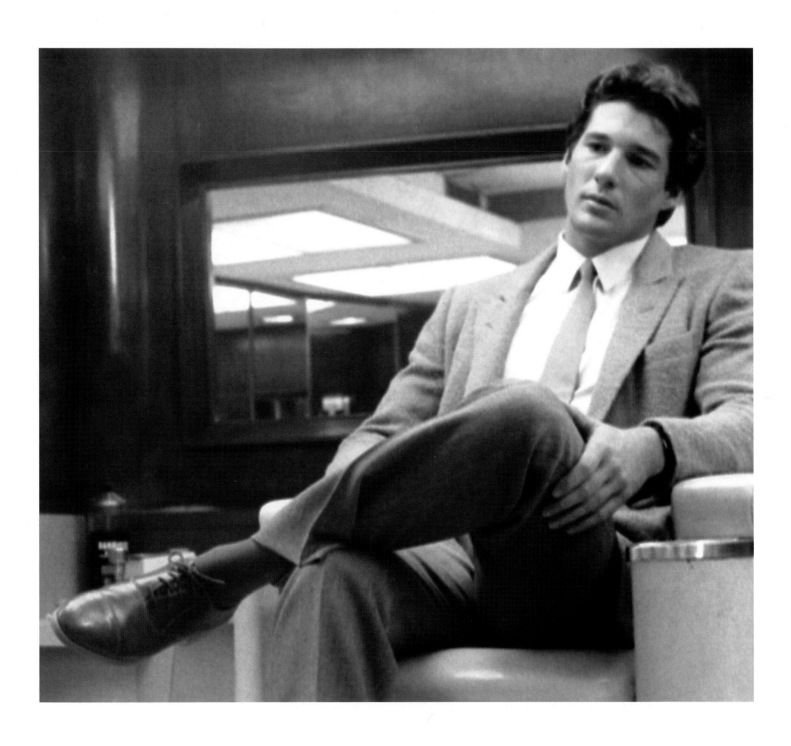

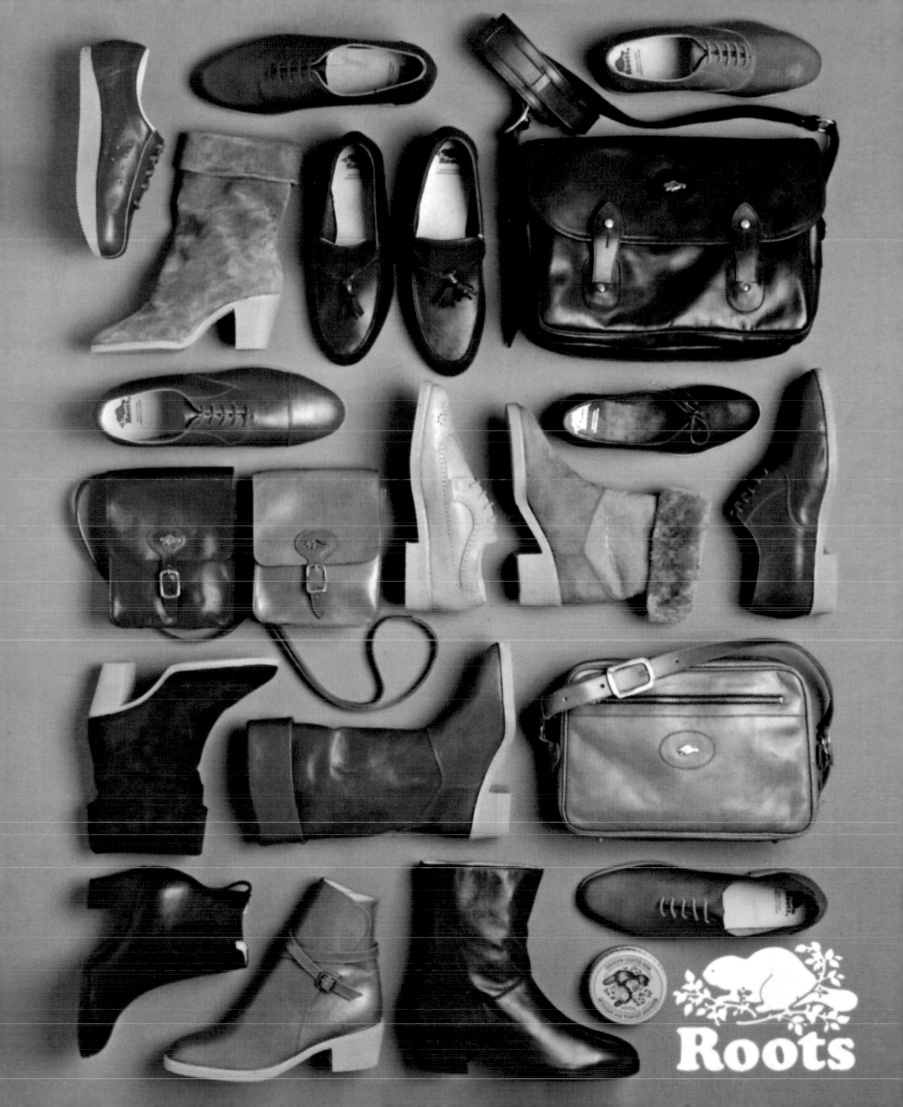

Roots

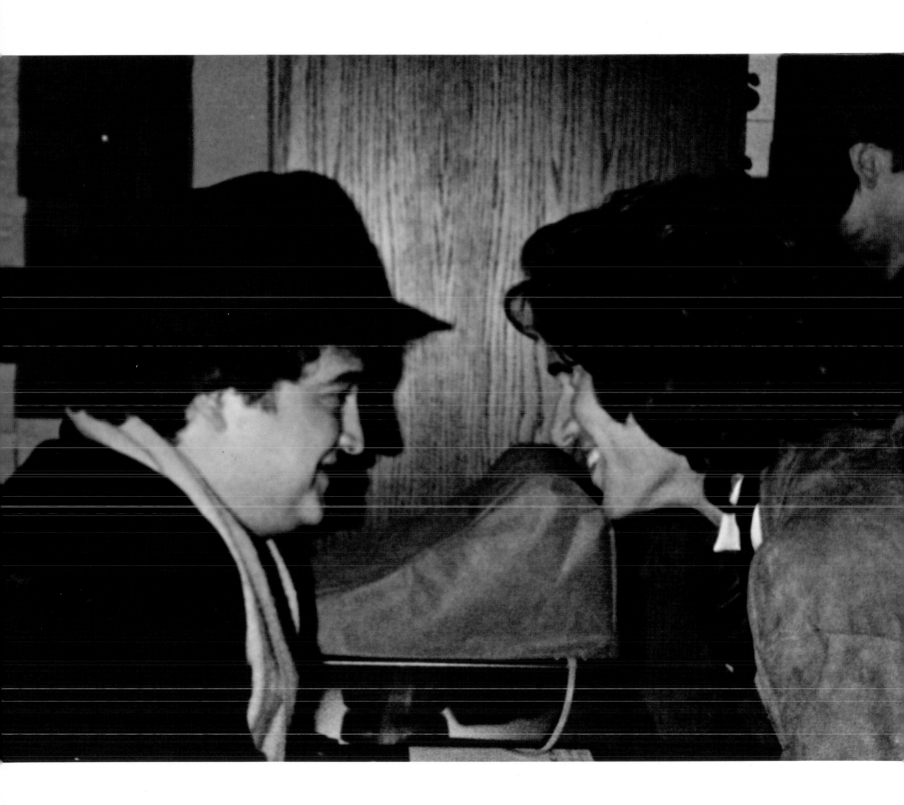

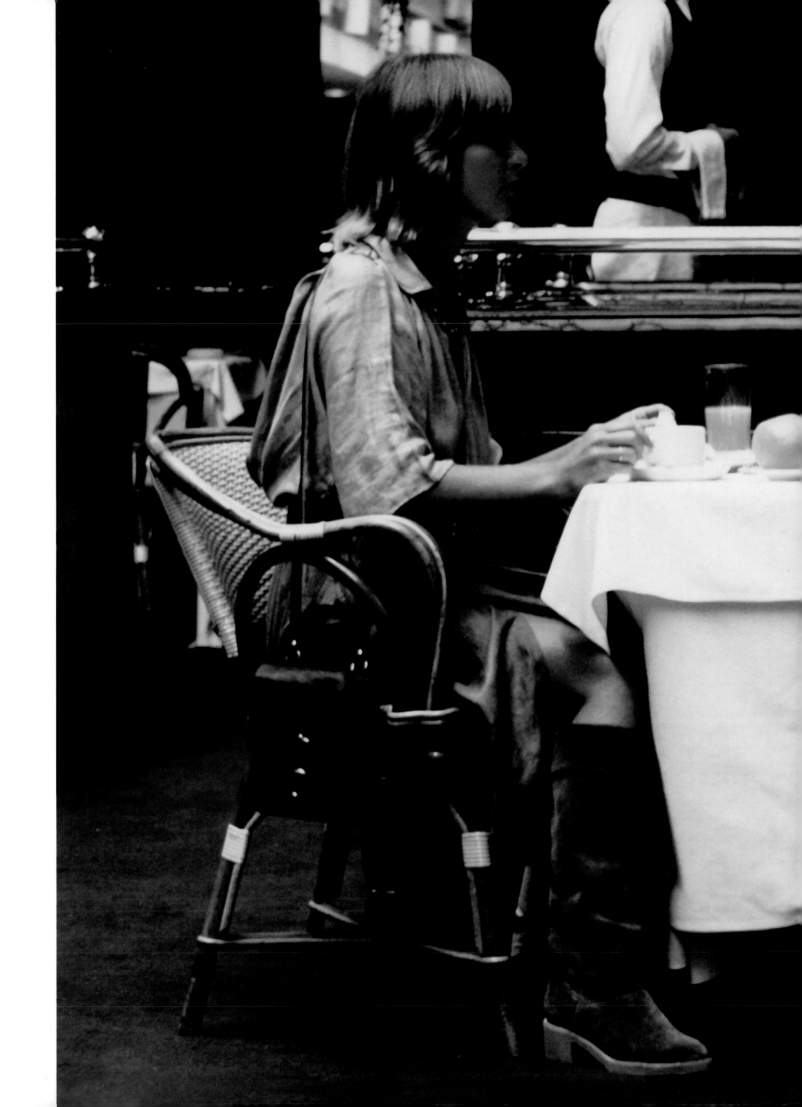

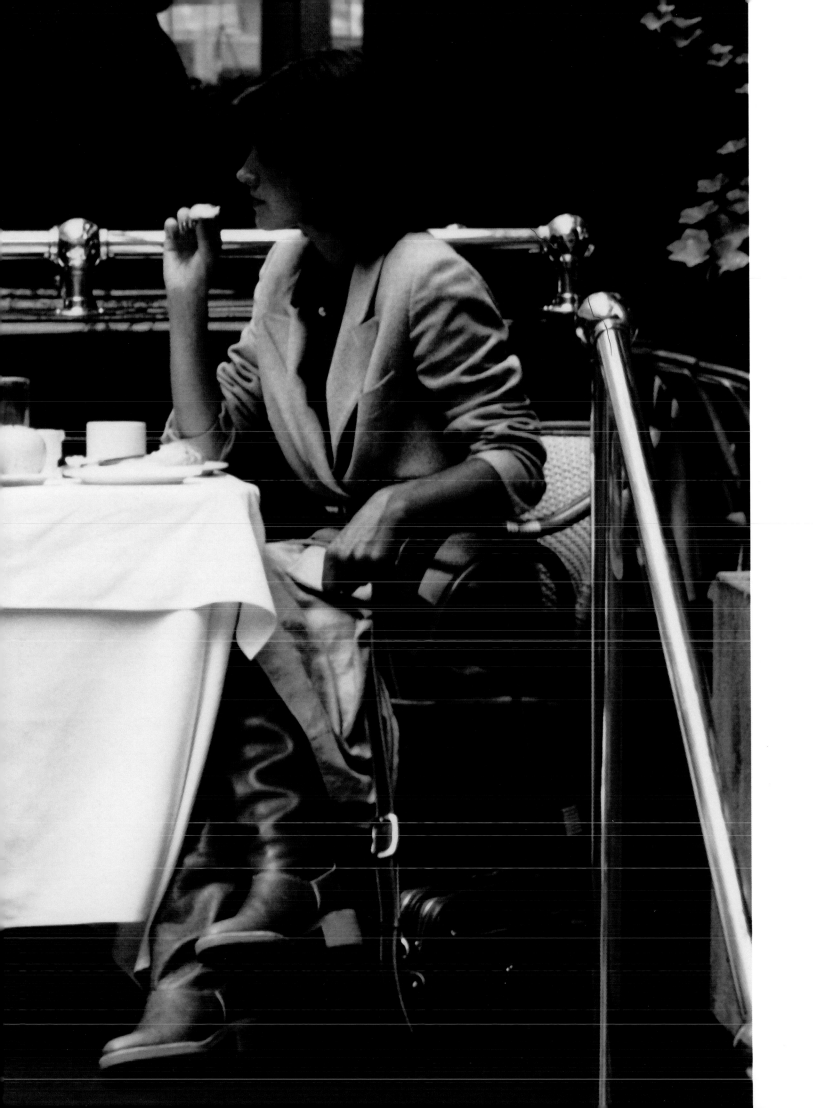

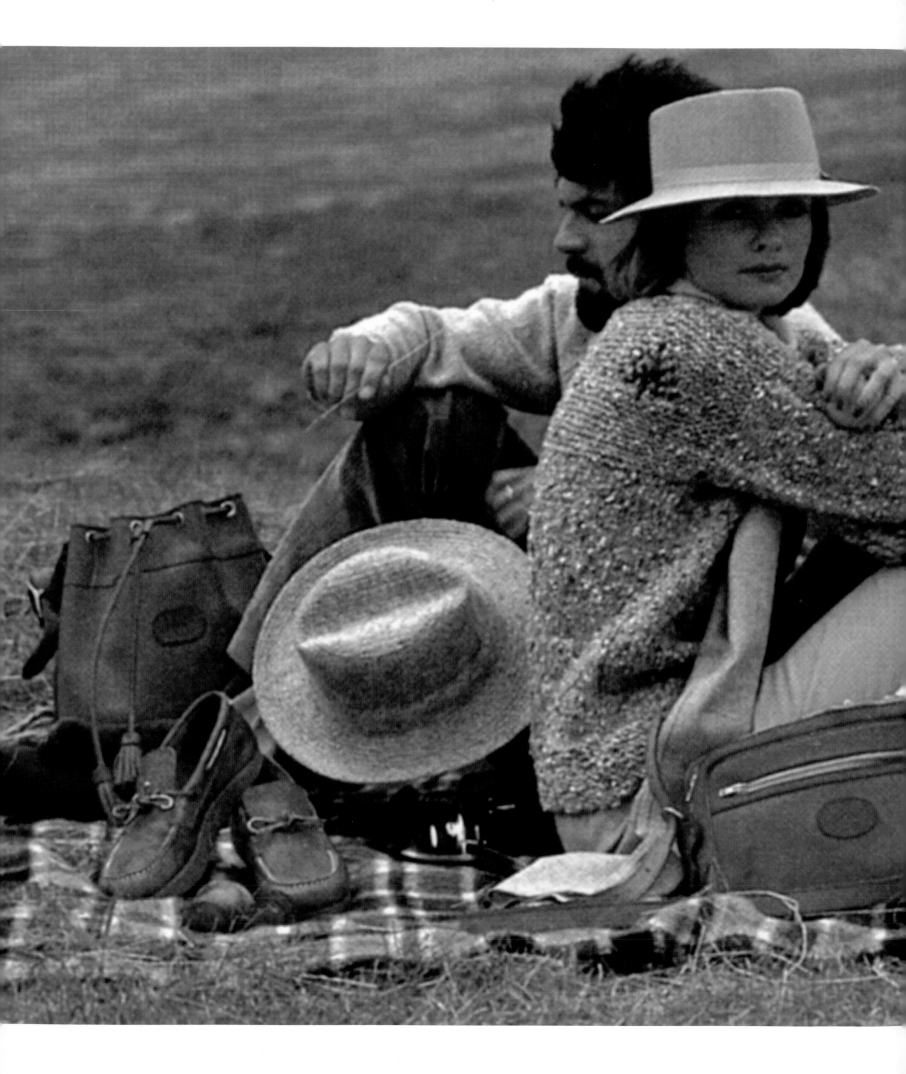

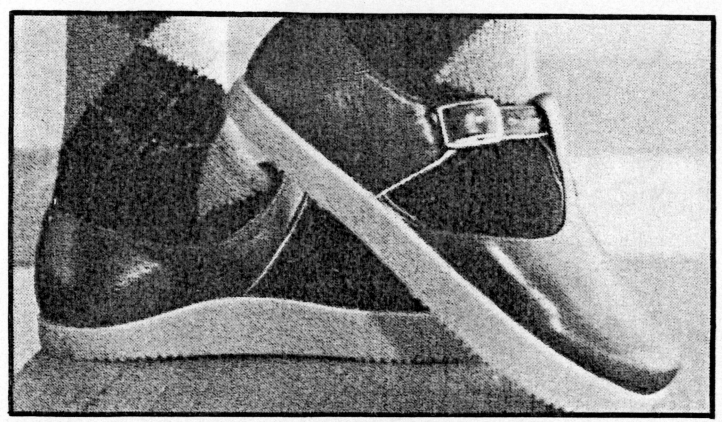

Roots, 1052 Yonge St. (967-5461), is a new shoe store representing a unique concept in footwear design. The molded rubber sole of every shoe sold here is lower in the heel than in the ball of the foot, which is said to give your feet better support—and you, better posture. Upper parts of shoes are of soft leathers and suedes in earth colors and come in today's styles: boots (high and low), loafers, sandals, straps and ties. After two years of research that began in Europe, these shoes are now available in Toronto for the first time. And they are manufactured right here. Prices range from $19 to $33. Hours: Monday to Saturday 10 a.m. to 6 p.m., Thursday 10 a.m. to 8:30 p.m.

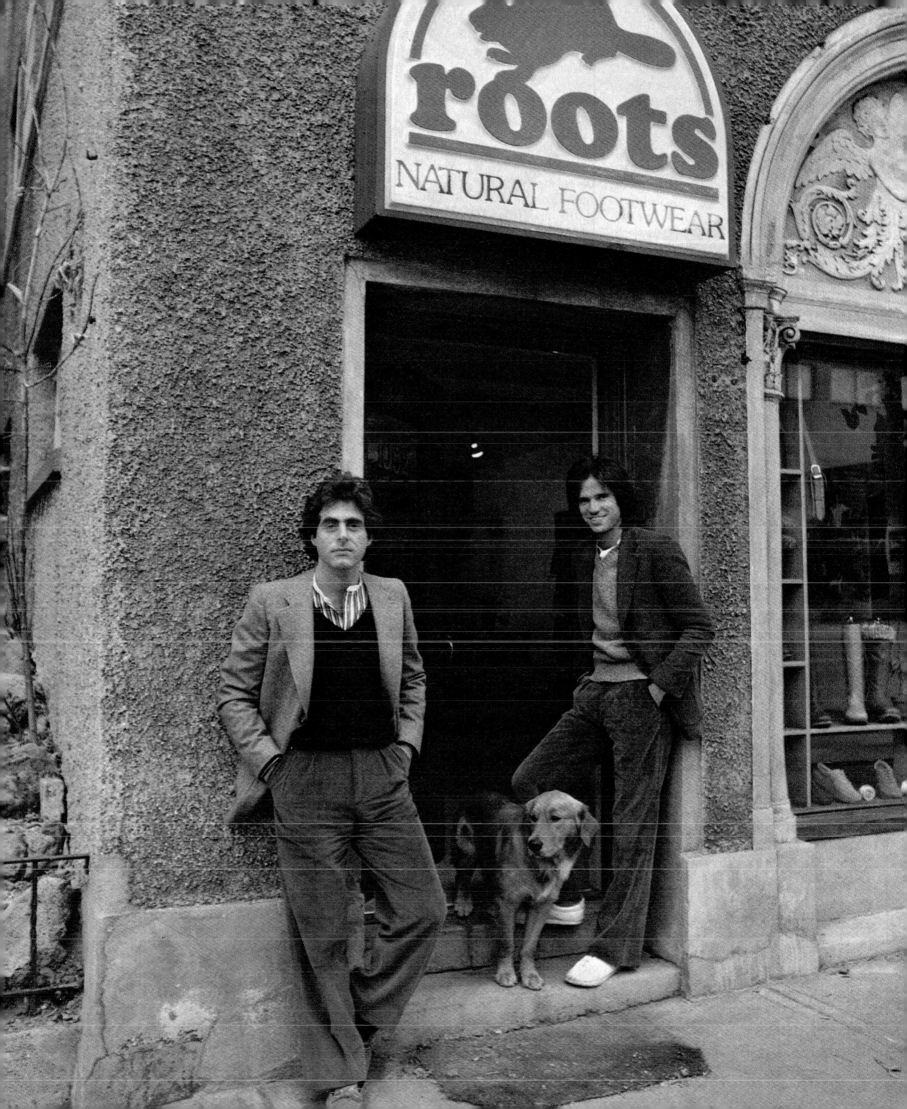

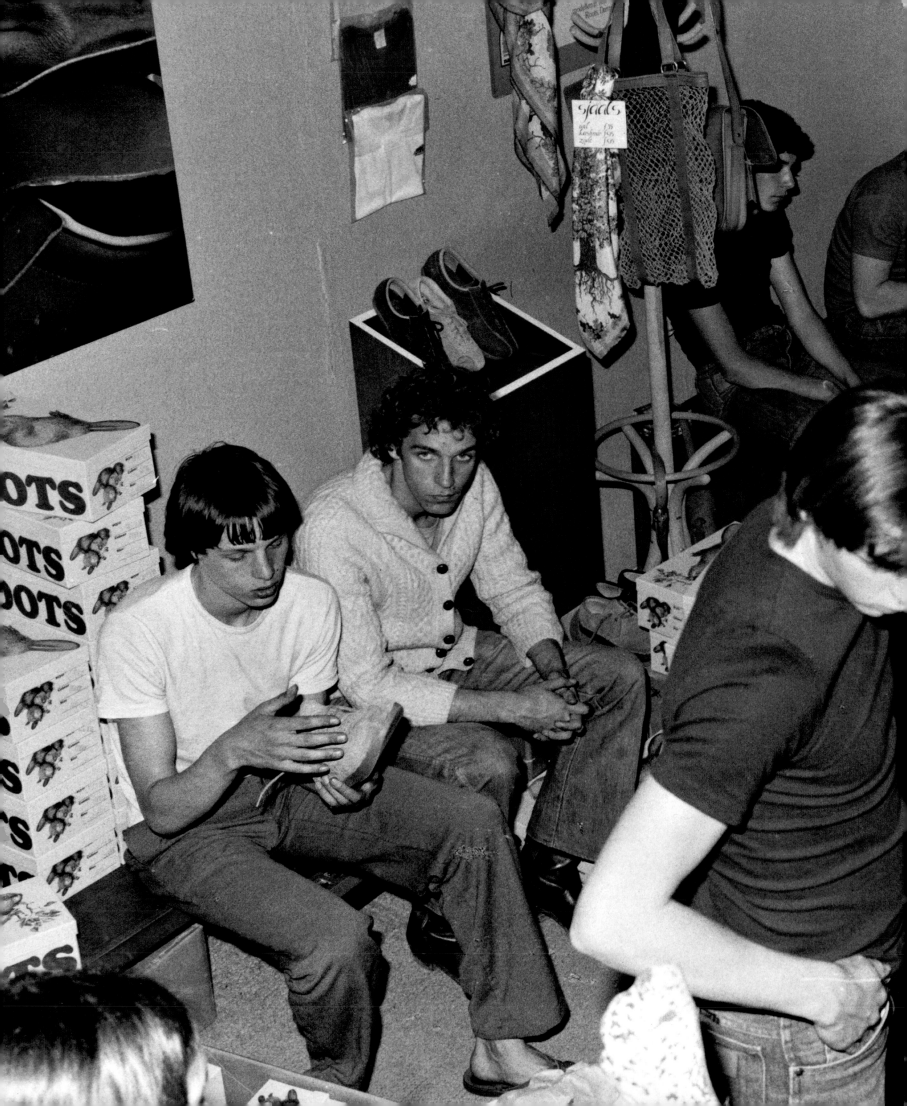

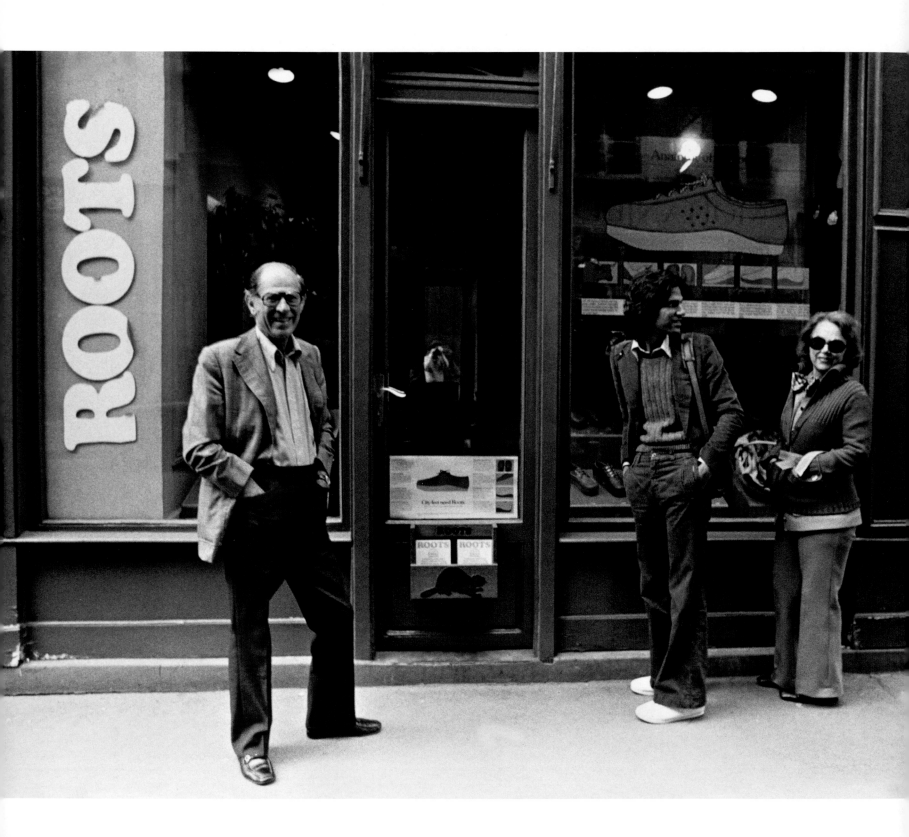

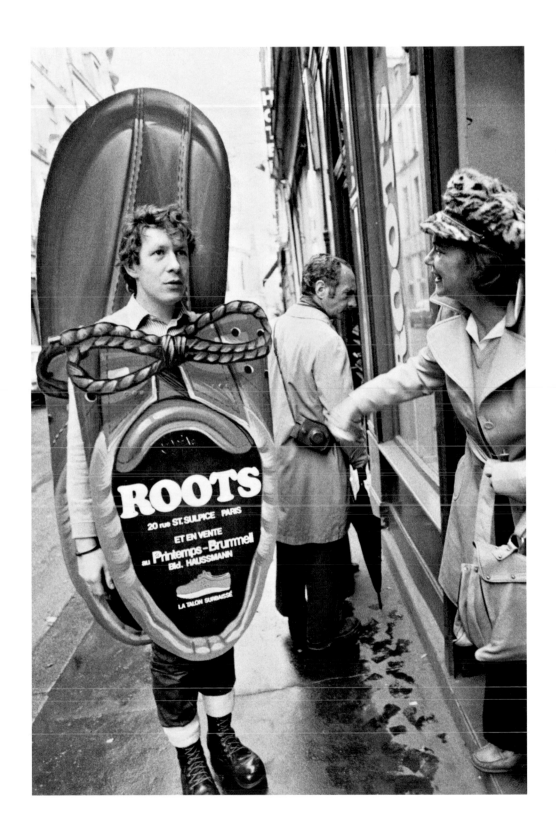

Cover 1

ISSUE NUMBER 12 USA $1.95 · CANADA $2.25 · ENGLAND £1 · HOLLAND 5 Glds. · GERMANY 6DM · SWITZERLAND 5SF

Masters of French Poster Design · Saul Bellow · Vegetarian Food Guide
Fashion Week Reviewed · Dispatch From Geneva · Hemingway Revisited

APRIL 15 - 28, 1982 EVERY TWO WEEKS 9 F

PASSION
THE MAGAZINE OF PARIS

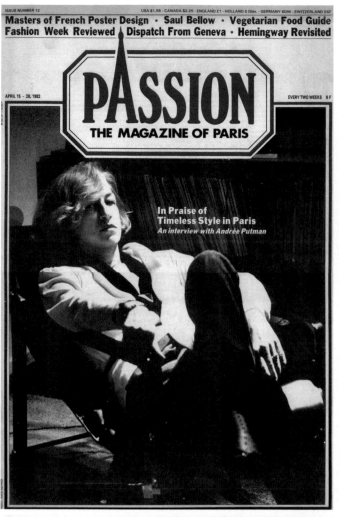

In Praise of
Timeless Style in Paris
An interview with Andrée Putman

Cover 2

ISSUE NUMBER 18 USA $1.95 · CANADA $2.25 · ENGLAND 75p. · HOLLAND 5 Glds. · GERMANY 6DM · SWITZERLAND 5SF

J.P. Gauthier · Tales of Modeling · Azzedine Alaia · Fashion Store Guide
Images of Les Collections · French Politics · Live Music Survey · Querelle

Featuring the
most complete
art, music,
restaurant and
other Paris
entertainment
listings in English

SALON DU
PRÊT-A-PORTER

OCT. 15 - NOV. 12, 1982 9 F

PASSION
THE MAGAZINE OF PARIS

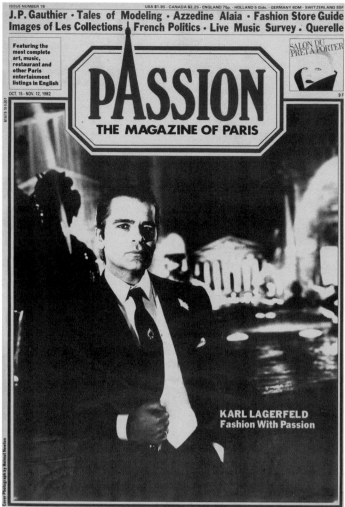

KARL LAGERFELD
Fashion With Passion

Cover 3

OCTOBER 1983 · ISSUE NUMBER 27 FRANCE 10F · USA $2.50 · CANADA $2.75 · ENGLAND 75p. · HOLLAND 5 Glds. · GERMANY 6DM

In Defense of French Rock · Baseball in Paris · L. Buñuel · Les Halles Update
Fall TV · Parisian Cabarets · La Rentrée Politique · Jodie Foster · Play Money

PASSION
THE MAGAZINE OF PARIS

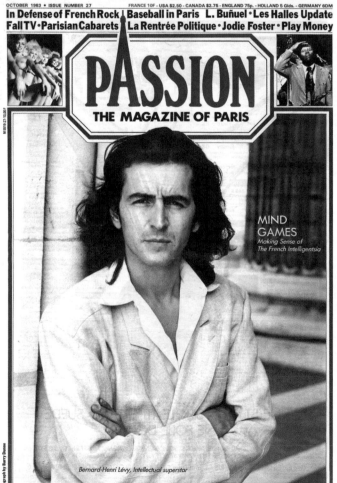

MIND
GAMES
*Making Sense of
The French Intelligentsia*

Bernard-Henri Lévy, Intellectual superstar

Photograph by Barry Danme

Cover 4

NOVEMBER 1983 · ISSUE NUMBER 28 FRANCE 10F · USA $2.50 · CANADA $2.75 · ENGLAND 75p. · HOLLAND 5 Glds. · GERMANY 6DM

Young Designers · E. Piaf · The Seine Story · Portraits In Style · Cocteau
From Hair To Eternity · Boutique Guide · Squatters · Fellini's Latest

UN CERTAIN
REGARD

PORTRAITS
BY ALICE SPRINGS

PASSION
THE MAGAZINE OF PARIS

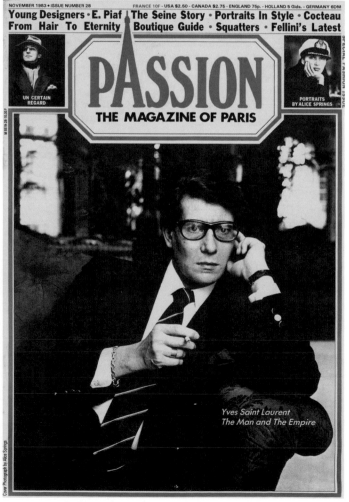

*Yves Saint Laurent
The Man and The Empire*

Cover Photograph by Alice Springs

THE MAGAZINE OF PARIS

PASSION

SPECIAL FASHION ISSUE APRIL/MAY 1986

That's Shoe Biz
Posters and Politics
Film and The Holocaust
The State of the Unions
The French Video Boom
Claude Régy at Chaillot
The Victims of Terrorism
Ralph Lauren Comes to Paris
Marxism & The French Revolution
Et dans les pages françaises
Les 100 Poids Lourds du Cinéma
Triangle Russe à Paris
La Nuit Parisienne

Photograph by David Seidner

M-5519-46-25.00F

ISSUE 46 • *FRANCE 25F* - USA $3.50 - CANADA $4.00 - UK £1.50 - ITALY 6000L - HOLLAND 9 Glds. - AUSTRALIA $5. 00 - JAPAN 1500 YEN - ISRAEL - N. ZEALAND - ICELAND - LUXEMBOURG - FRENCH POLYNESIA - MONACO.

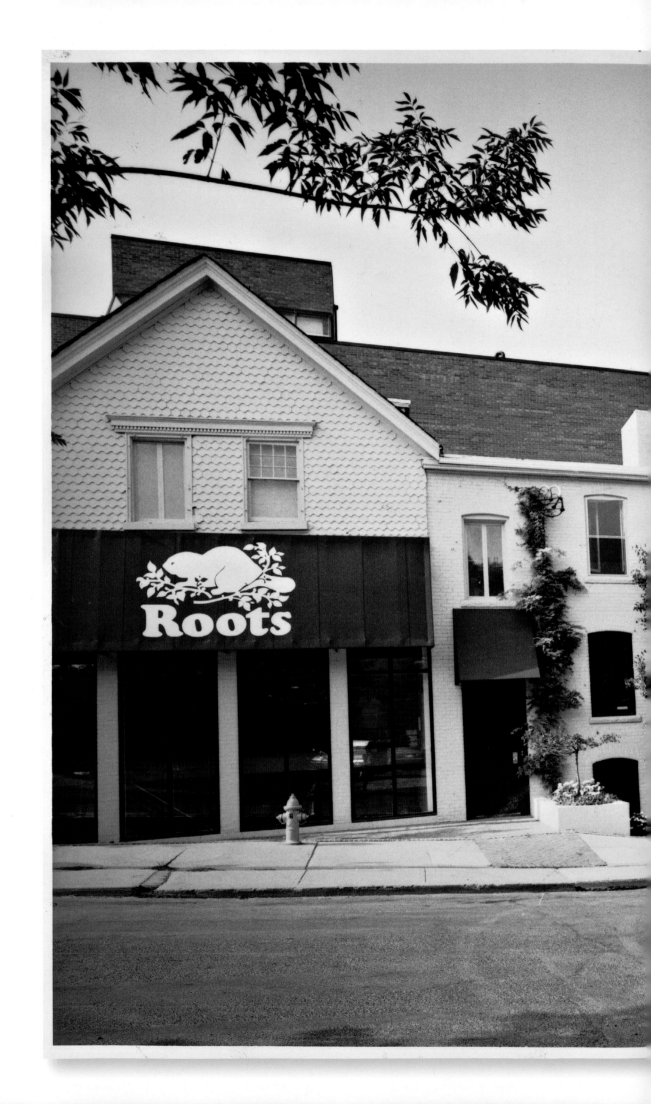

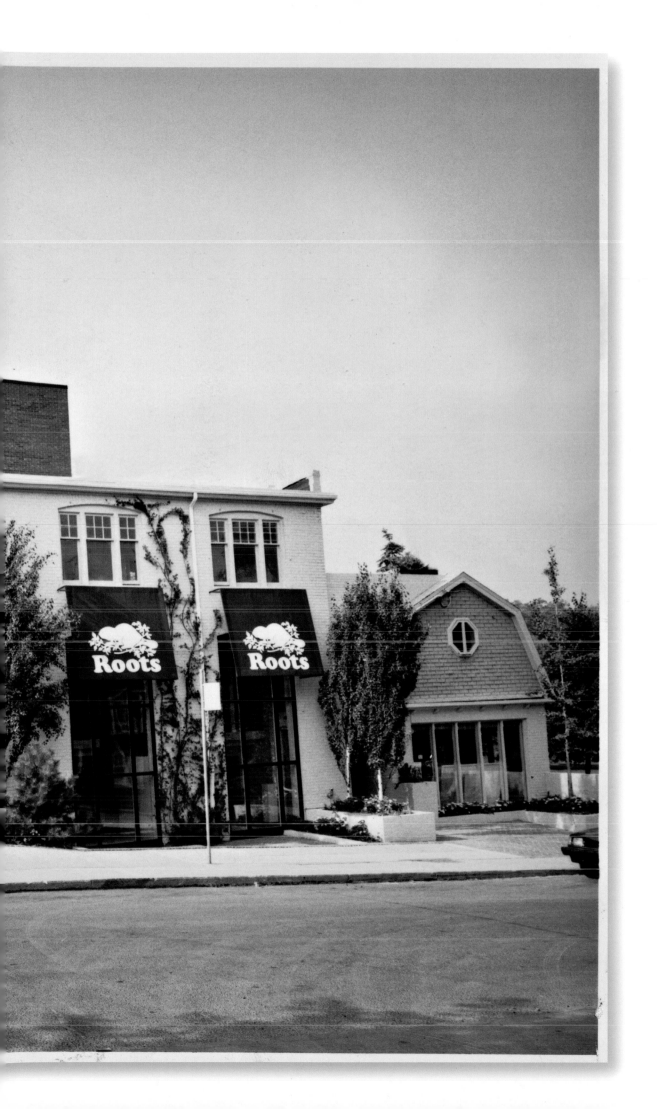

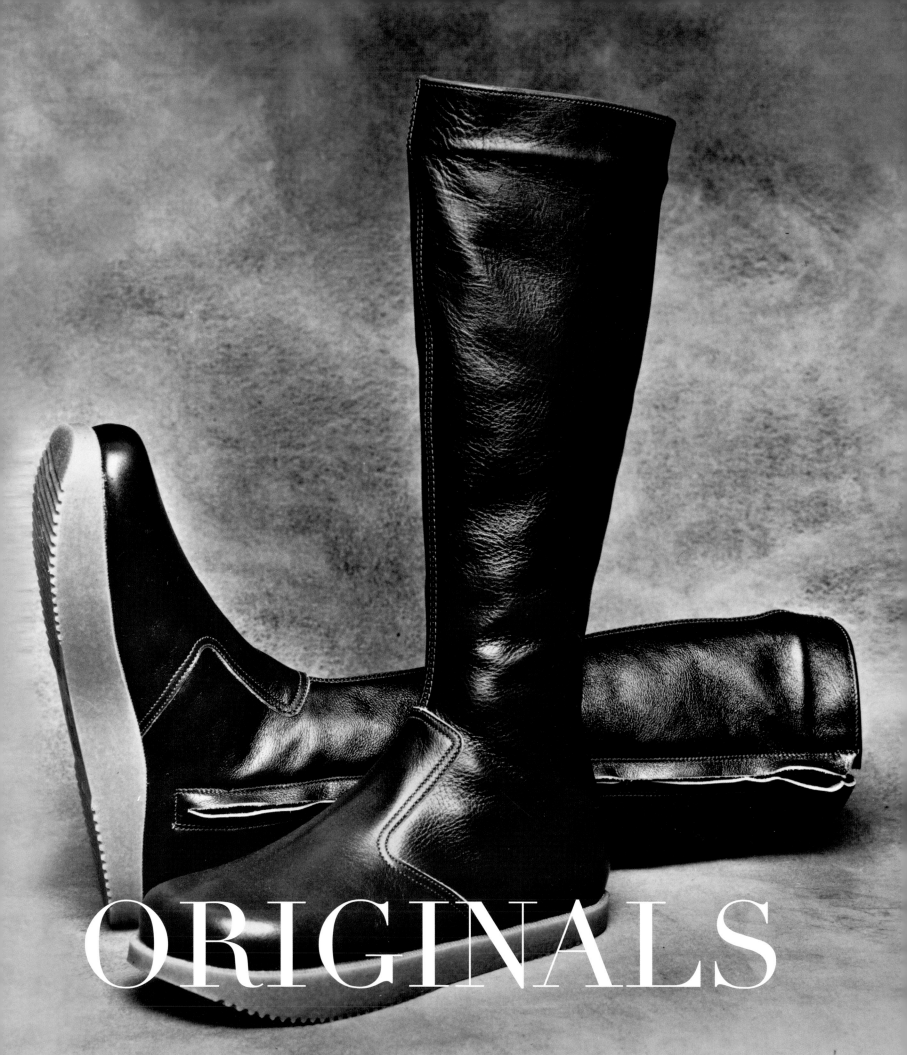

ORIGINALS

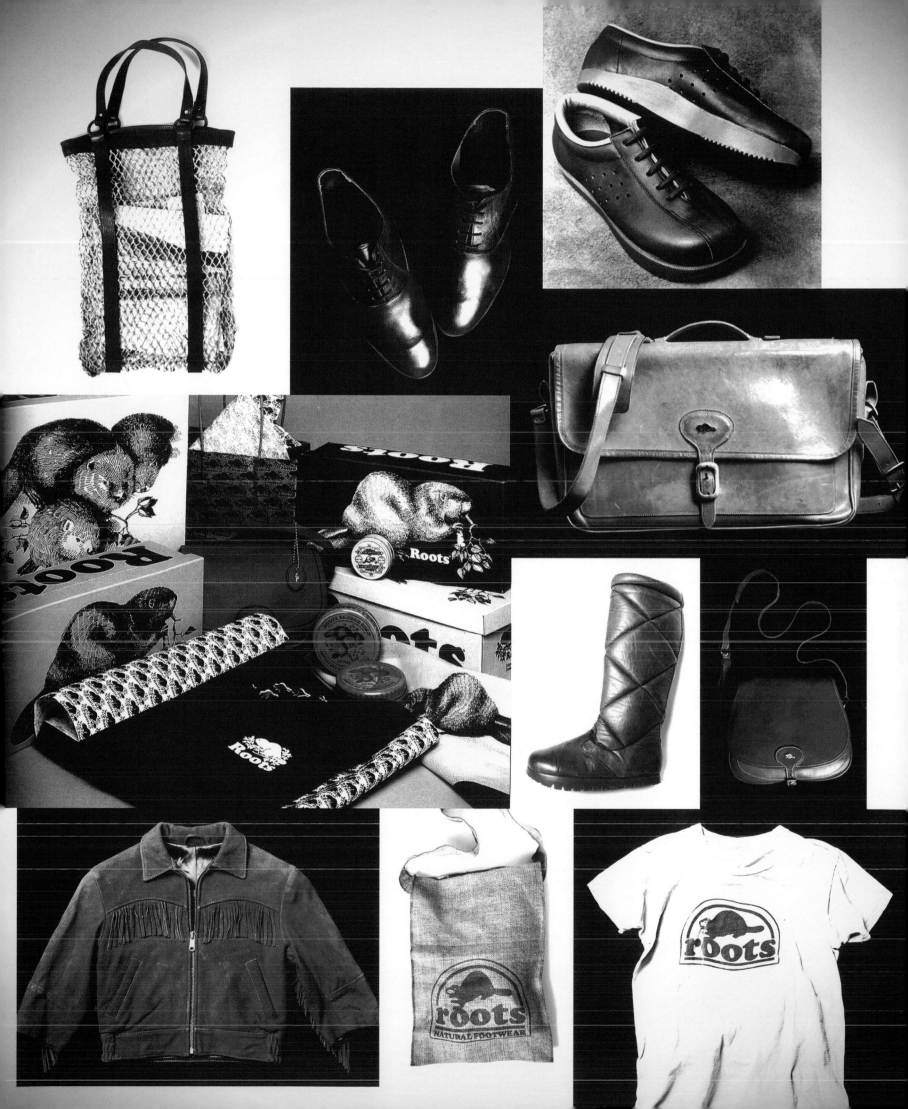

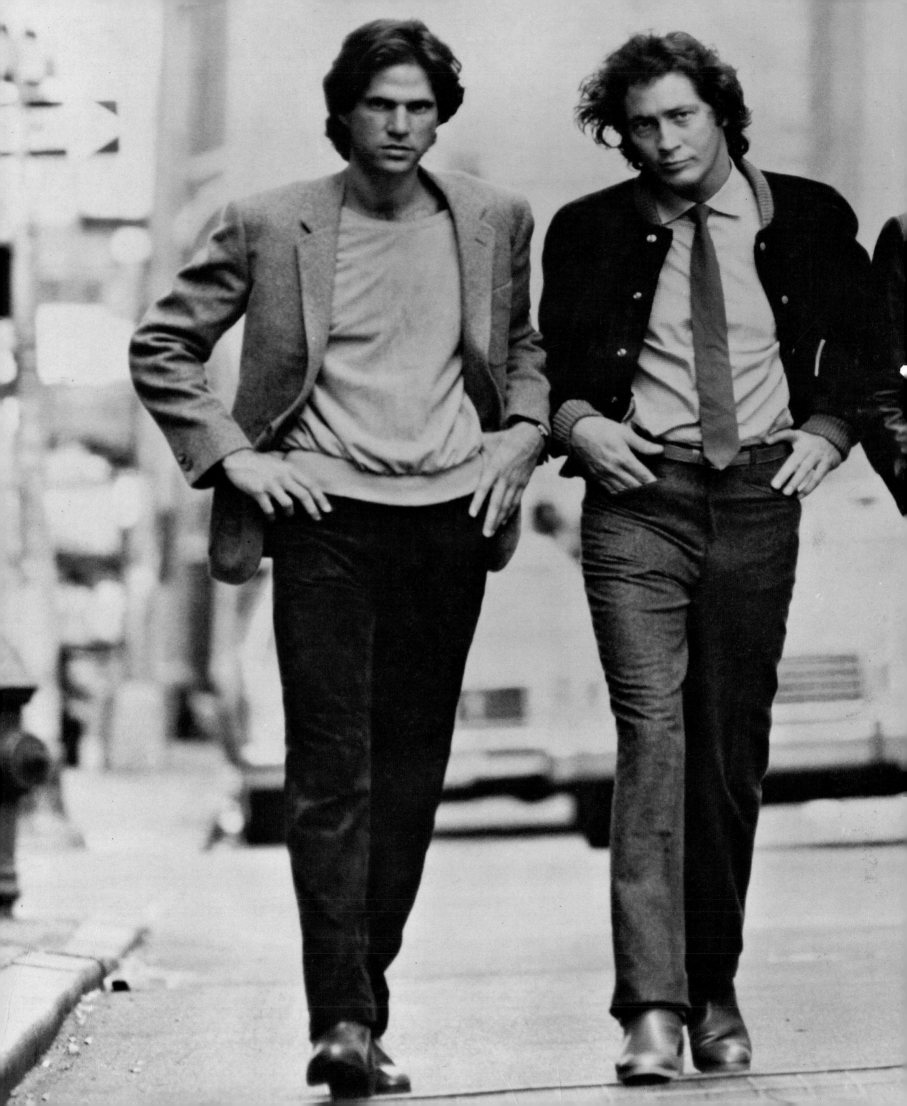

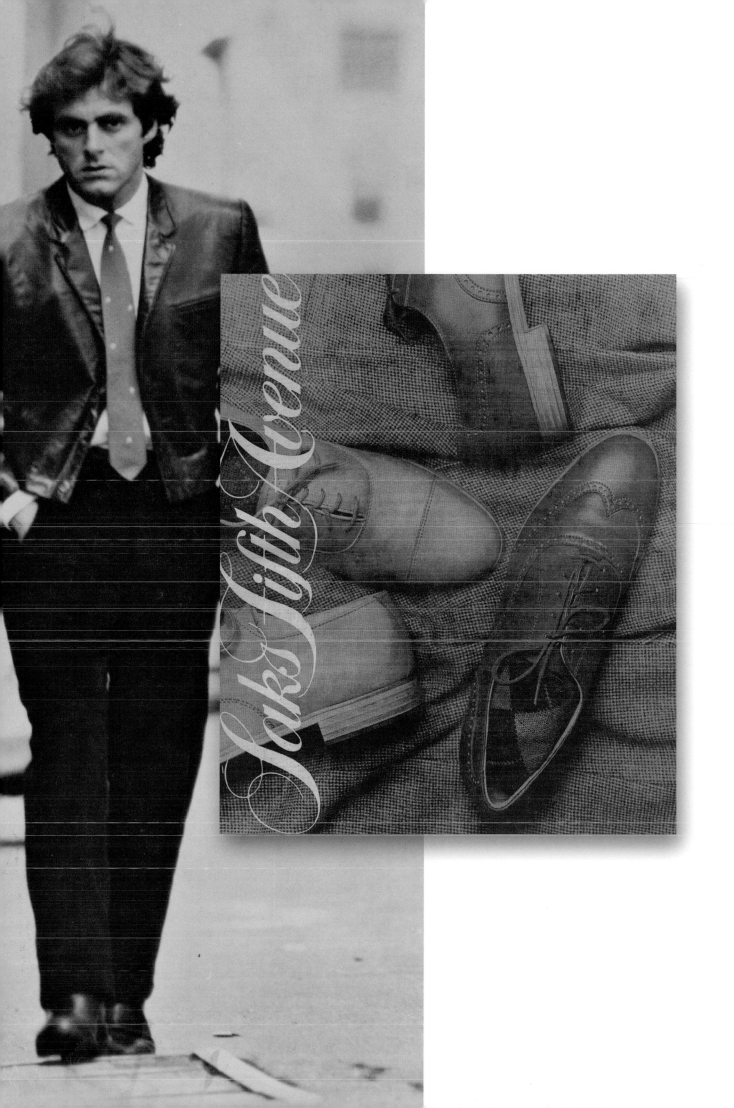

Saks Fifth Avenue

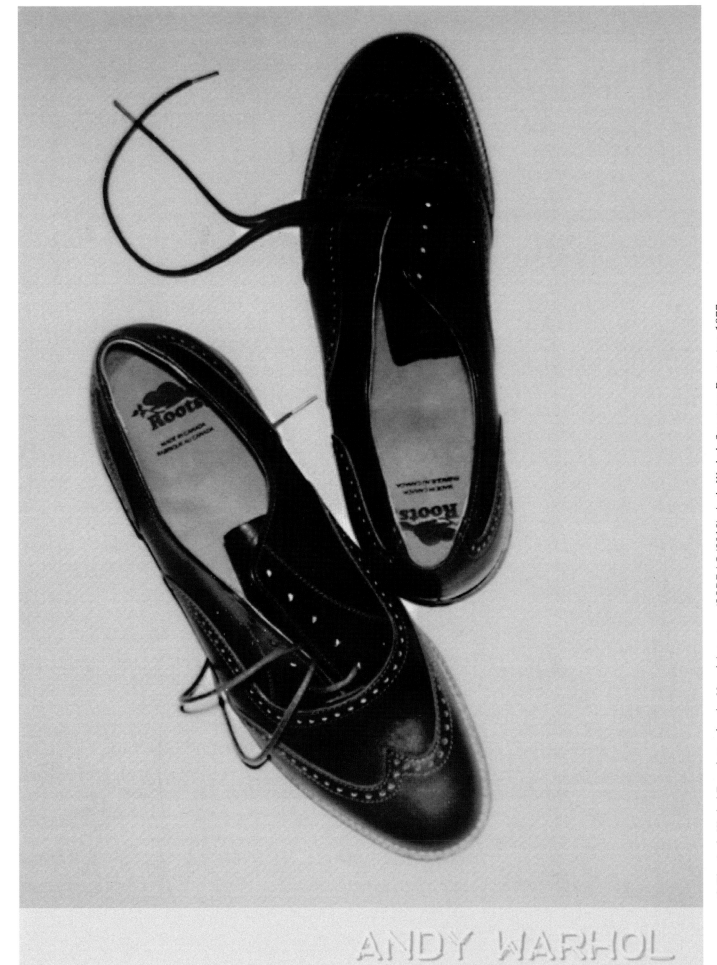

ANDY WARHOL

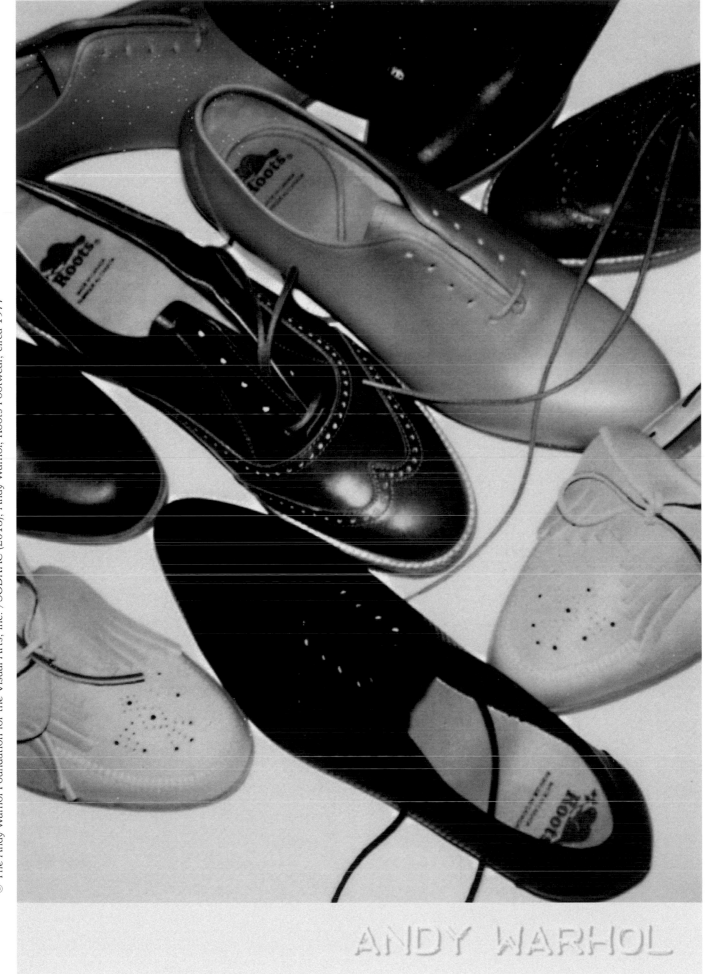

ANDY WARHOL

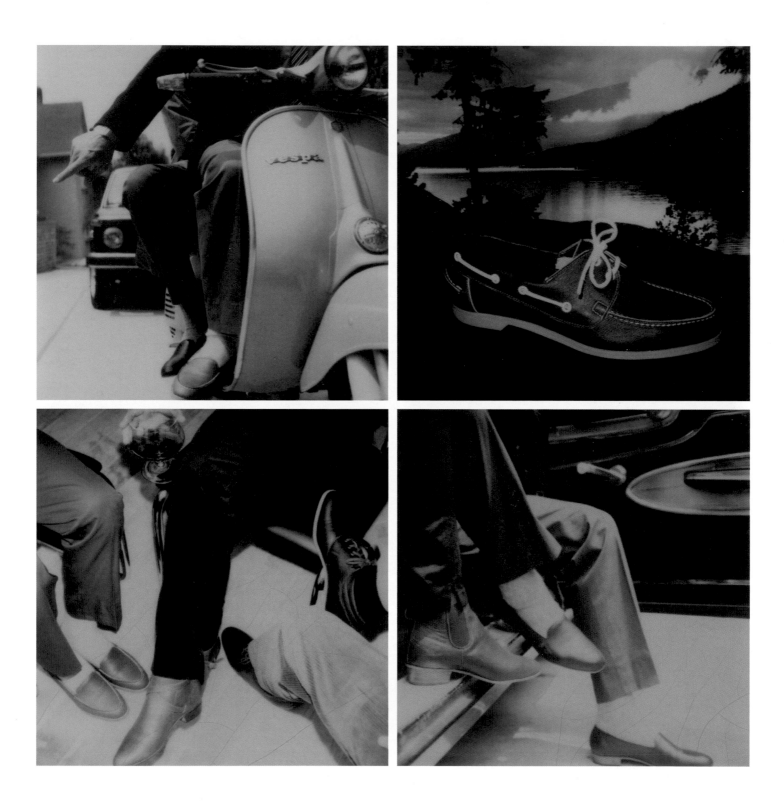

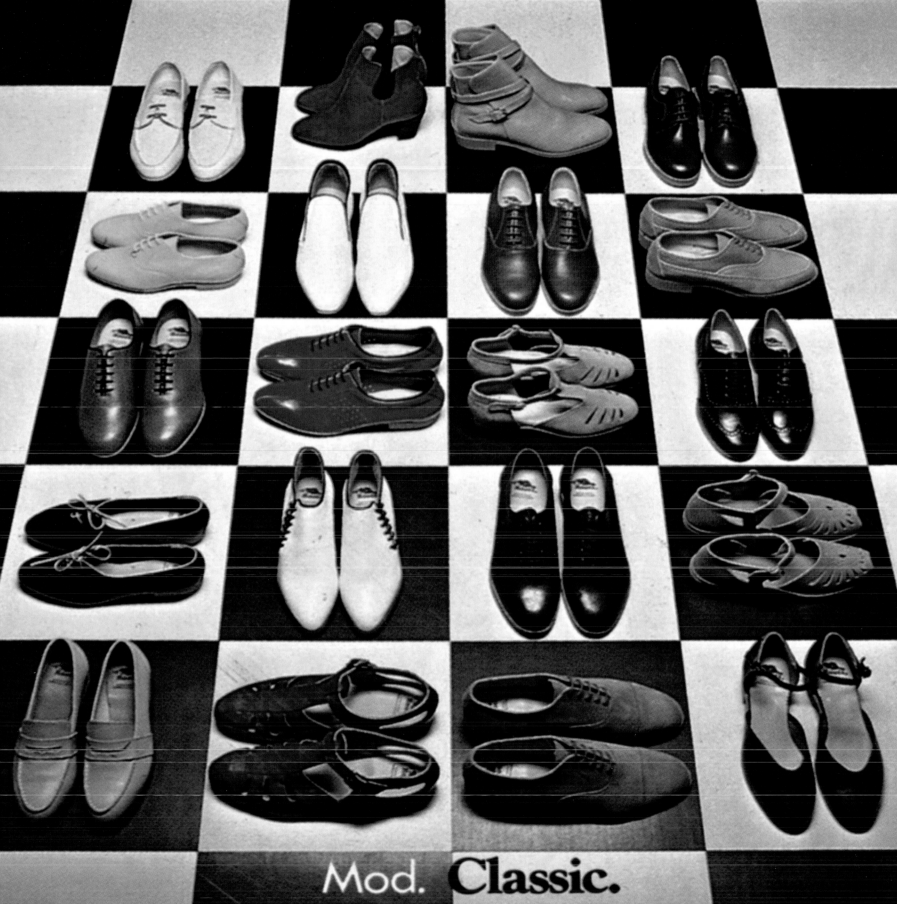

Mod. Classic.

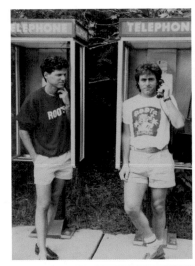
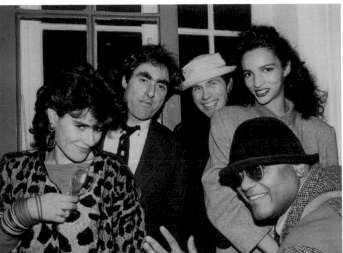
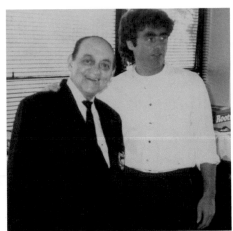

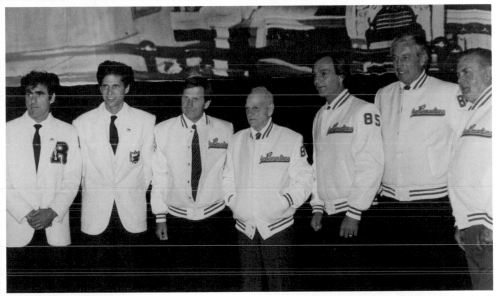
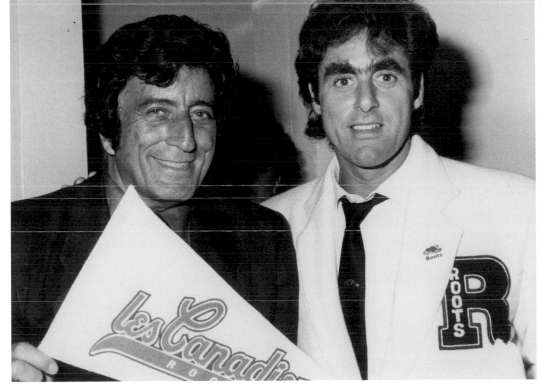

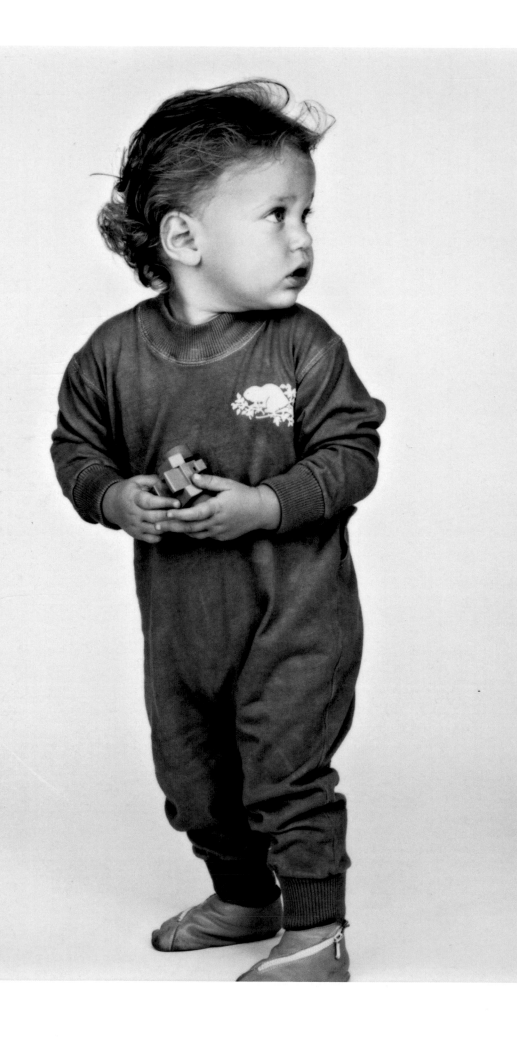

NORWEGIAN SWEATER

Algonquin: A Love Story

By Don Standfield

I just got back from Algonquin Park. The bugs had arrived and were starving but it was so nice to see the transformation of the landscape from the cold dark winter to the newness of spring and then quickly into the hot and lazy days of summer.

I want to tell you a little bit about how important Algonquin is to the Roots Boys and me. While a lot of my stories can't be repeated, I'm going to do my best.

I spent my early childhood in Algonquin because my father was a wolf biologist and we lived at the Research Station for many years. I was also a canoe trip guide at one of the camps in the Park and now have a cottage on Smoke Lake close to the Greens and the Budmans.

I have been fortunate to know Don and Denyse, Michael and Diane for almost thirty years. Most of our adventures have happened in Algonquin Park, or somewhere in the natural wilderness. Over the years, I have enjoyed listening to stories about their latest trips to various parts of the world. But, funnily enough, when they return home, they always comment on the beauty of Algonquin, and mention how happy and lucky they are to get back to the shorelines and to be so closely connected to the landscape.

Algonquin is a character in our Northern Family — one that we are all grateful to be a part of. I don't think any of us take for granted the importance of this lifelong connection. All of our memories from Algonquin are tied to the clear water, the trees, the sun and moon and stars, and it has become part of our spirit. But the people around us are equally as important. We have travelled with them in wooden canoes, shared food cooked over a fire, slept side-by-side in trip tents, watched terrifying storms from our small cabins, and had talks filled with laughter and heartfelt sadness that have changed this lifelong bond of friendship to a deep love of family.

Our feelings toward Algonquin mimic true love between people. It is the collected stories and intimate experiences along the shores of the beautiful lakes and portages that turn this boreal forest into a special and valuable place in the lives of Don and Michael, Denyse and Diane, and all of their children. These are

memories that we started collecting as small children at summer camps or on canoe trips with our families, and continue to collect today. Algonquin has influenced us in so many ways — the stories and memories are measured by a lifetime.

The lifestyle in Algonquin is one of voluntary simplicity. We sleep better in the silence of true darkness. We dream magnificent dreams. We wake to beautiful bird-song. We marvel at the harmonies of Mother Nature throughout each day. We take care of each other.

The Budmans and the Greens have cottages on Smoke Lake and welcome visitors to a shared guesthouse on Bonita Lake, nestled on a peninsula between South Tea Lake and Canoe Lake. It is a gathering place with canvas prospector tents, fire circles, a dining hall, and a main building for sleeping. Bonita has been a gracious host to many delicious meals to hundreds of people throughout the seasons. It is a place for laughter. It is a place that allows us to be our true selves. It is a place filled with the history of many Algonquin legends. It is a place filled with future dreams.

We leave Bonita after these gatherings with stomachs full of healthy food and heads adrift from good wine. In wooden boats under star-lit skies, we journey back to different cabins on different lakes. The heavy boats slowly plough the dark waters of narrow creeks and weave through islands covered in great pine trees made famous by the Group of Seven painters. These slow trips give us time for reflection and gratitude as we huddle close to each other to stay warm.

How could a dream like Algonquin and its lifestyle not influence the clothing and philosophy of Roots?

I think all of us, in a small or large way, can feel the romanticism that comes from such a wonderful landscape and lifestyle. The unique character of Algonquin resonates in different ways with everyone buying Roots clothing. We want to be identified as part of the Roots "tribe" and the clothing allows us to connect with this traditional Canadian Shield community.

The wilderness is a love story. It never goes out of fashion.

D. Standfield

Don Standfield
Artist-photographer

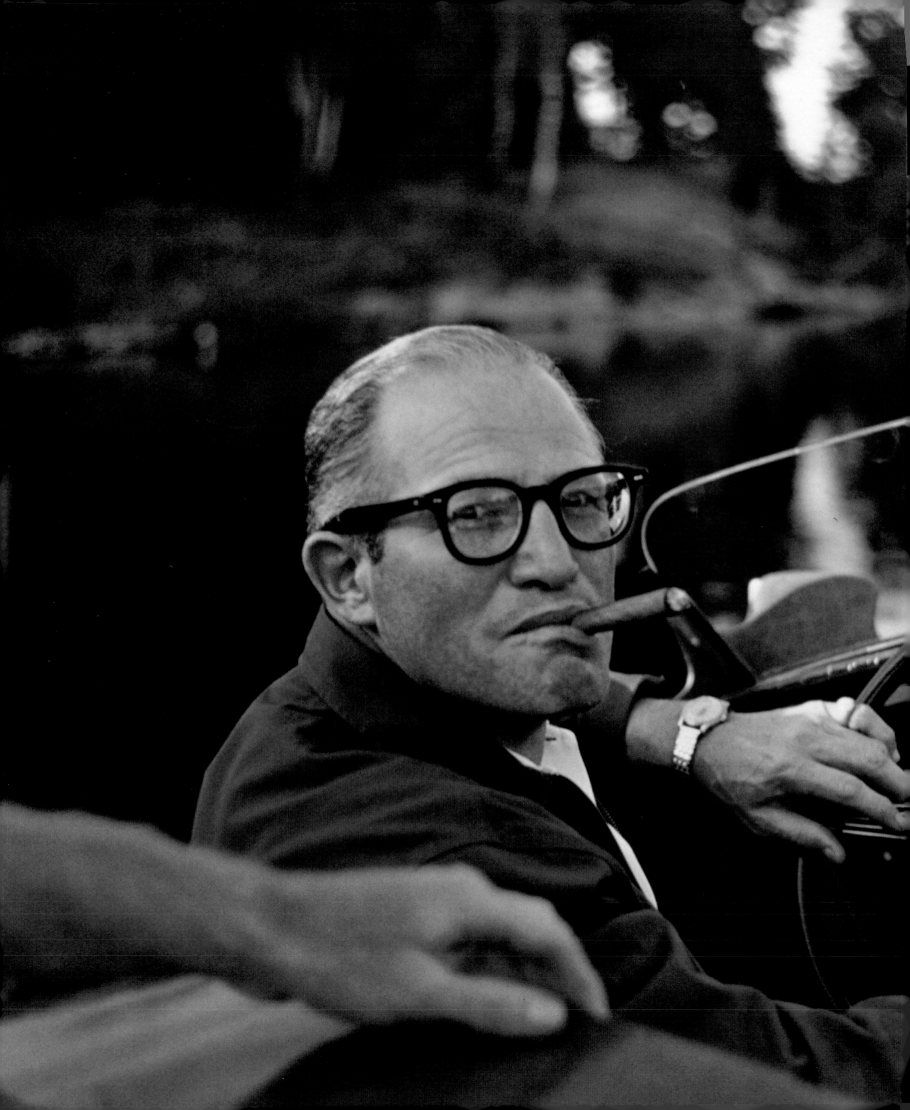

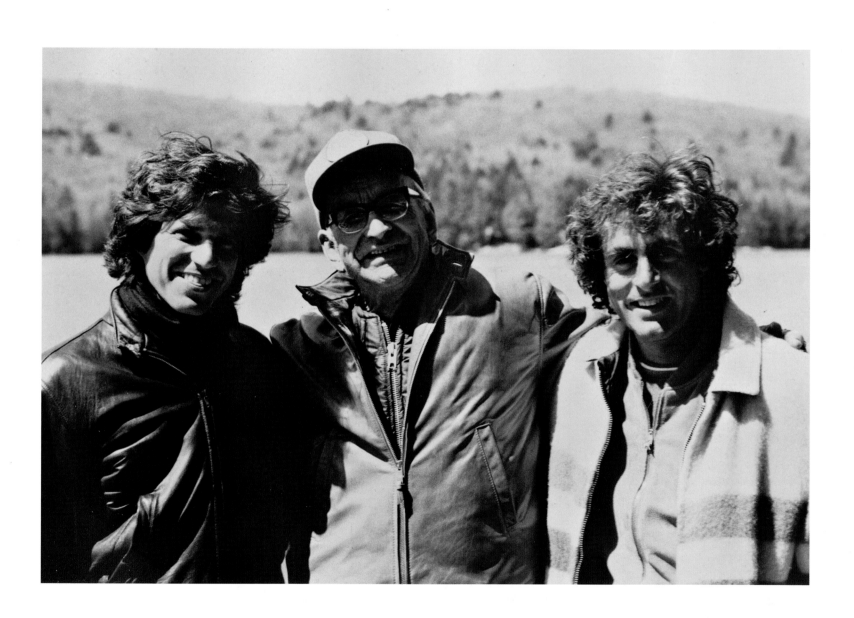

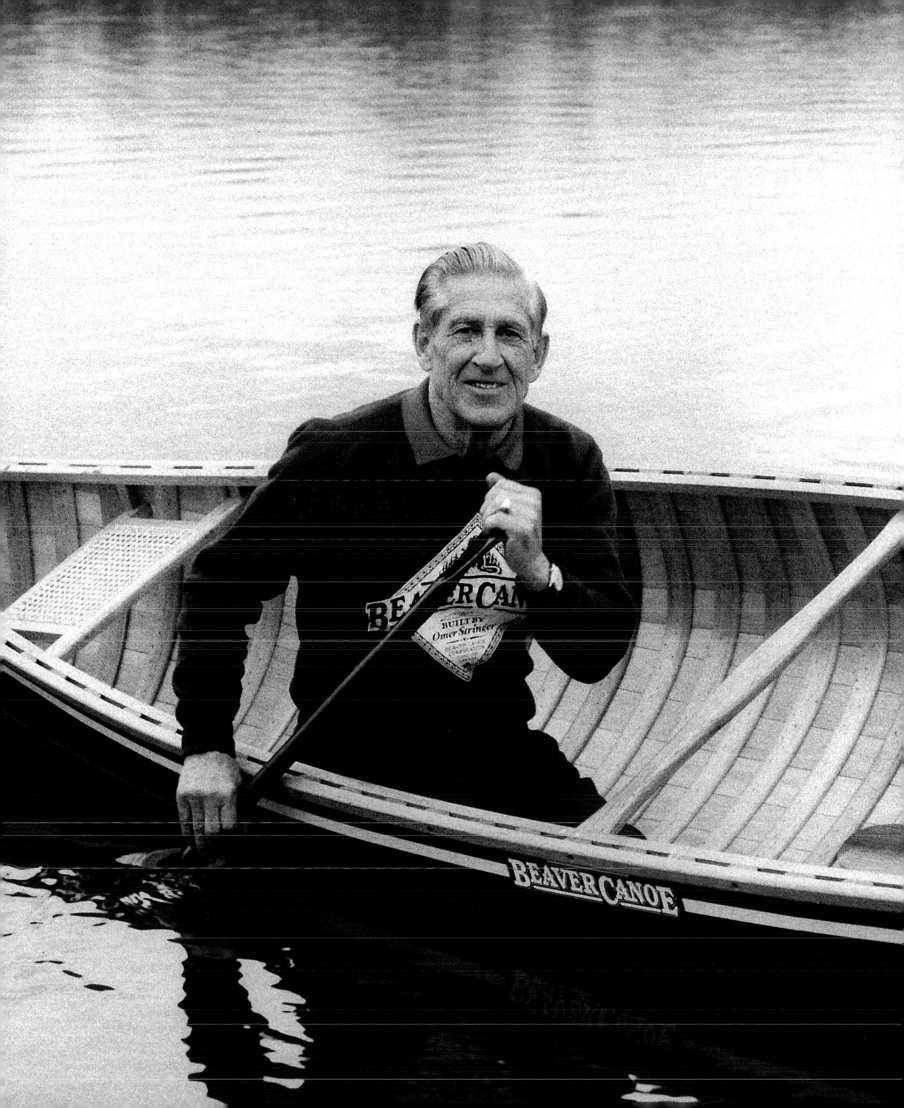

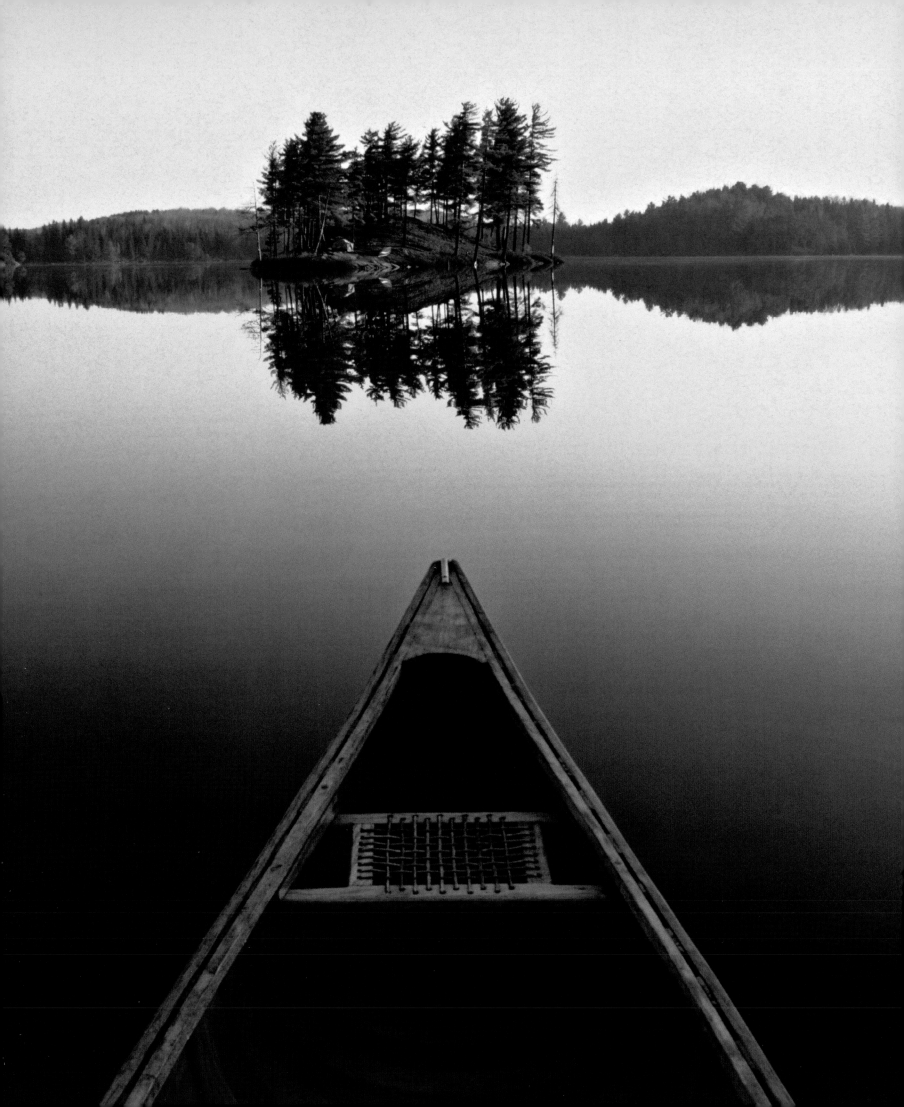

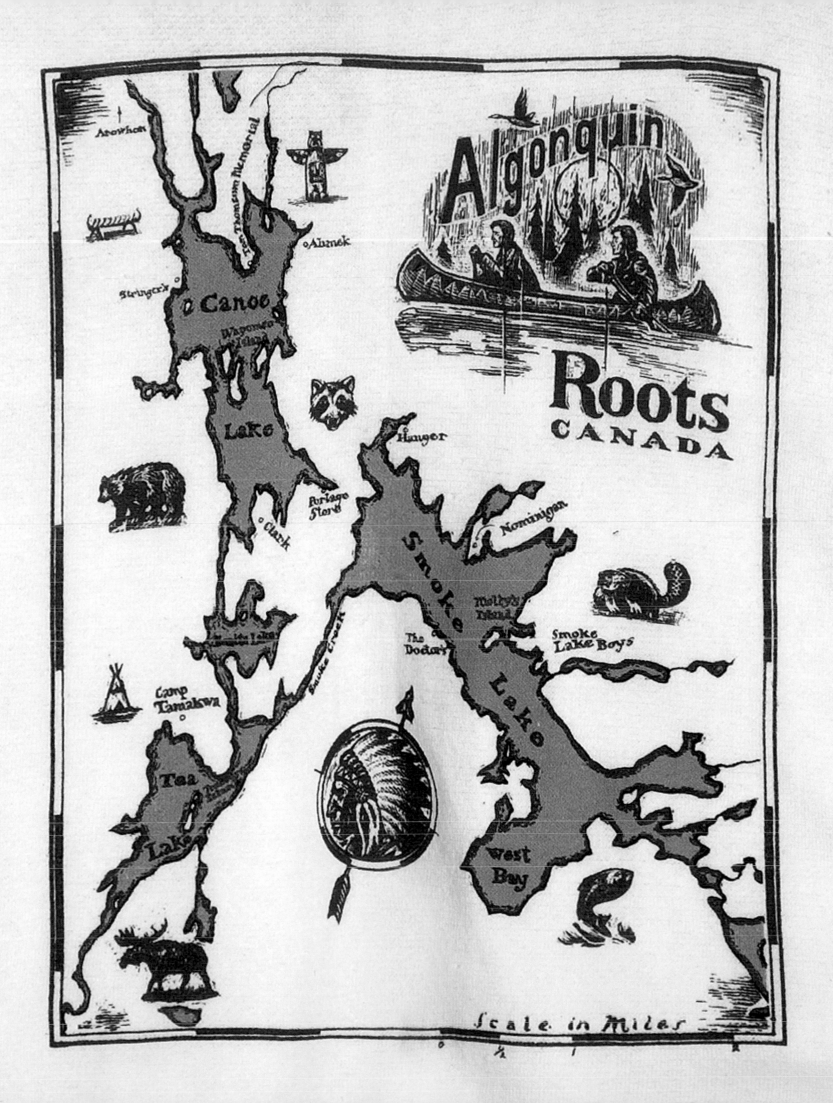

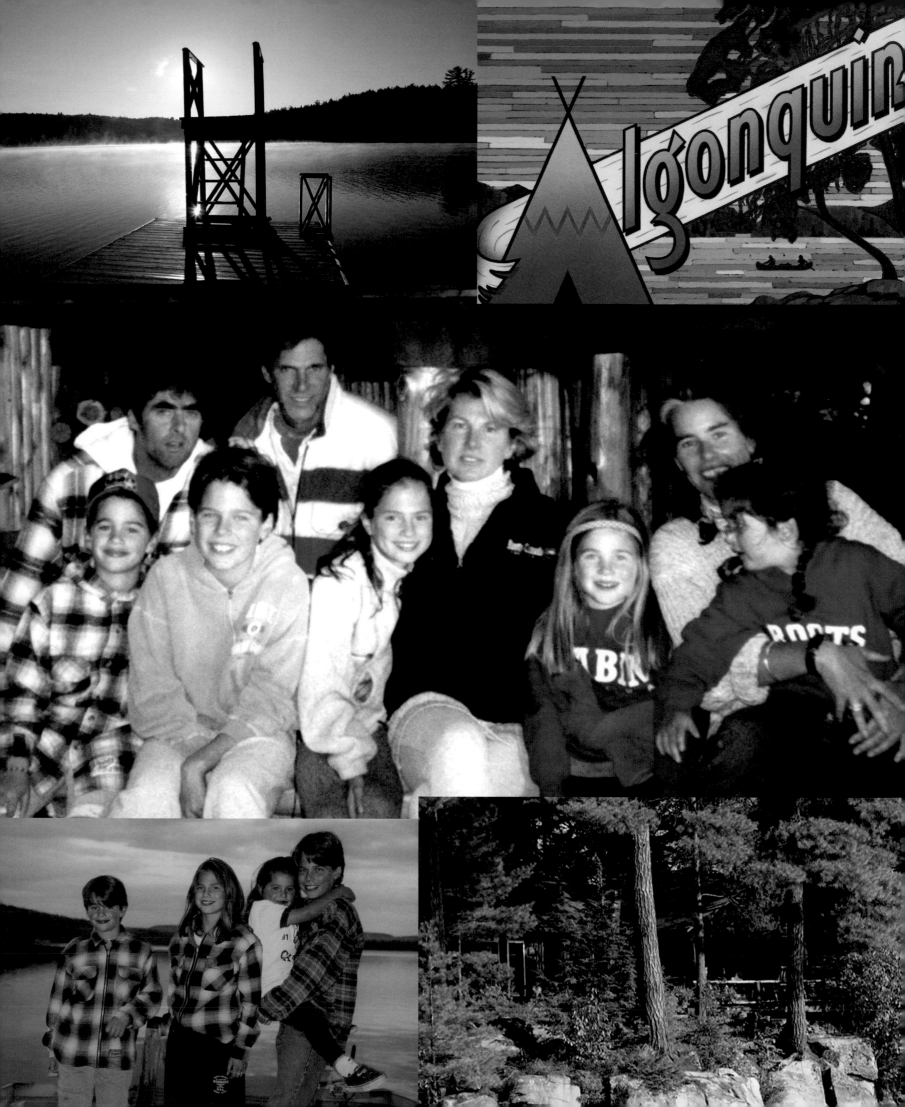

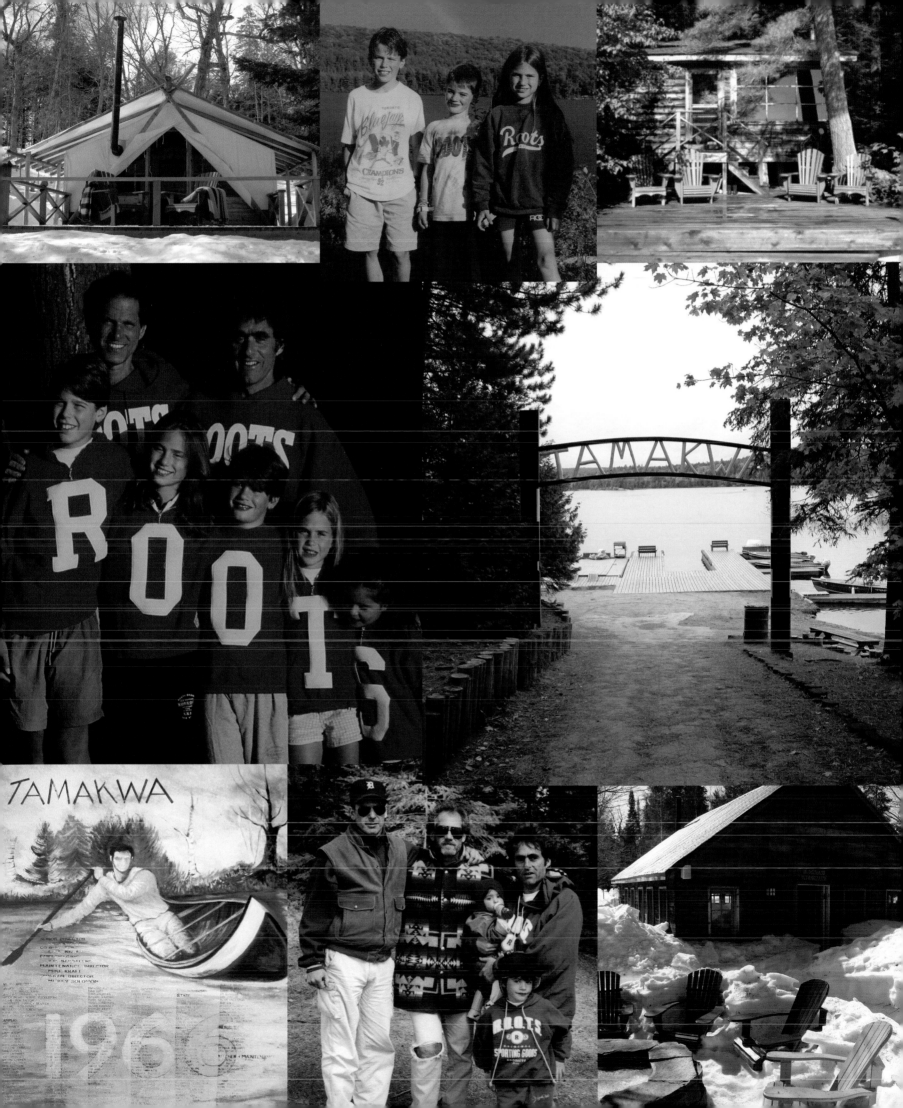

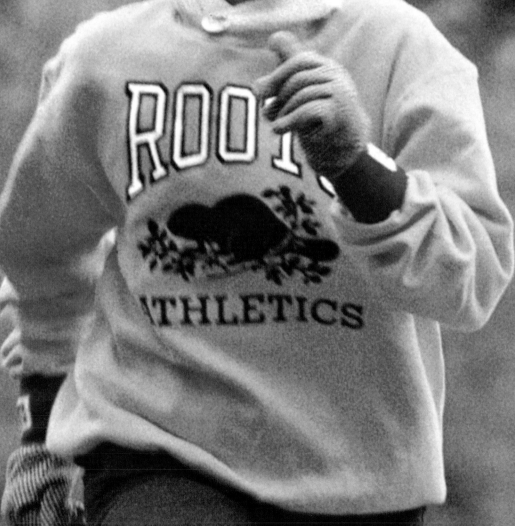

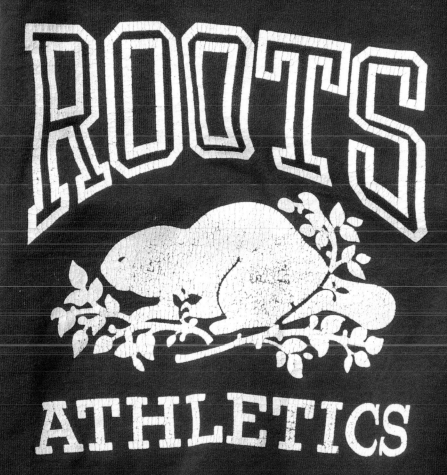

RBA
SWEATSHIRT

I have been lucky enough to have been involved in the world of Roots for over forty years. What a spectacular journey I've seen them take. What a spectacular association we've had. An association tied to brilliant friendship, brilliant loyalty, and let's face it … the ultimate … brilliant style. Style is knowing who you are, what to say, and not giving a damn. Roots=Style. Lucky me to have been part of it.

Martin Short

Martin Short
Actor-comedian

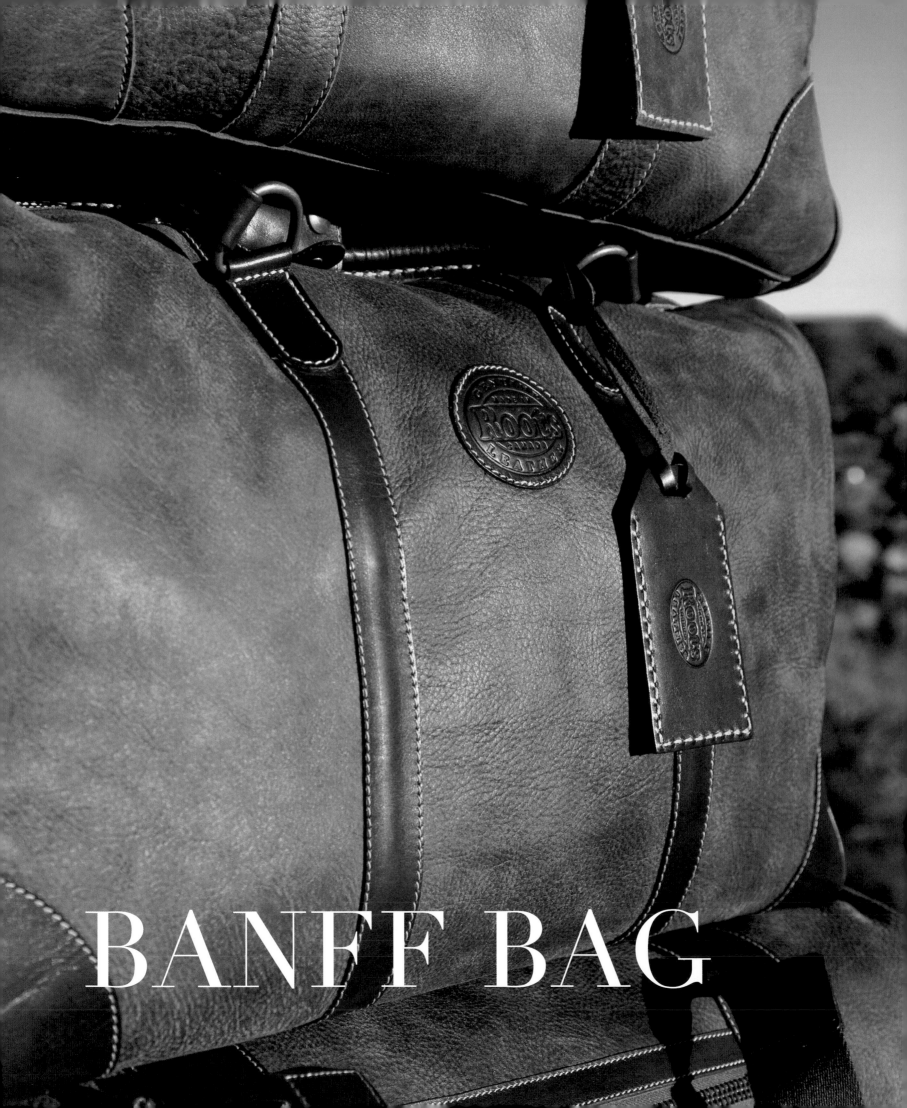

BANFF BAG

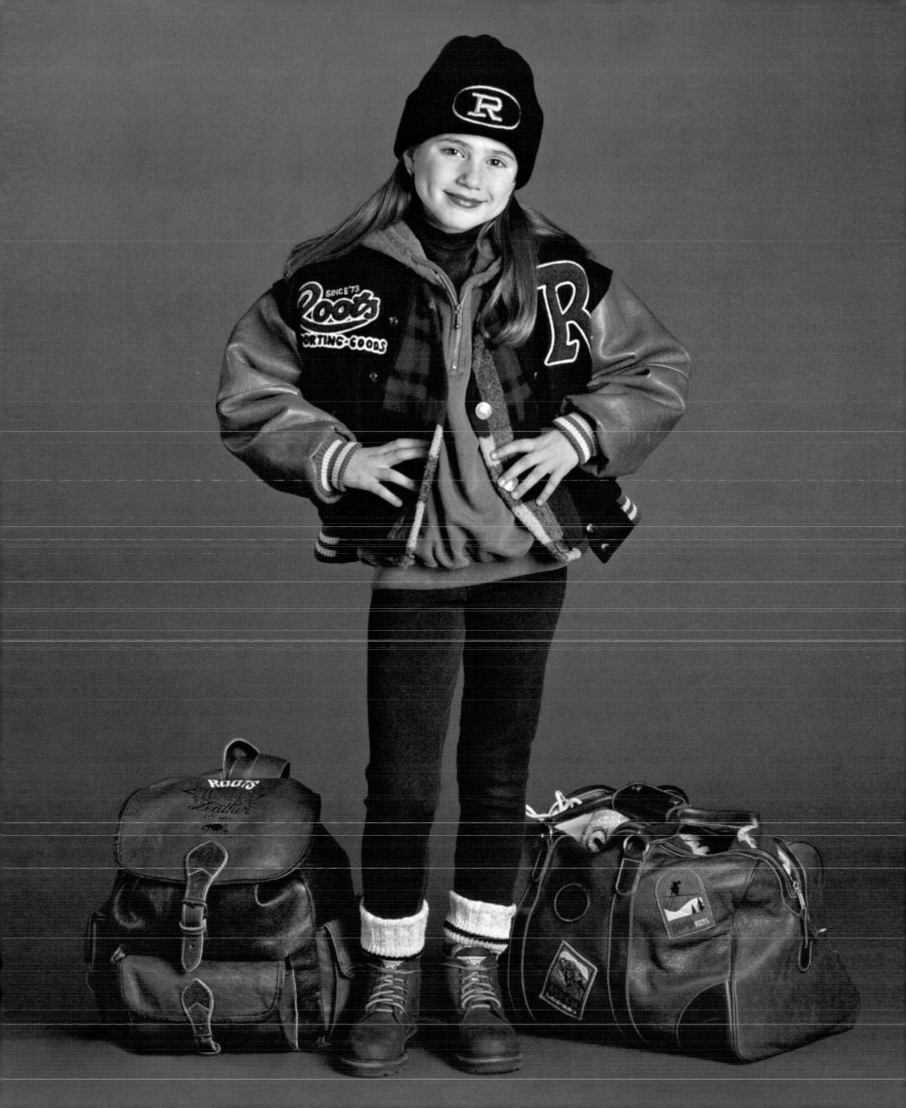

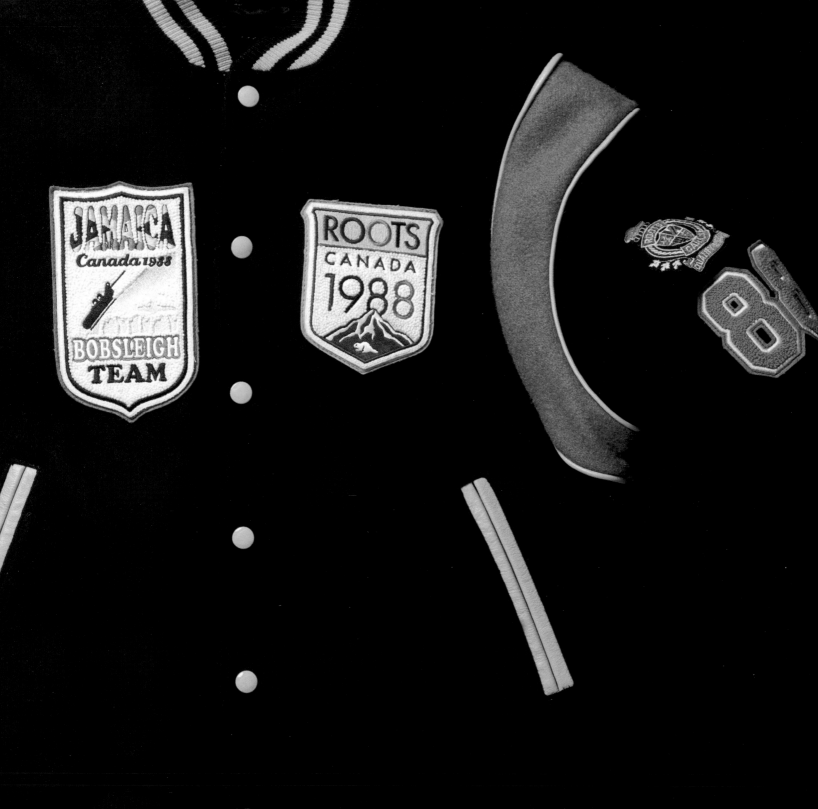

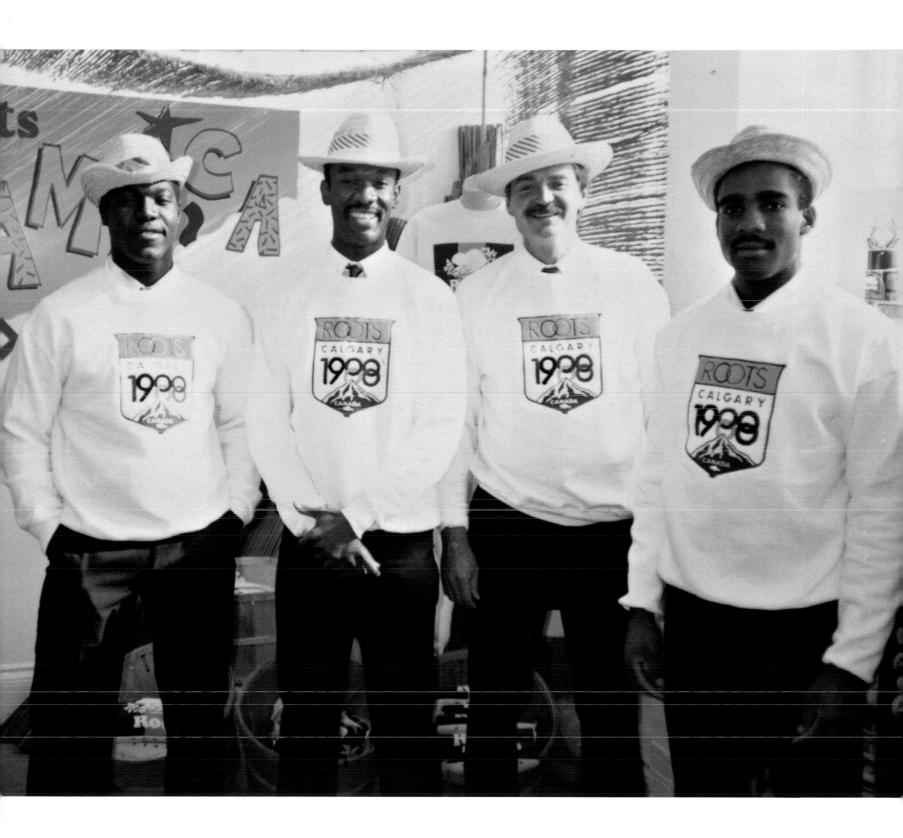

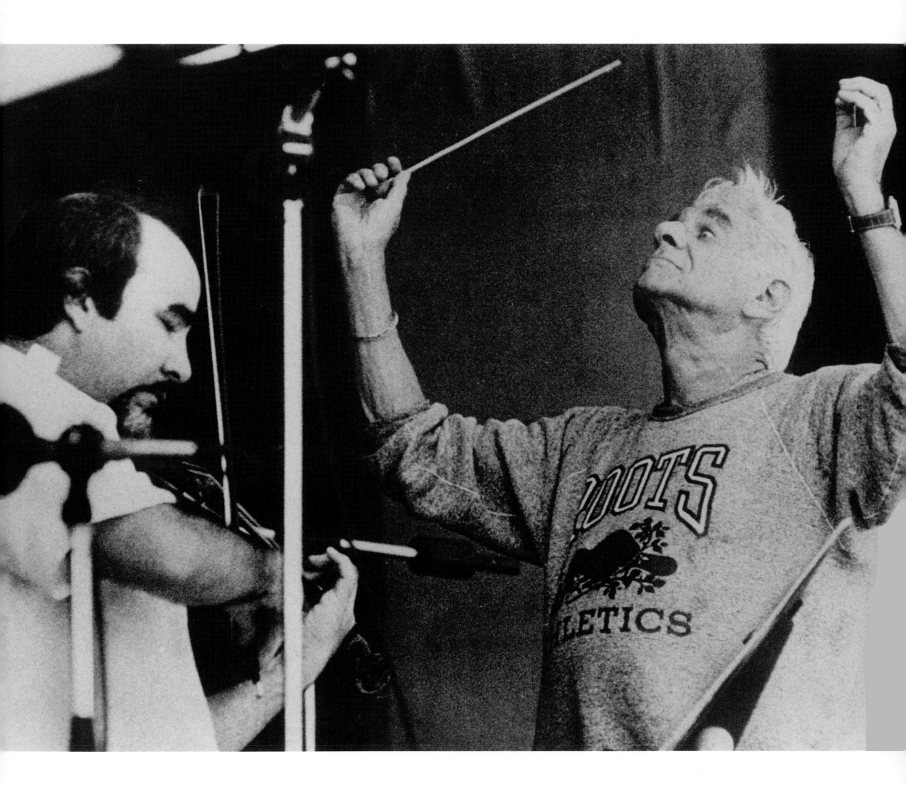

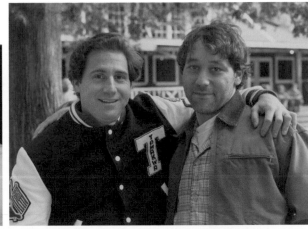
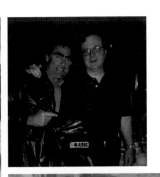

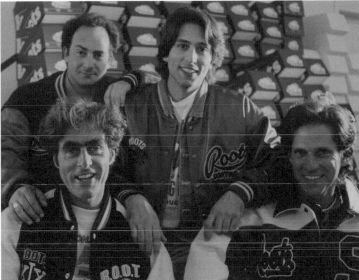

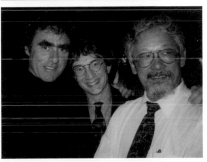

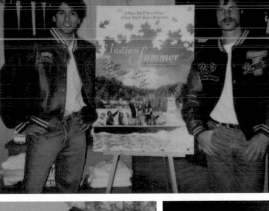
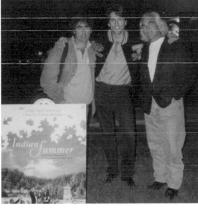

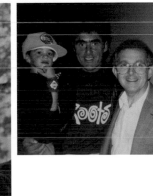

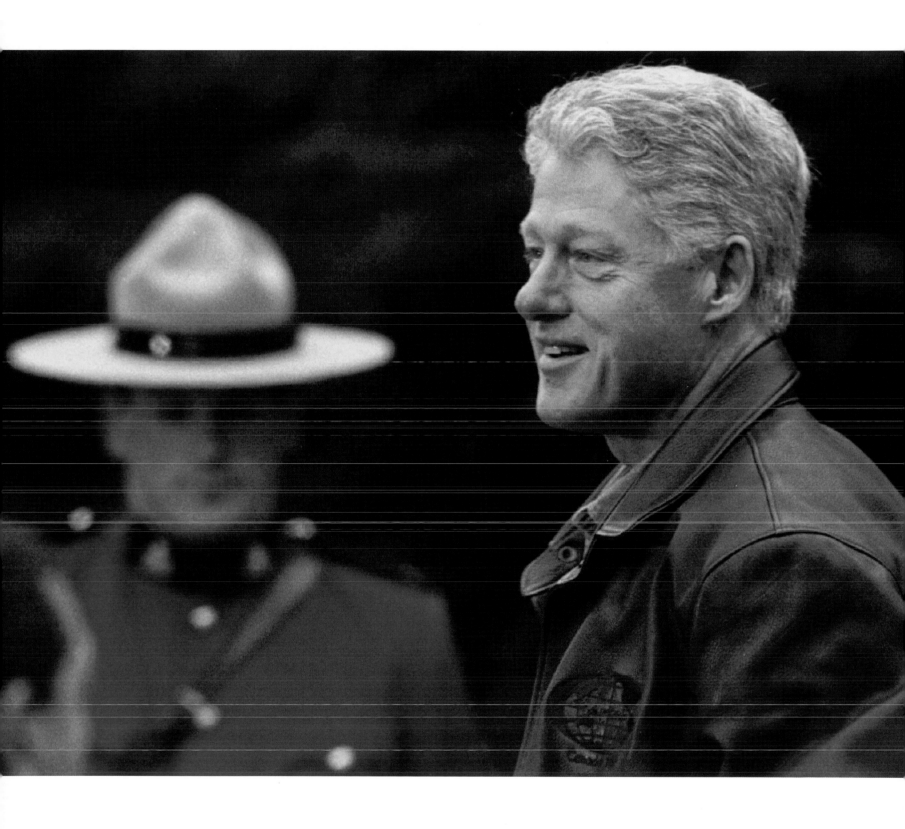

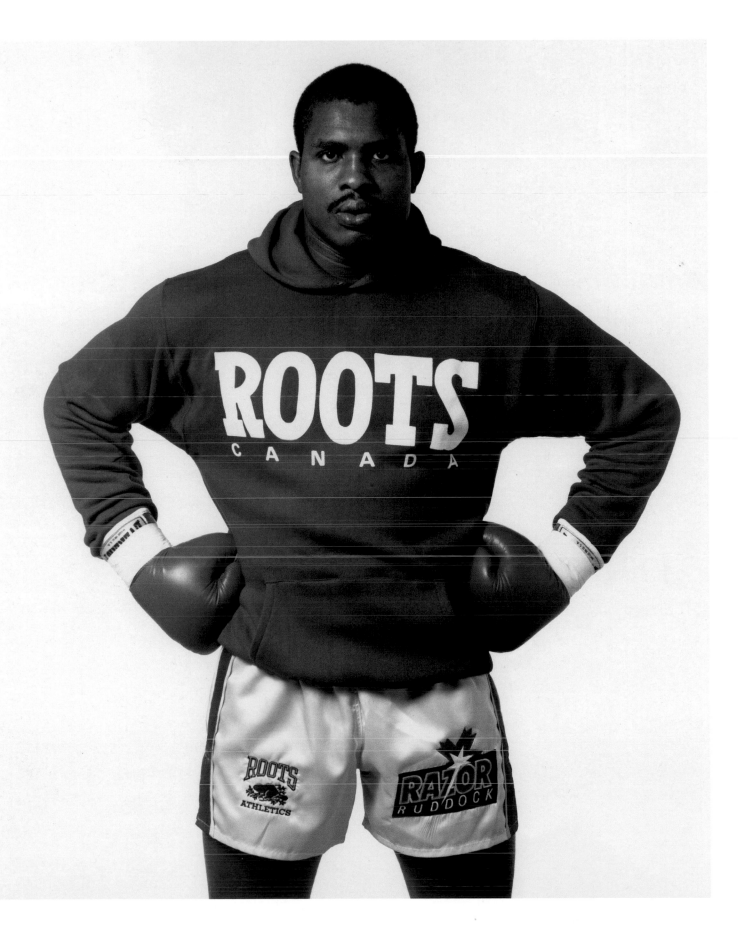

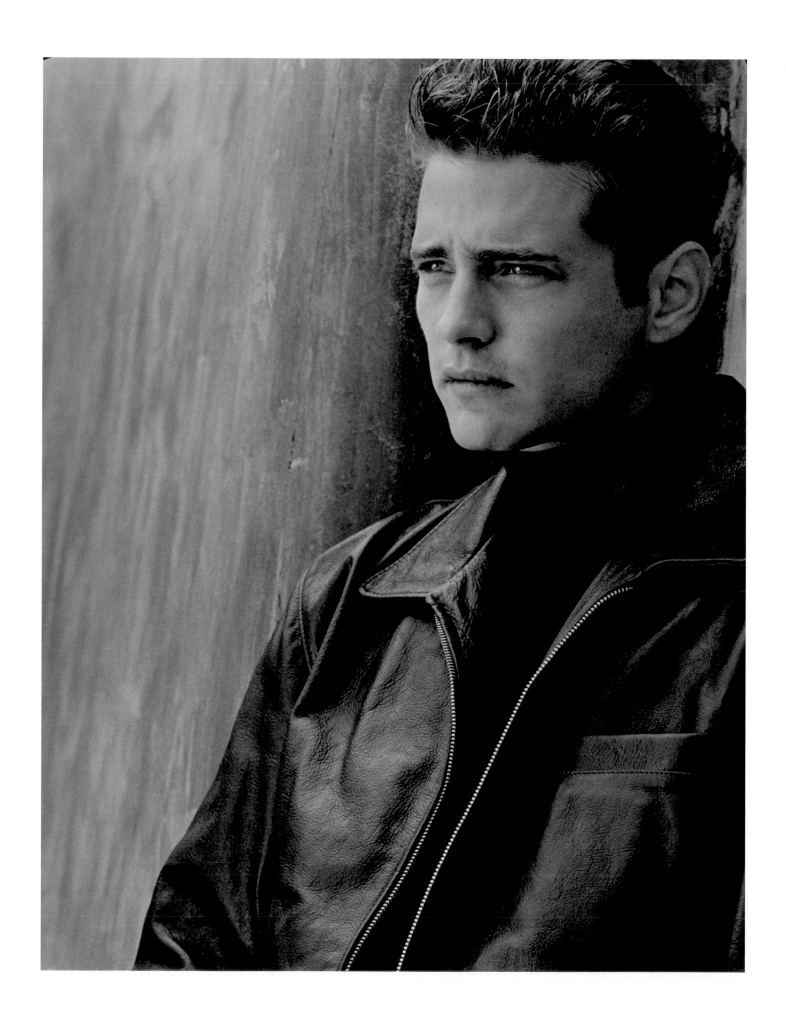

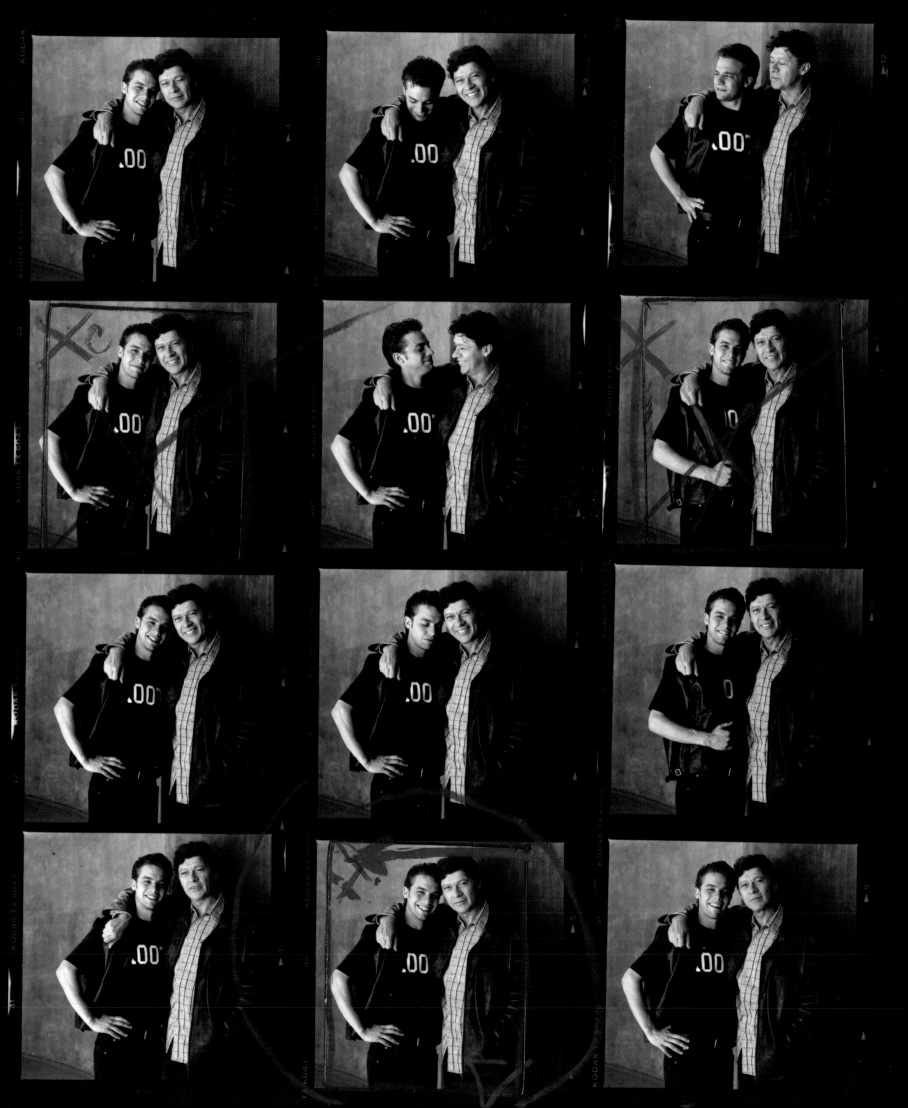

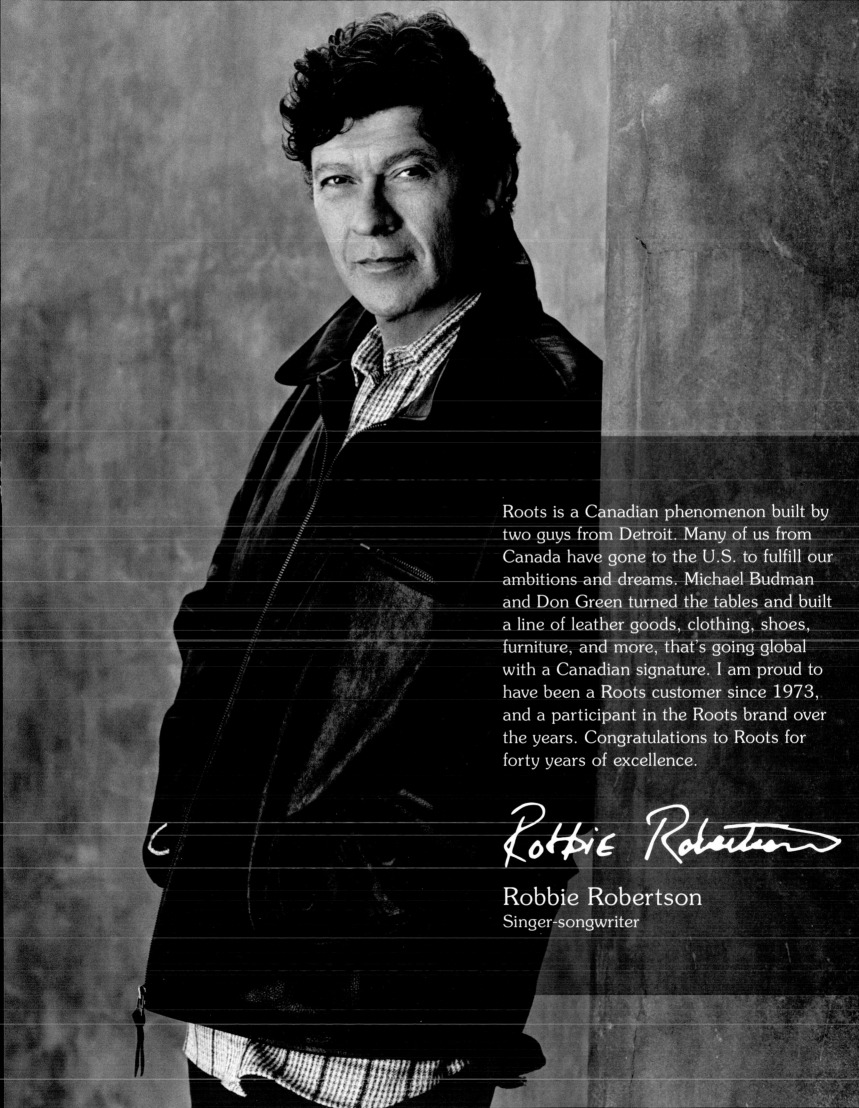

Roots is a Canadian phenomenon built by
two guys from Detroit. Many of us from
Canada have gone to the U.S. to fulfill our
ambitions and dreams. Michael Budman
and Don Green turned the tables and built
a line of leather goods, clothing, shoes,
furniture, and more, that's going global
with a Canadian signature. I am proud to
have been a Roots customer since 1973,
and a participant in the Roots brand over
the years. Congratulations to Roots for
forty years of excellence.

Robbie Robertson
Singer-songwriter

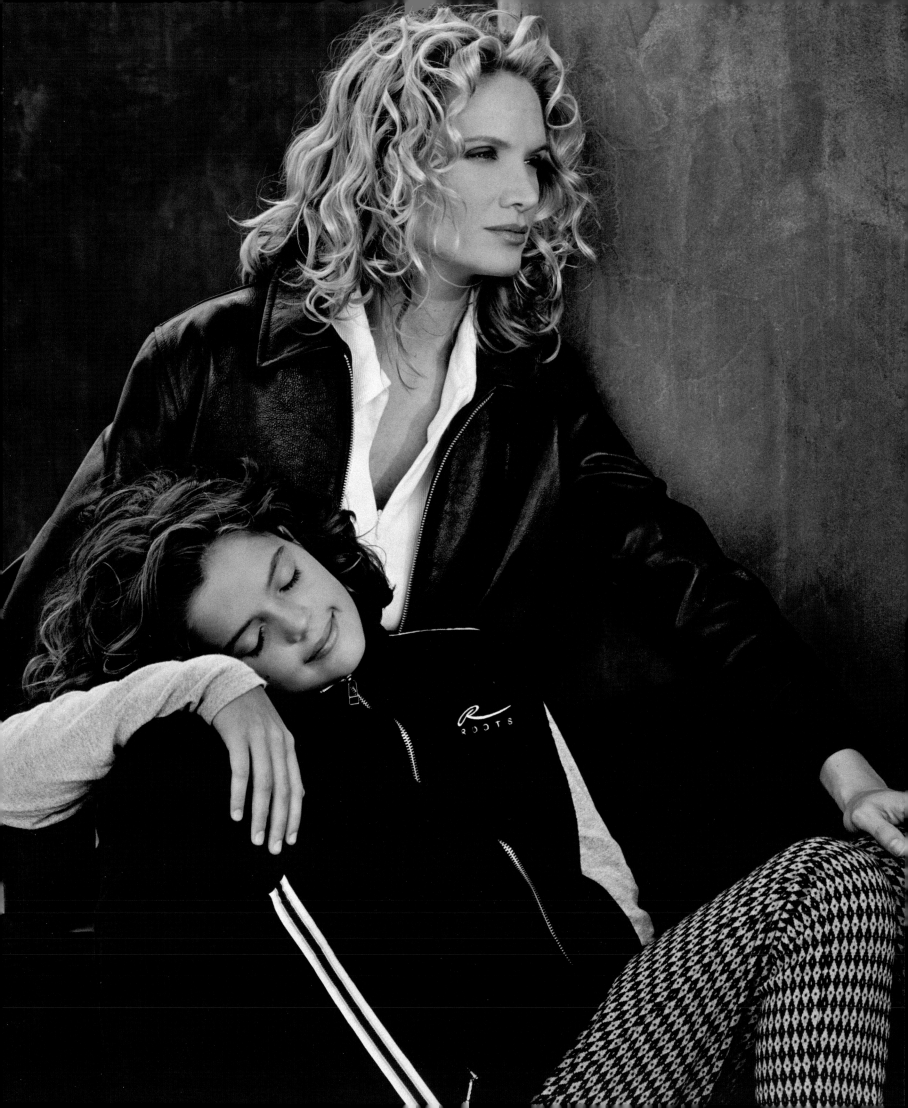

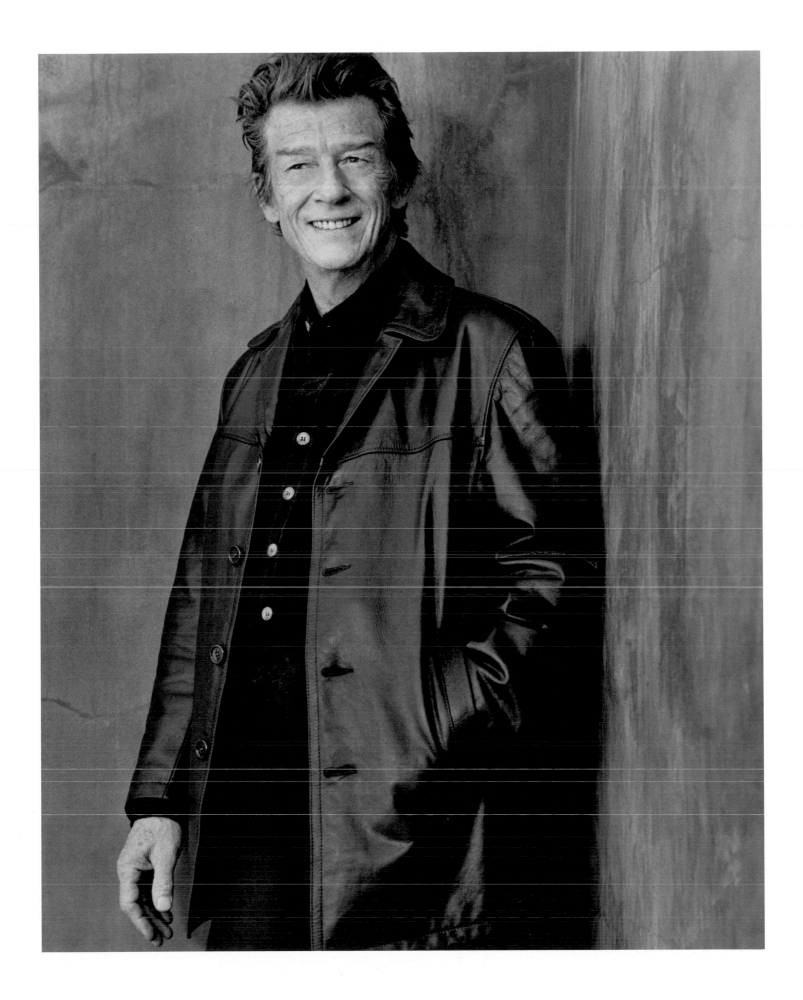

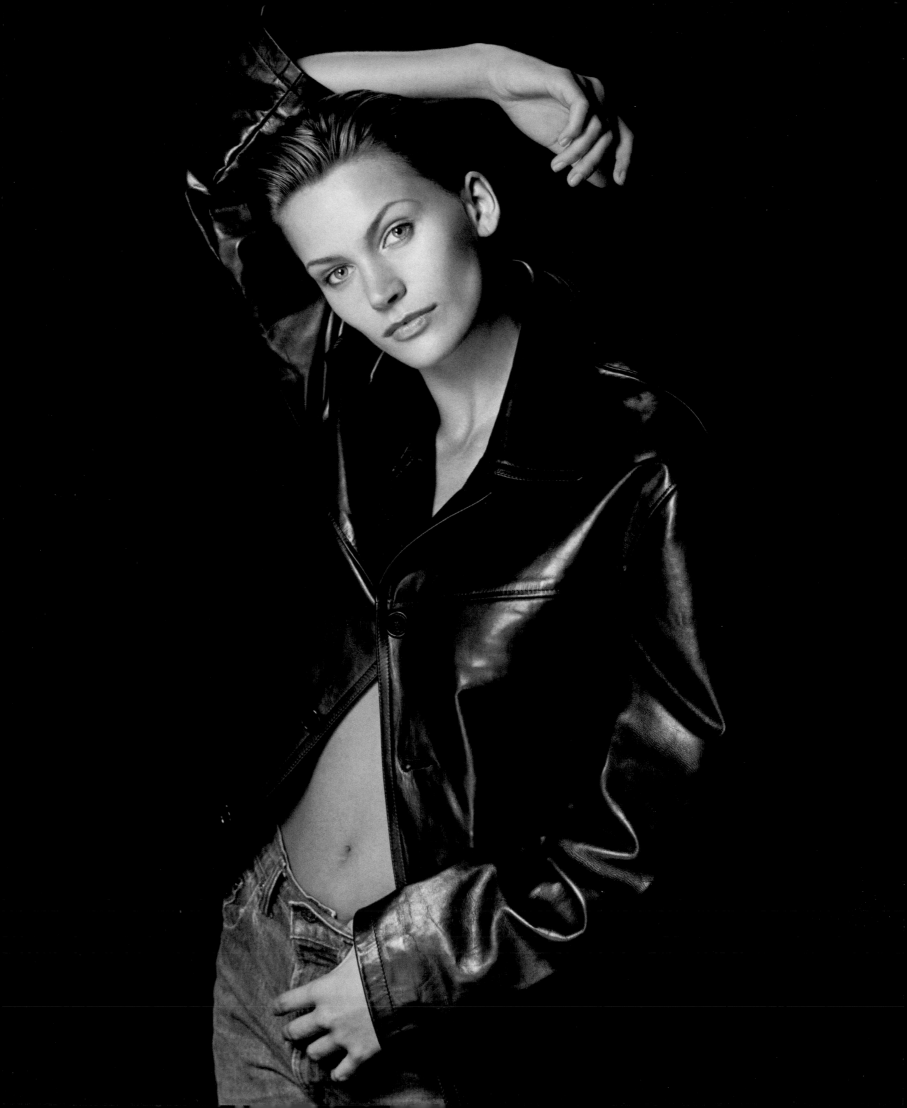

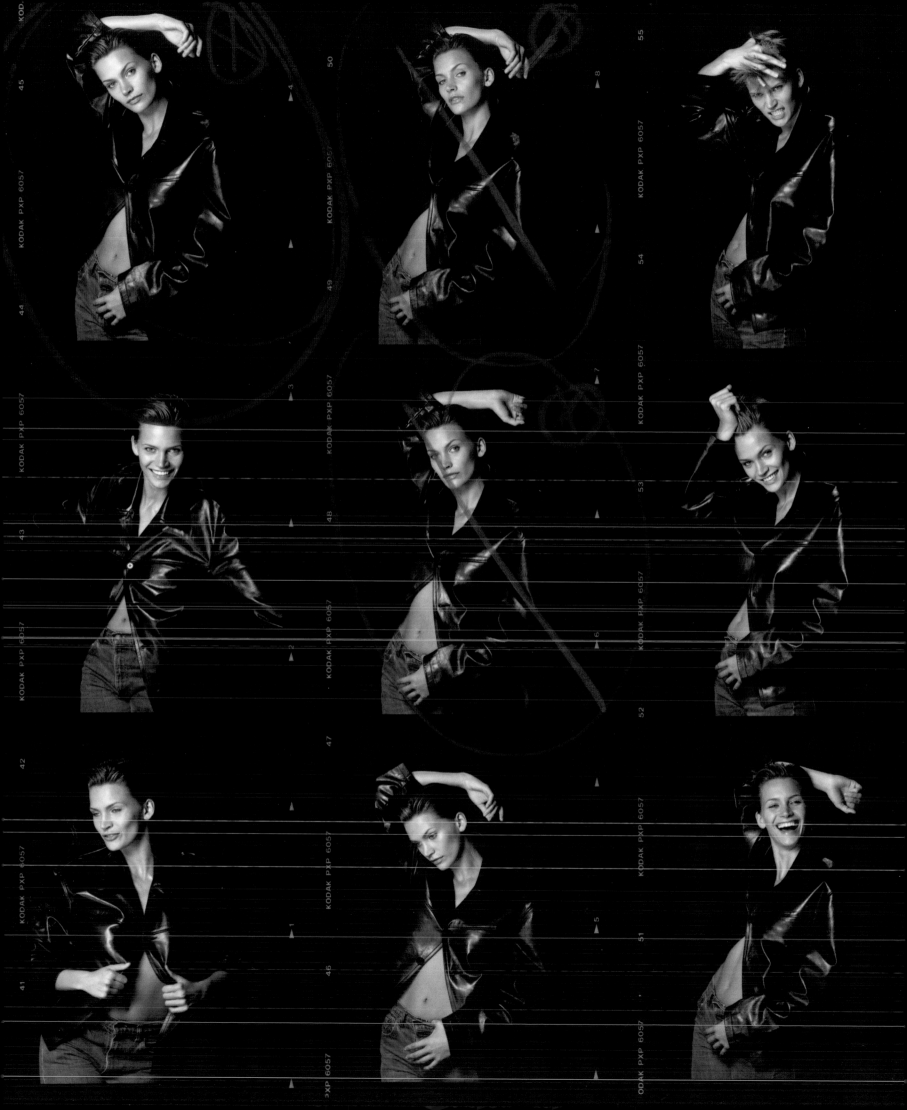

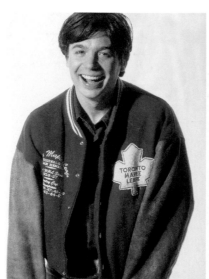

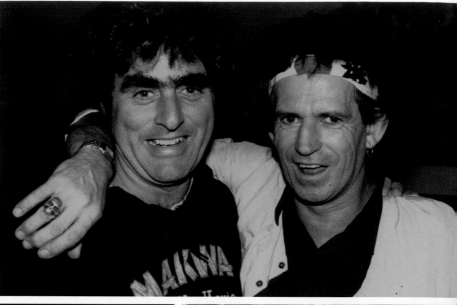

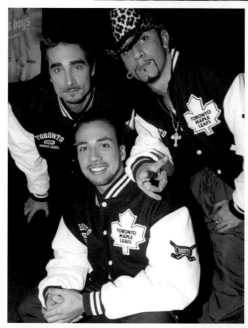

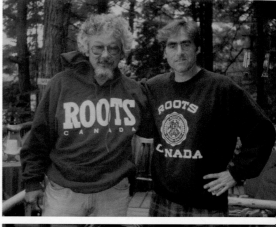

THE SOURCE

A week in the world of *Roots*
Issue 66 – September 15, 2000

IN SEARCH OF CANADA THROUGH WORDS

Noah Richler and his new book take centre stage at Roots

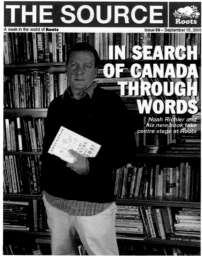

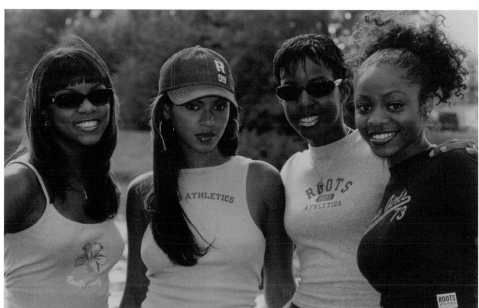

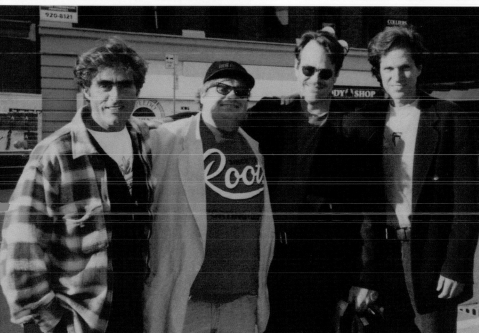

SCORING BIG

World Cup fever leads to major success for special Roots collection

Singer Hayden Neale takes a break from the pitch in Roots

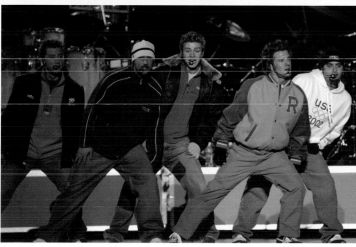

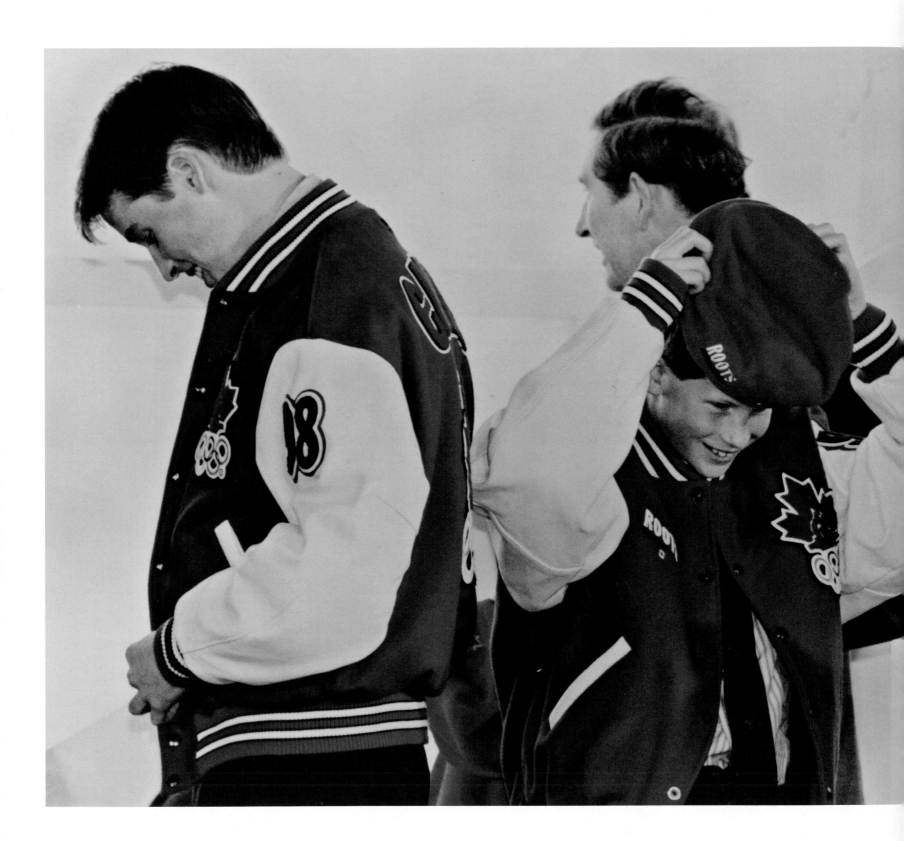

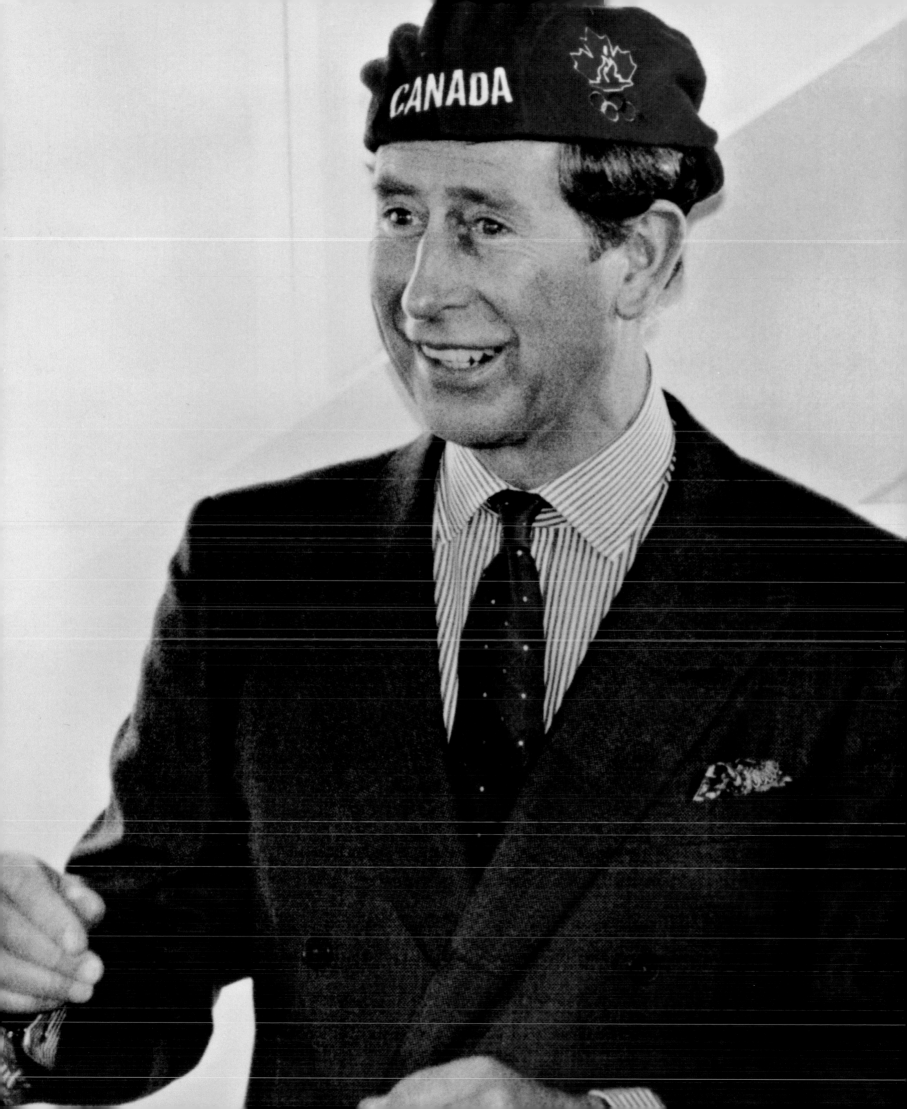

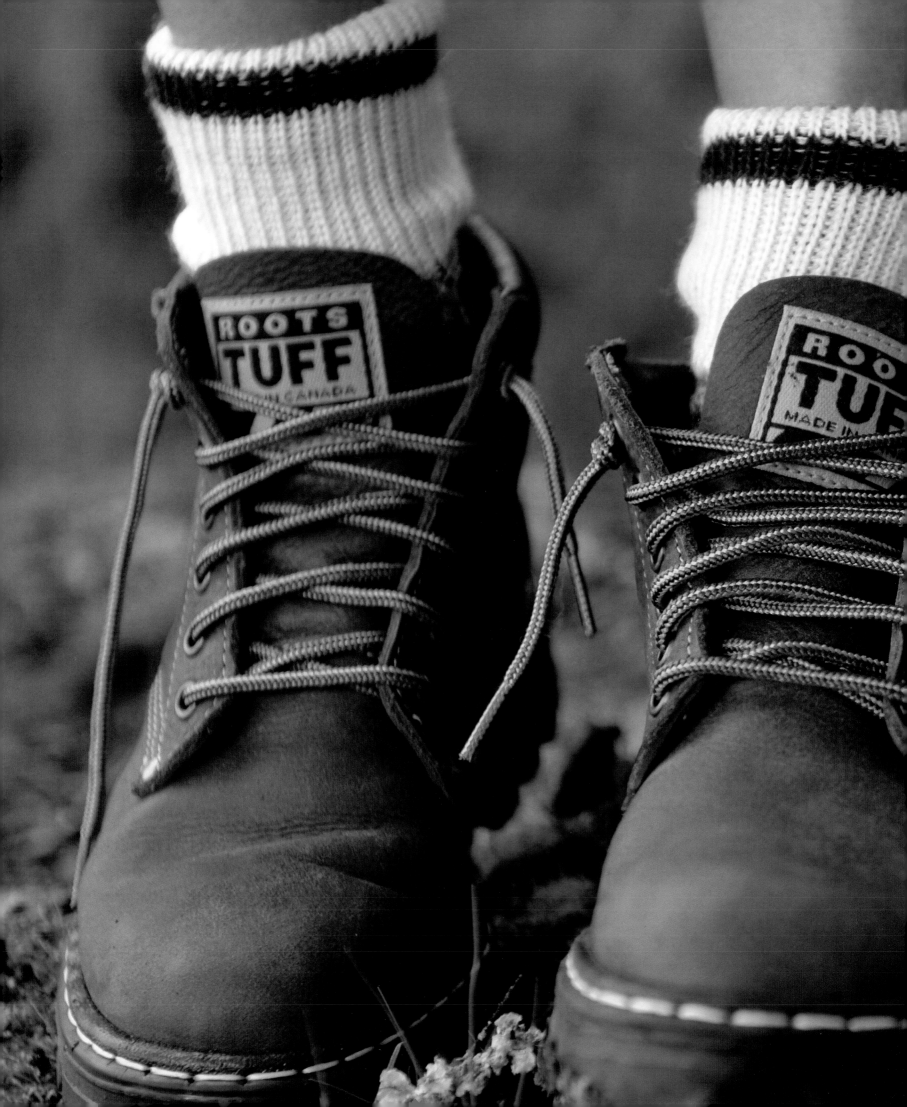

TUFF BOOT

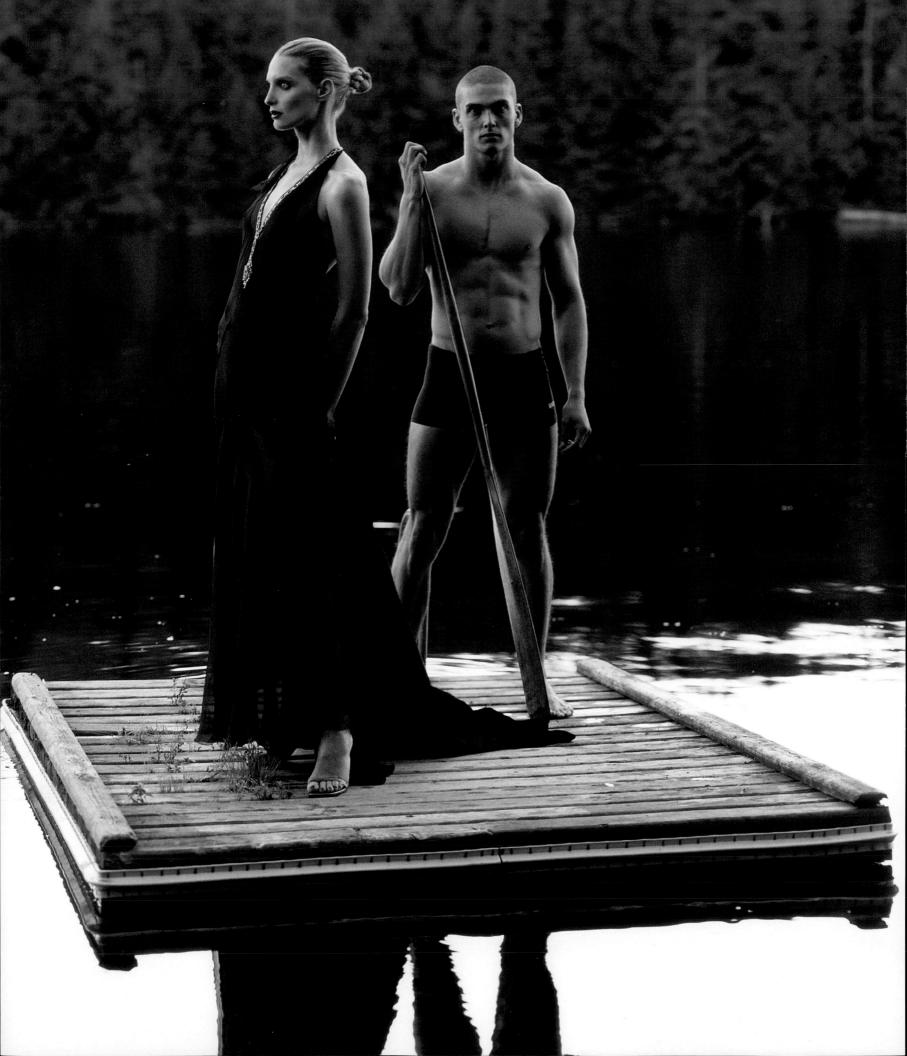

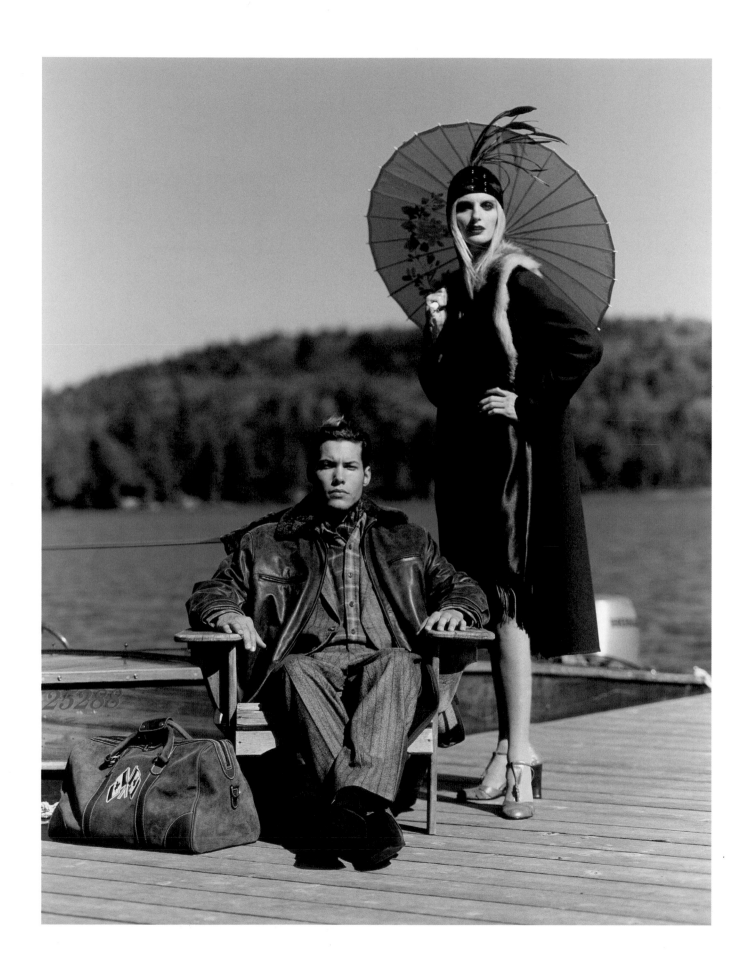

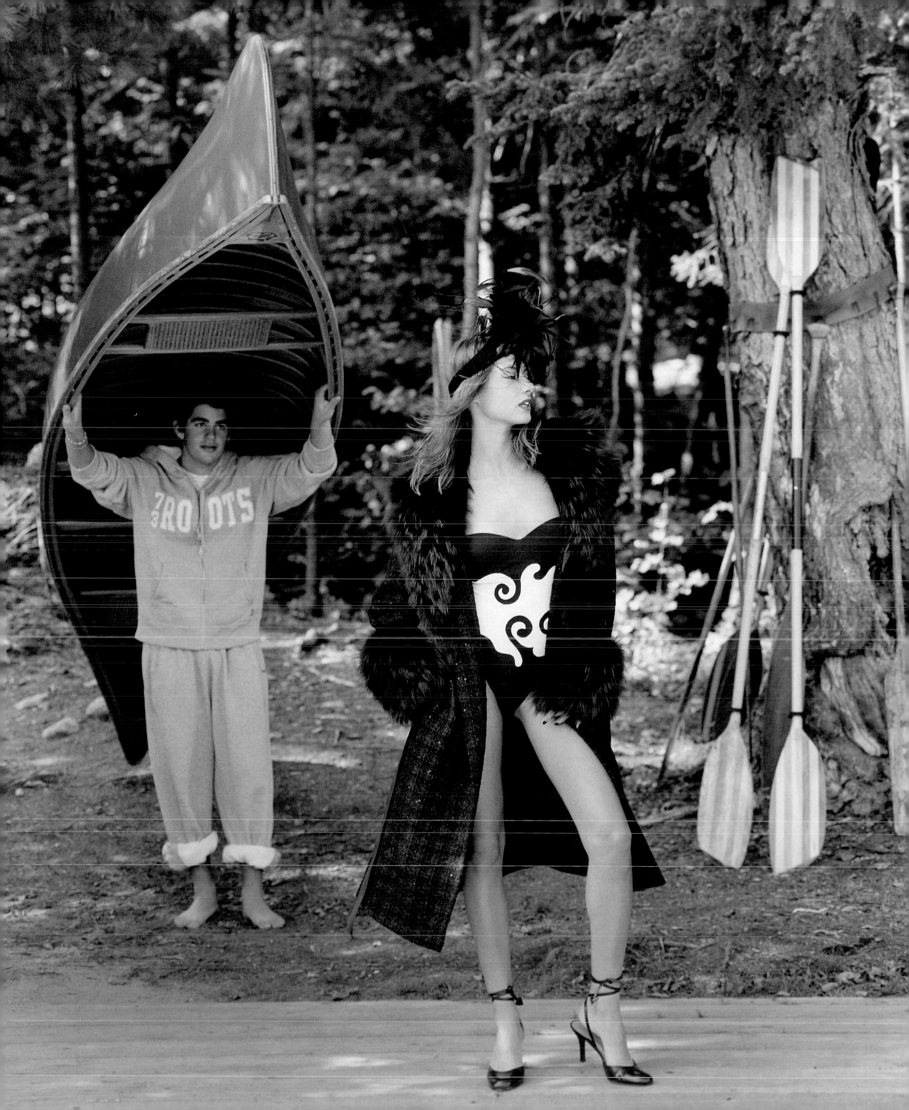

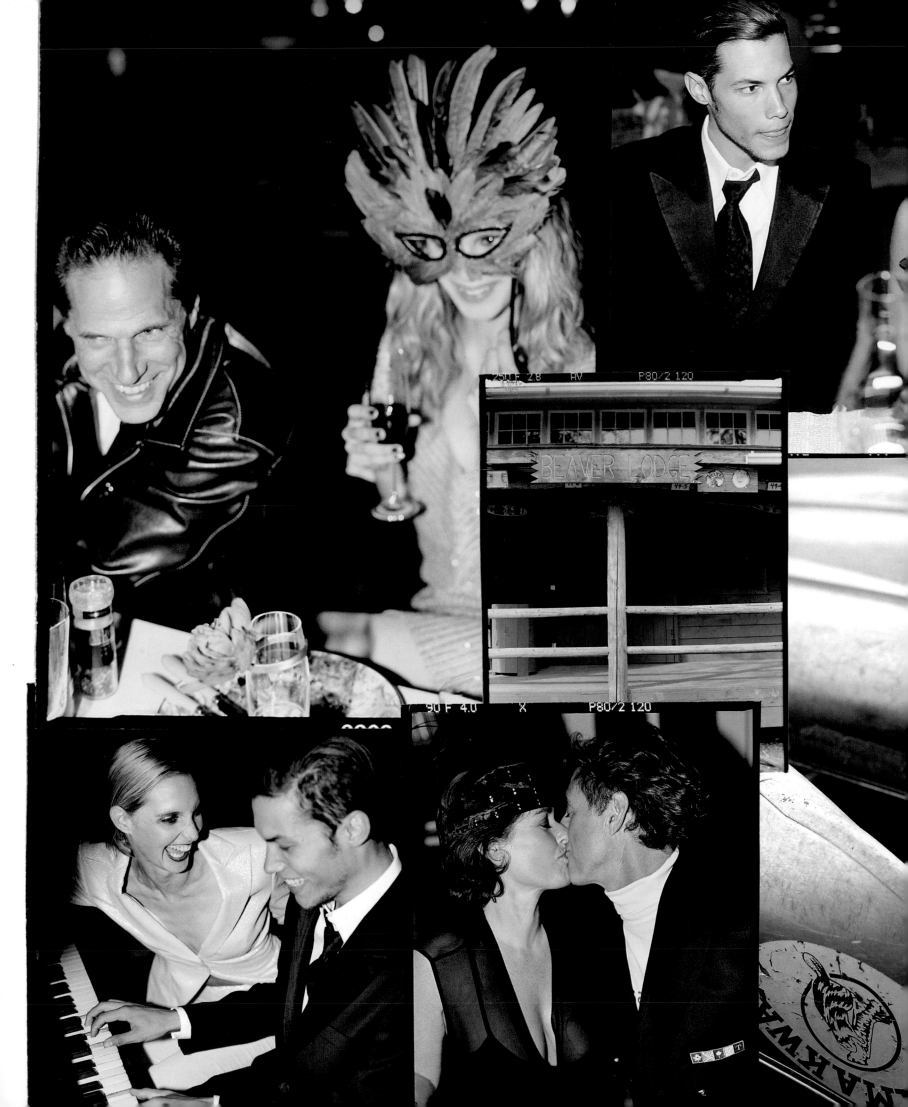

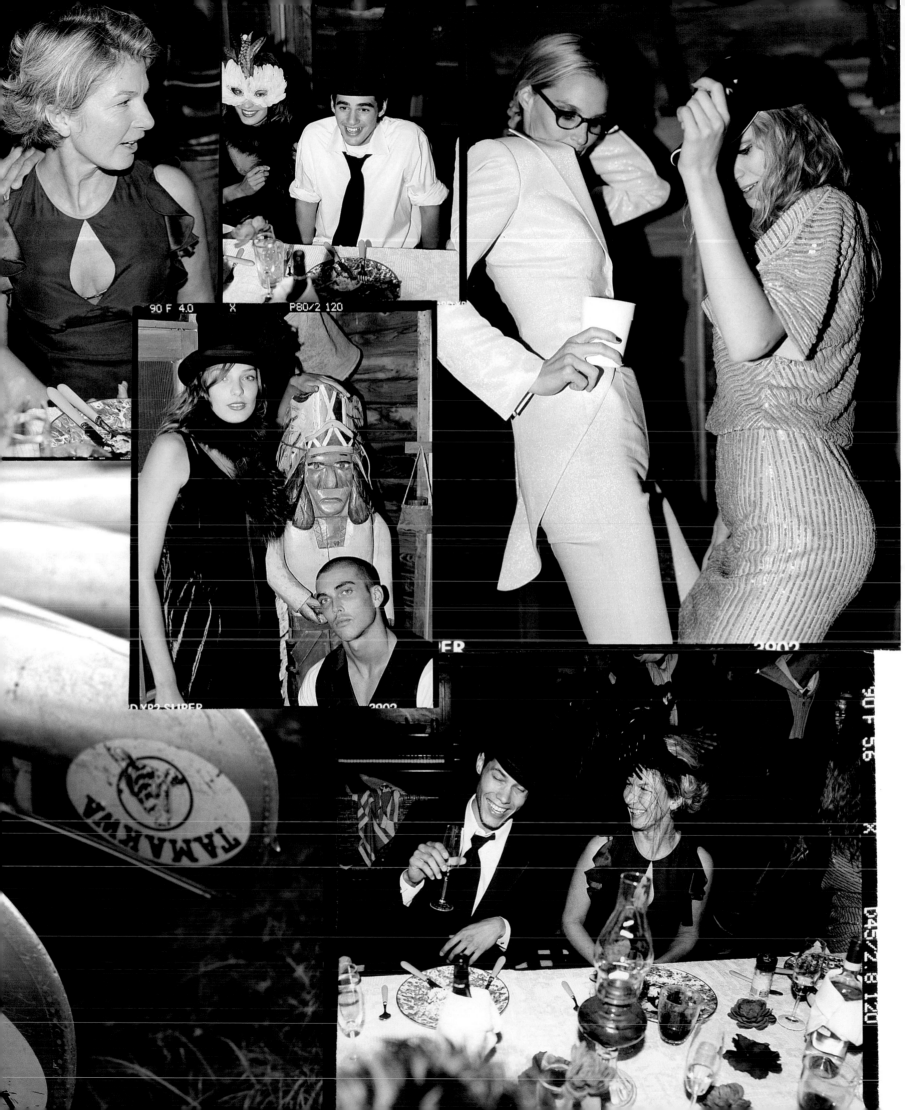

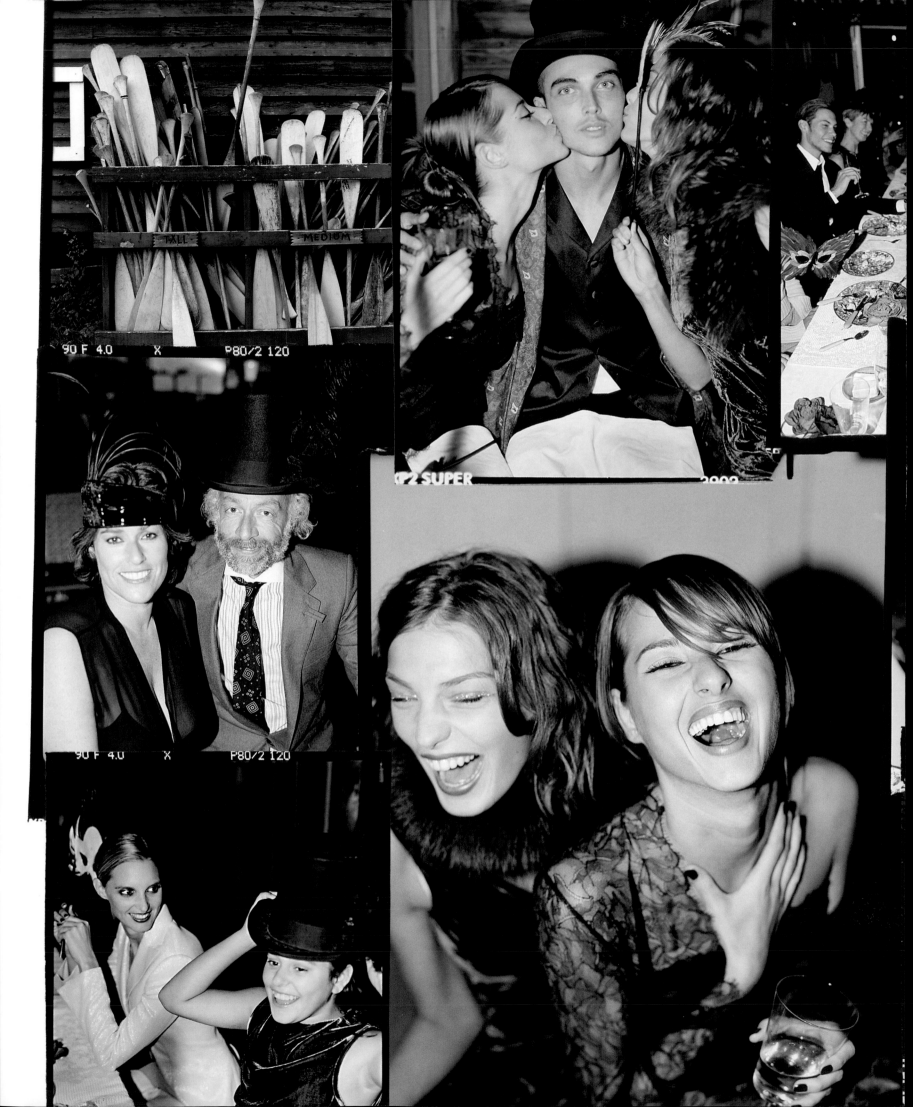

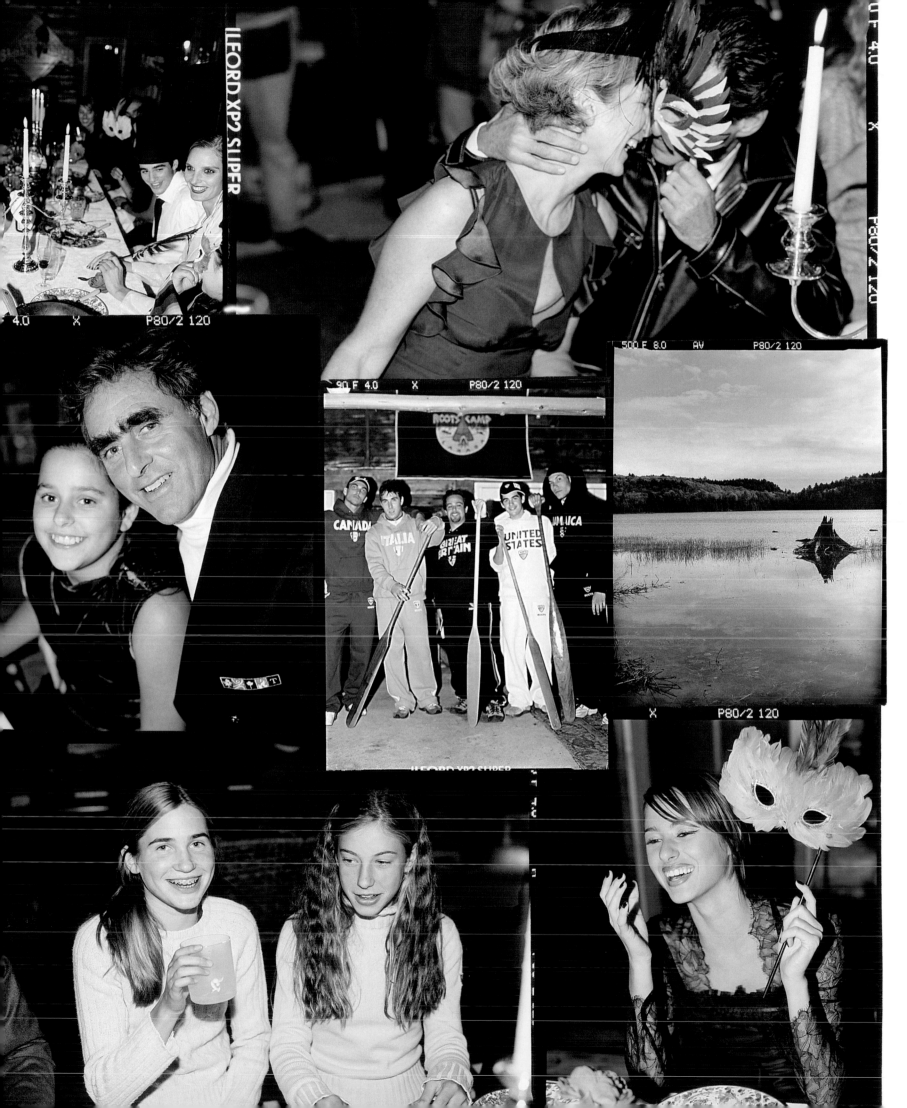

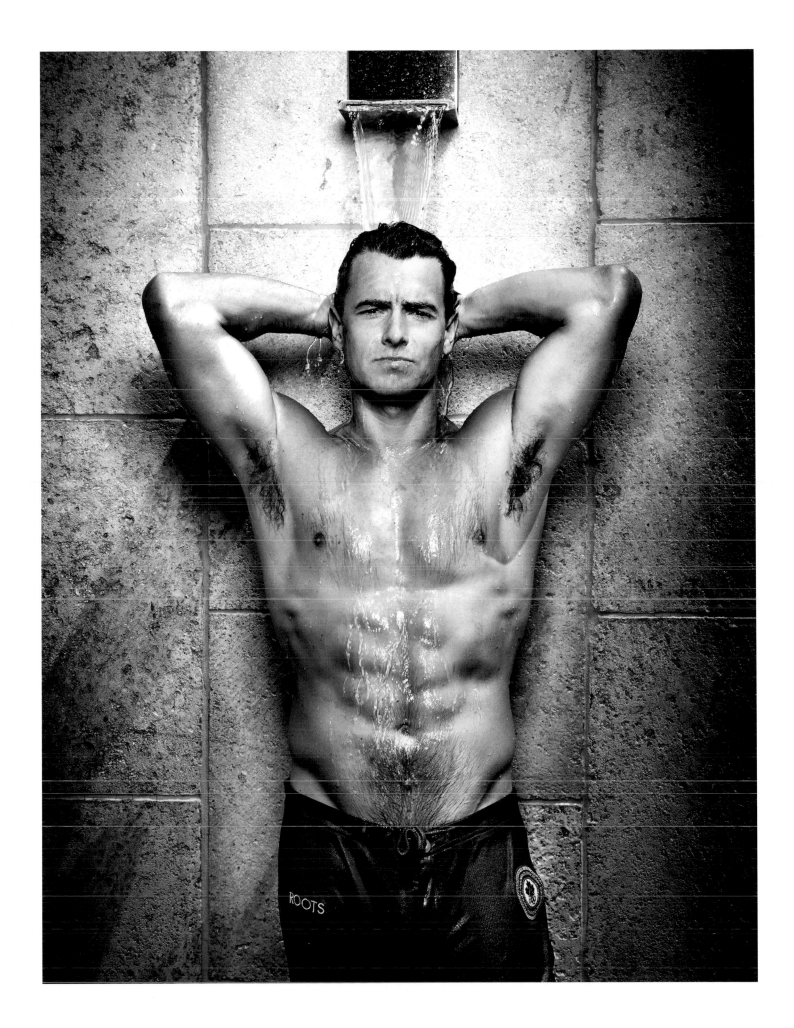

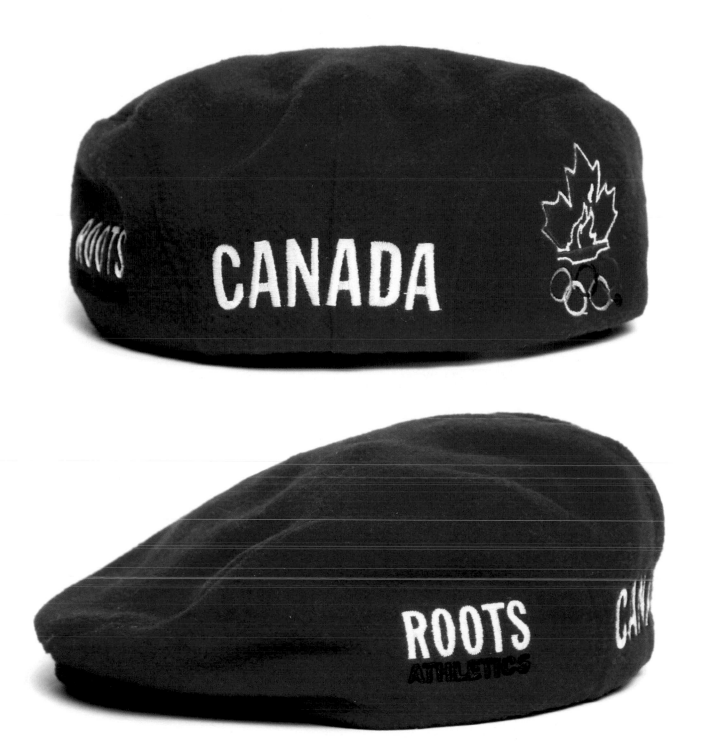

OLYMPIC
TEAM HATS

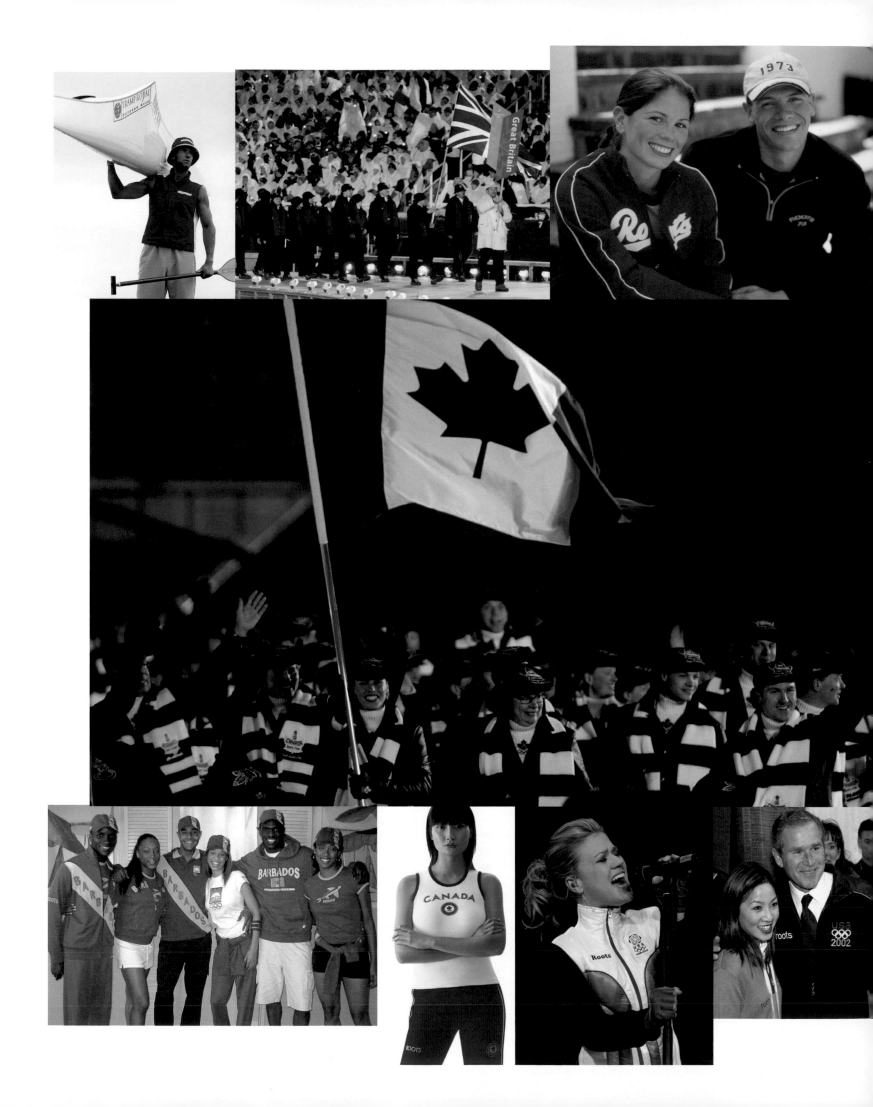

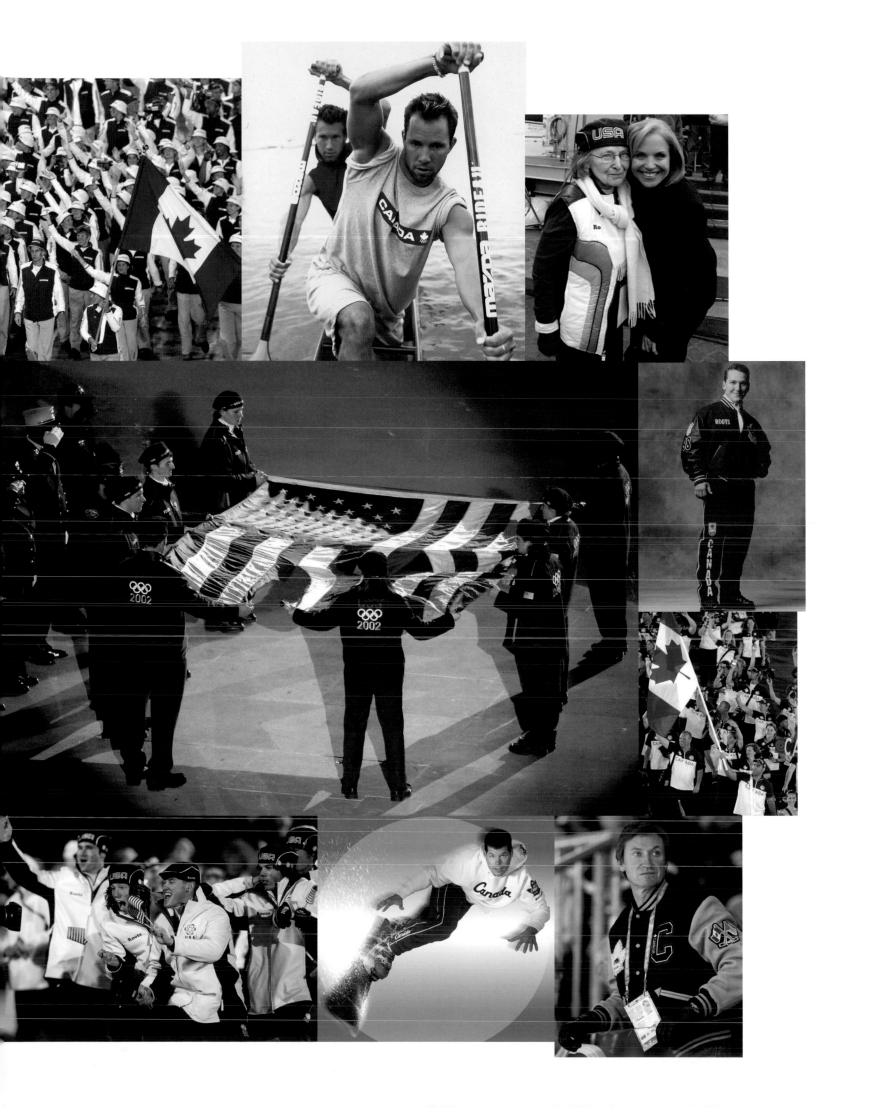

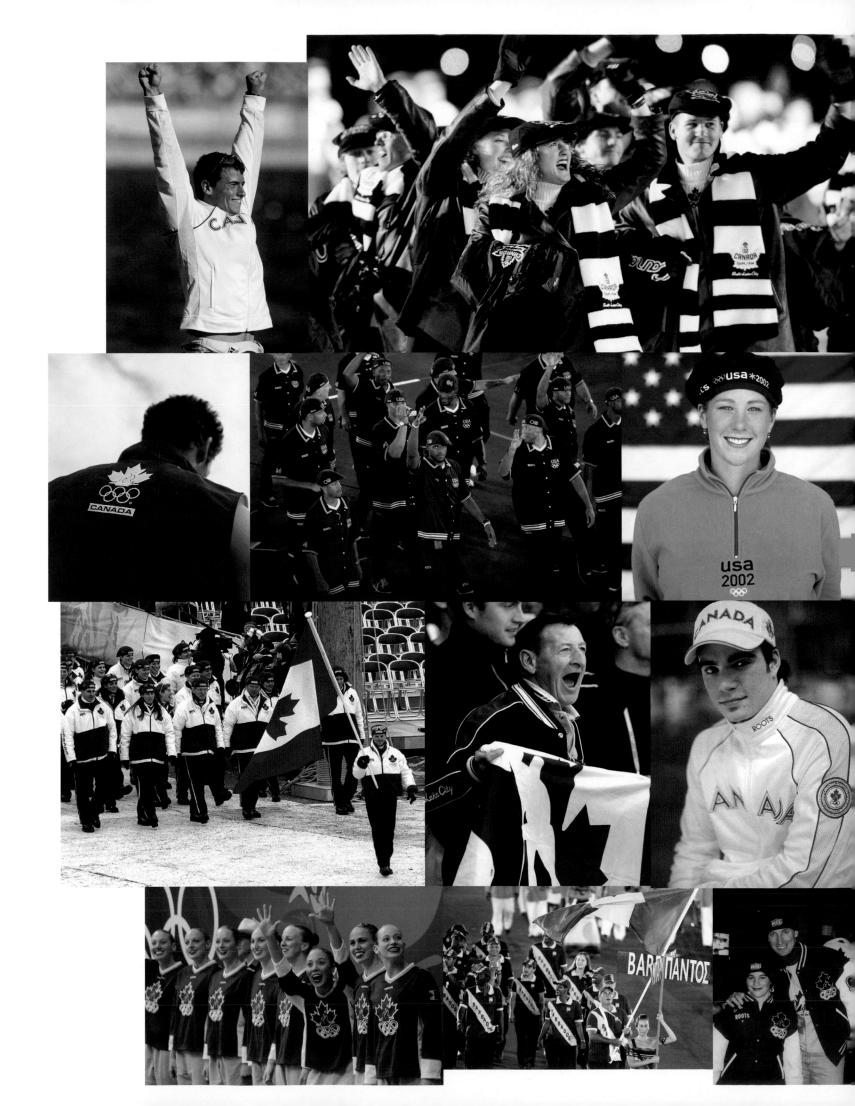

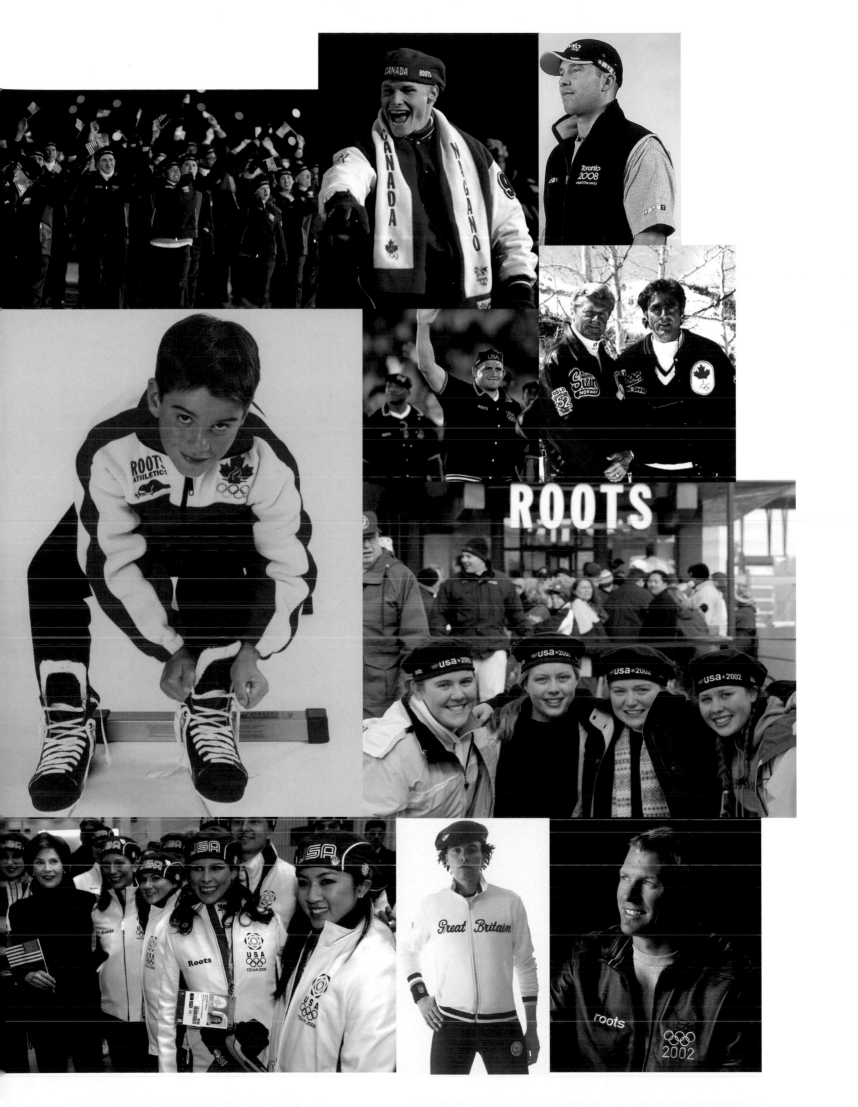

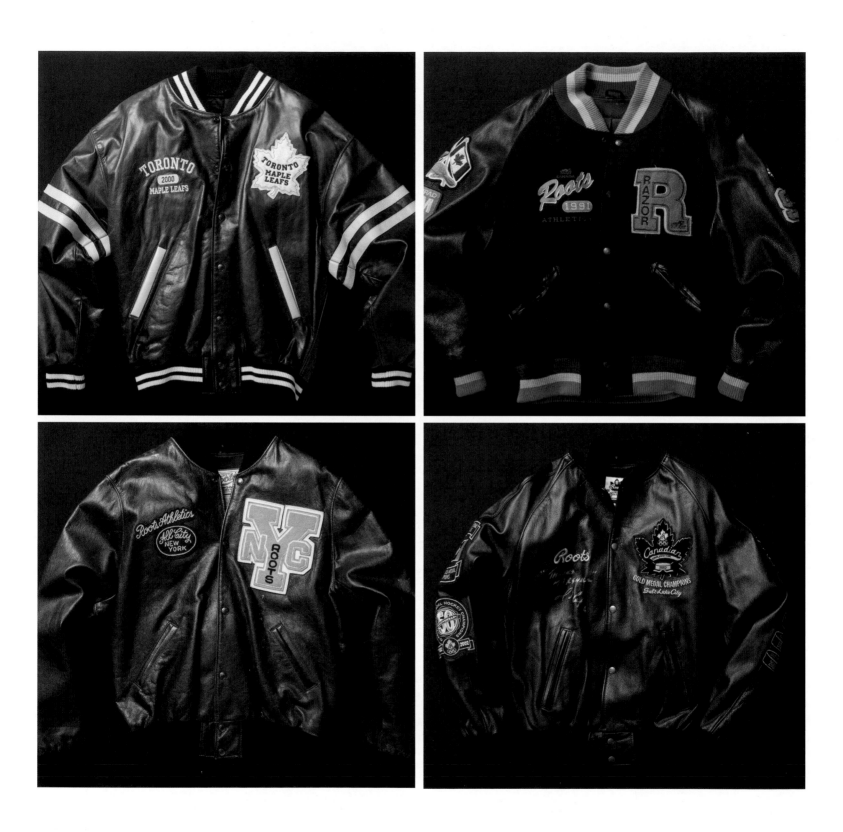

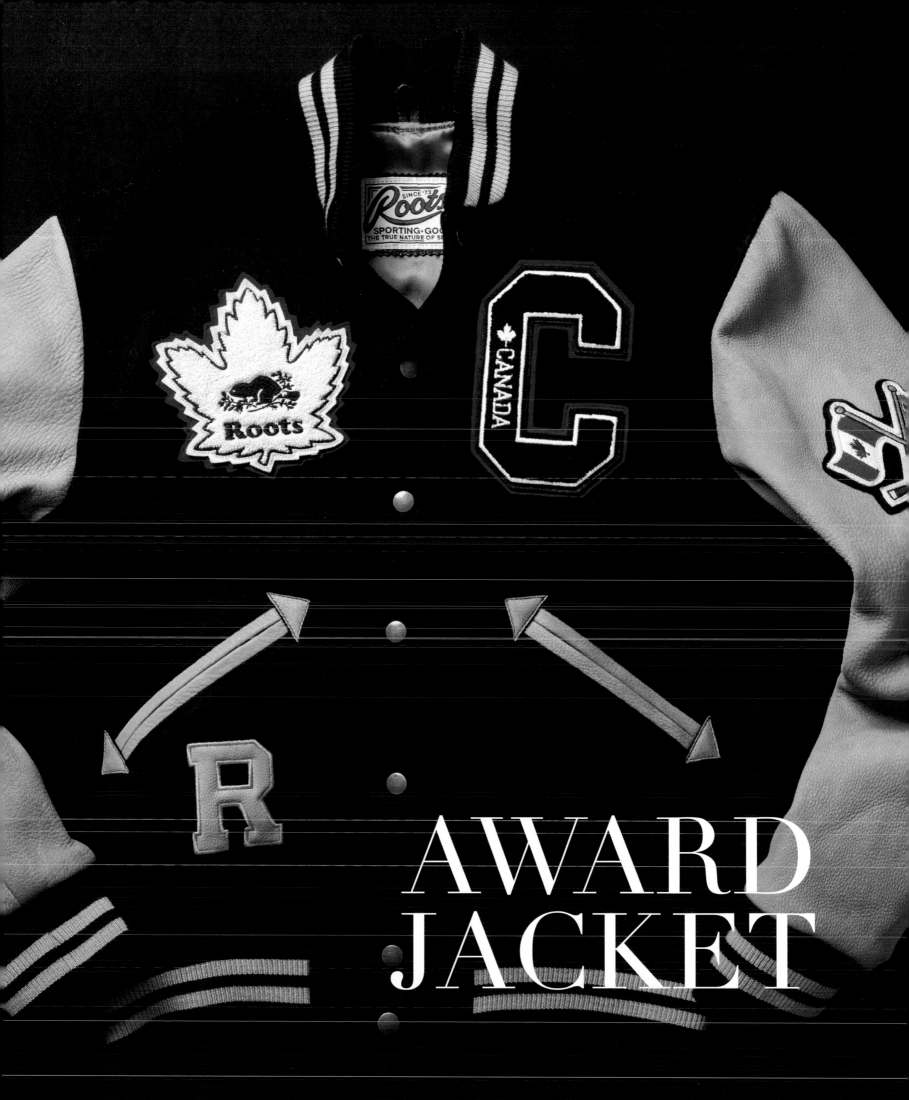

AWARD
JACKET

TORONTO
2000
MAPLE LEAFS

TORONTO
MAPLE
LEAFS

18

So Far Gone
★ ★ ★ ★ ★
Thanks Me Later
★ ★ ★ ★ ★
Take Care

NYC
ROOTS

SINCE '73
Roots
SPORTING GOODS
THE NATURE OF SPORTS

CANADA

Roots

100 YEARS
ALGONQUIN
PARK
ROOTS

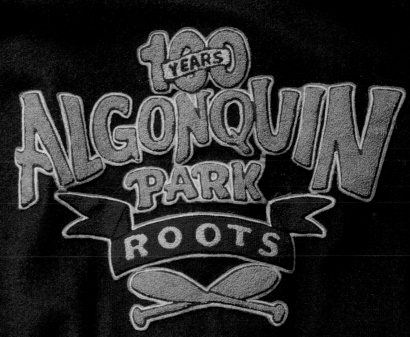

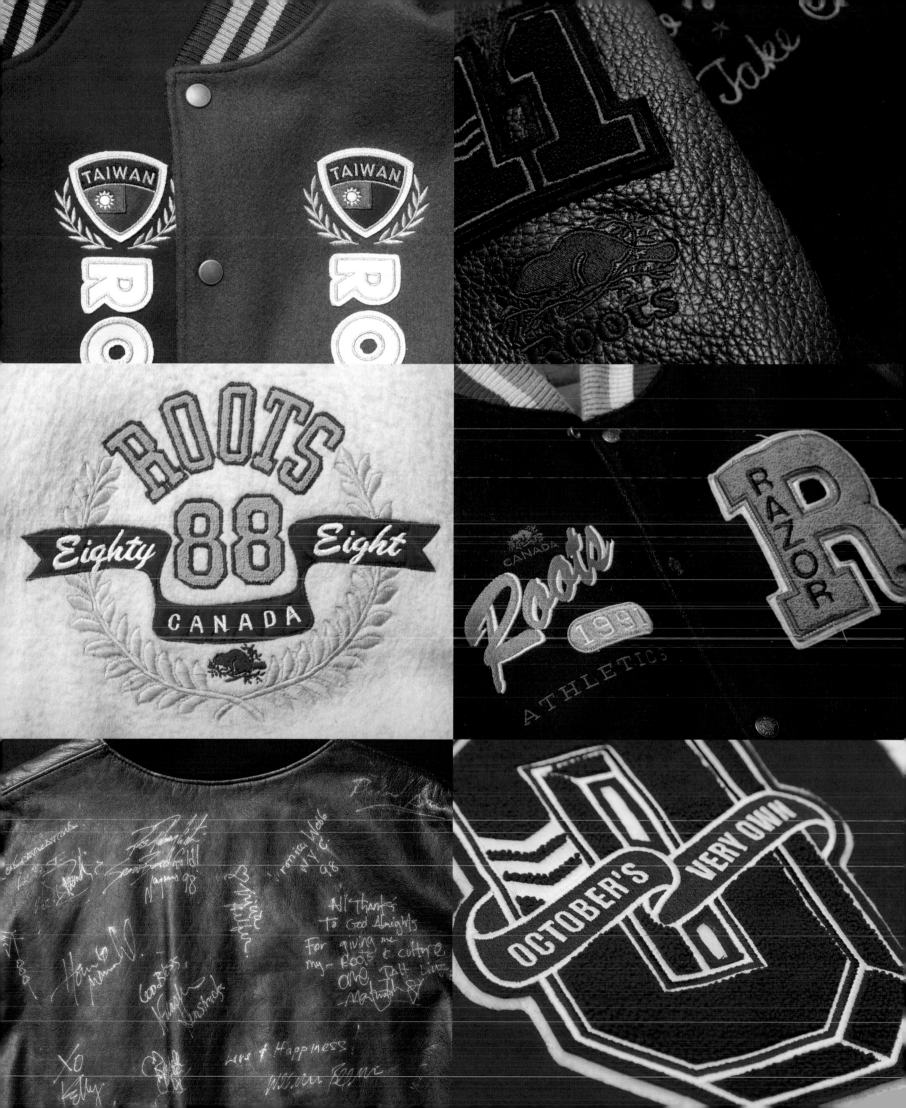

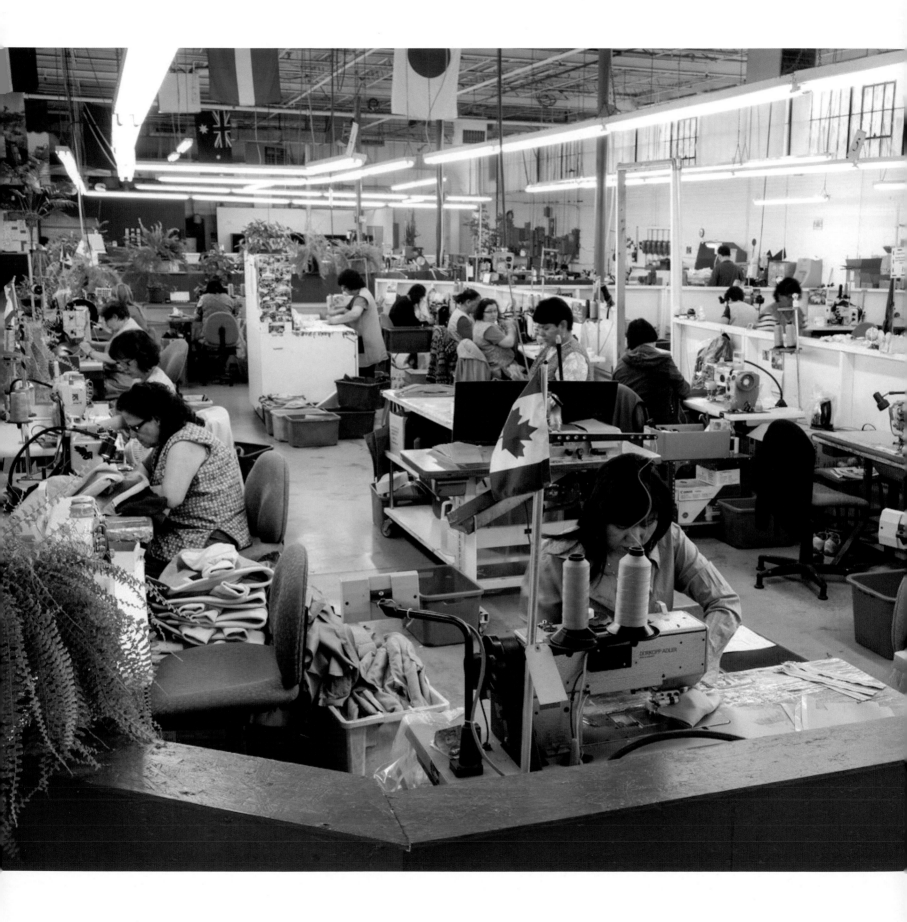

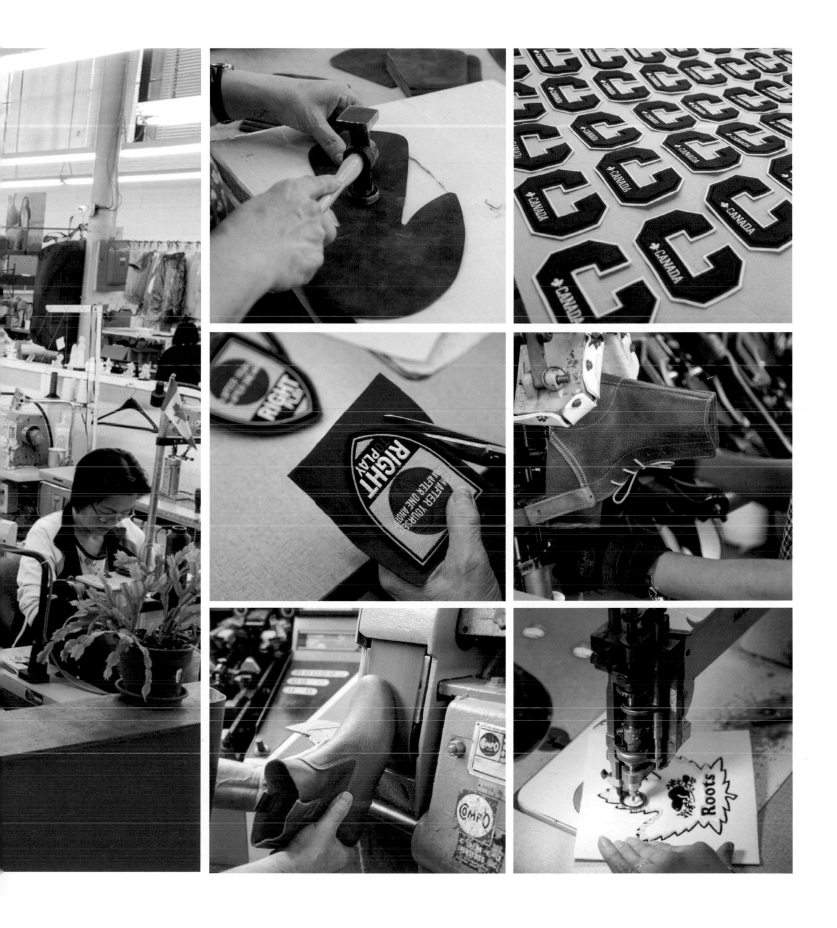

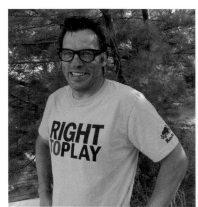
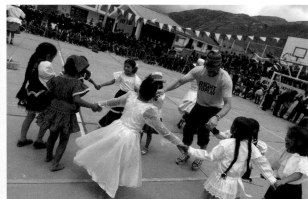
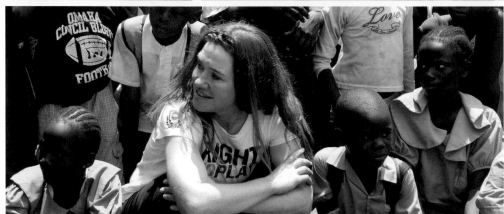

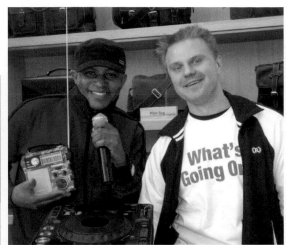

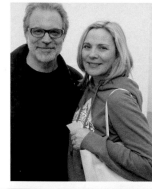

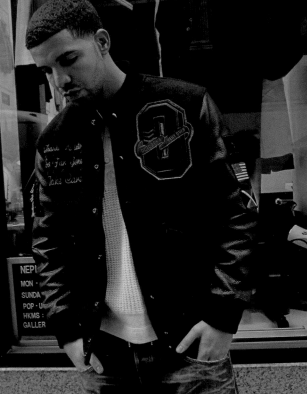

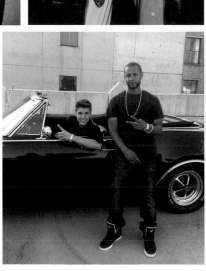
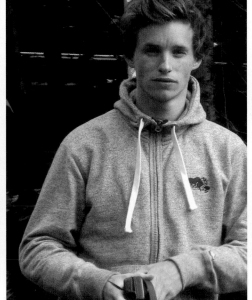
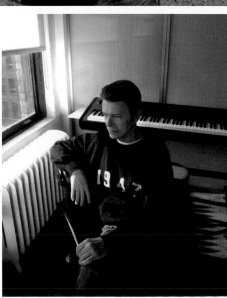

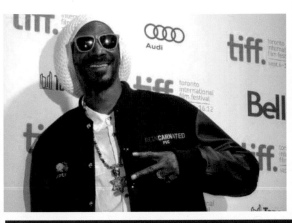

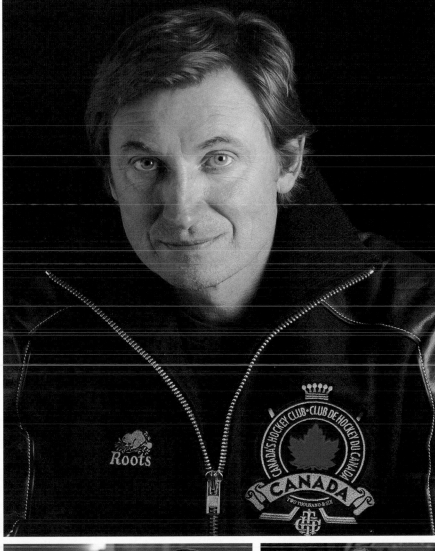
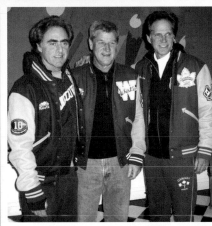
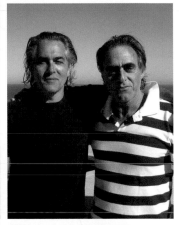

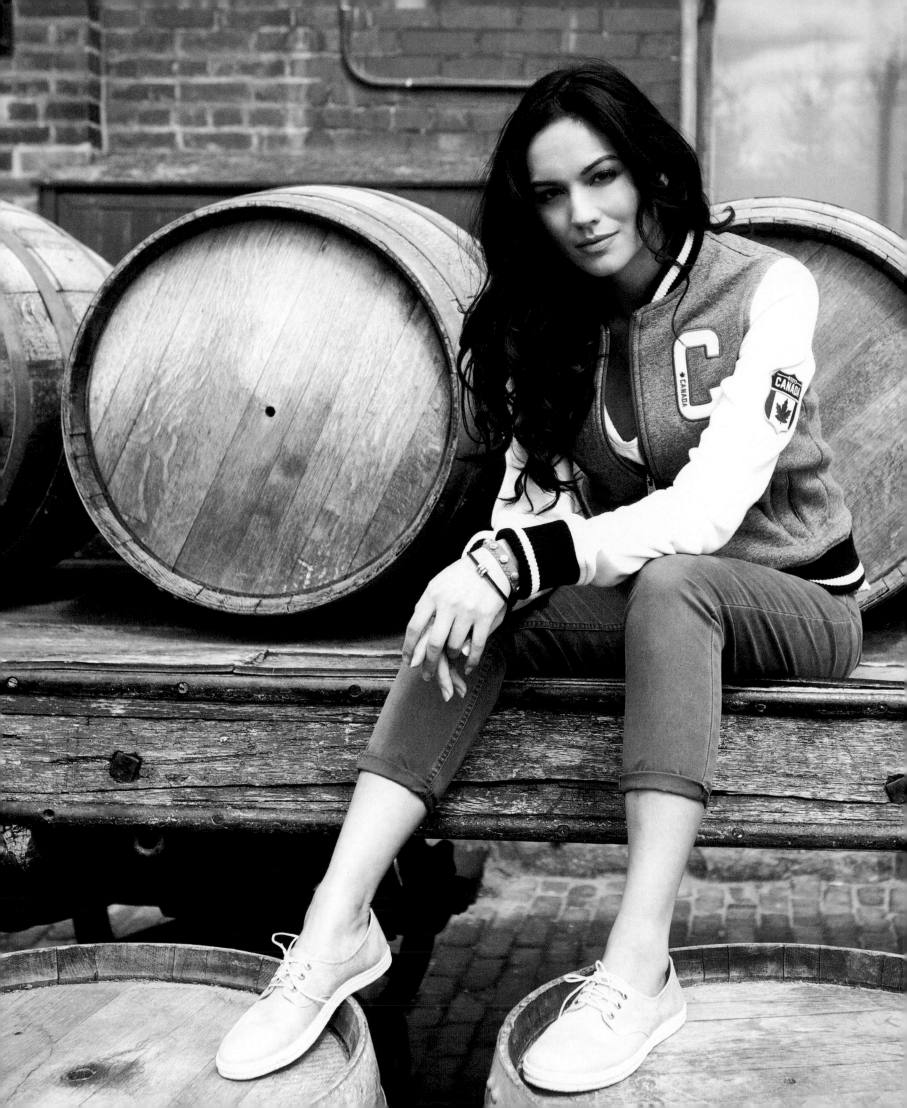

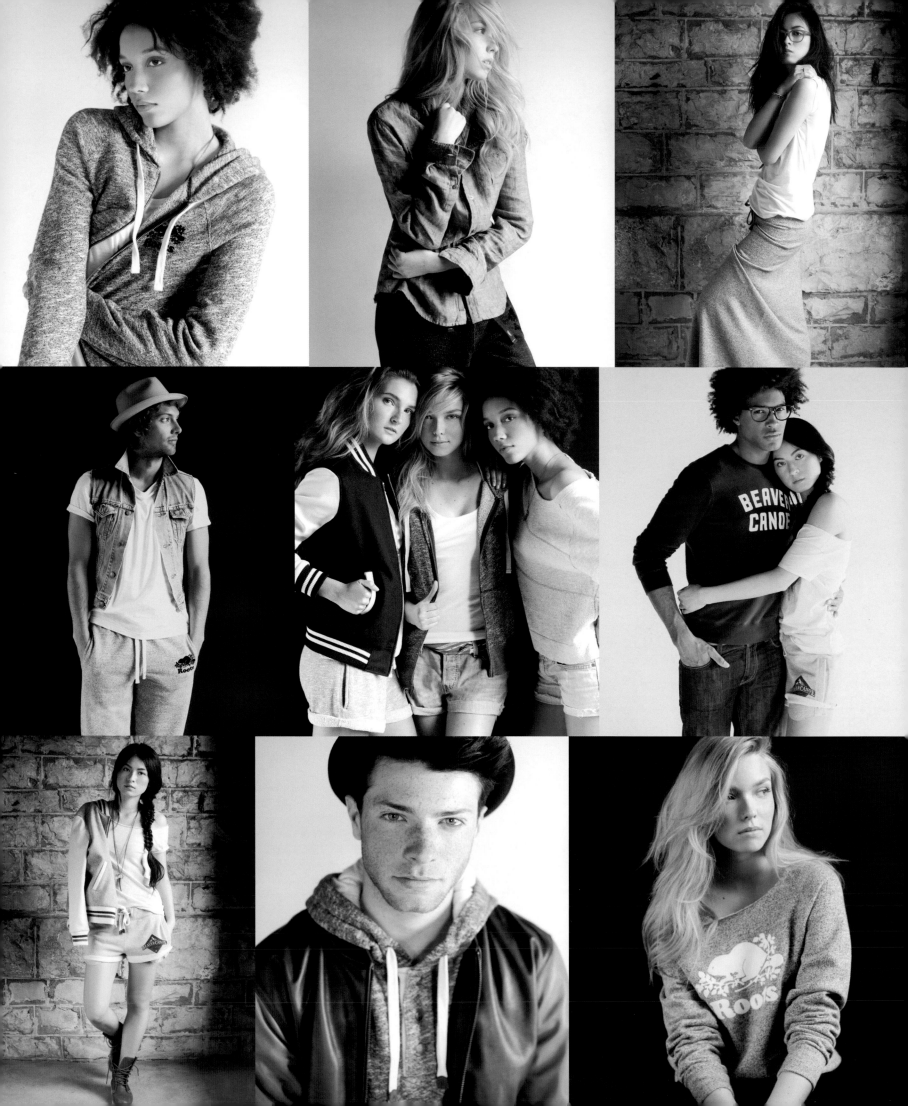

SALT &
PEPPER
SWEATS

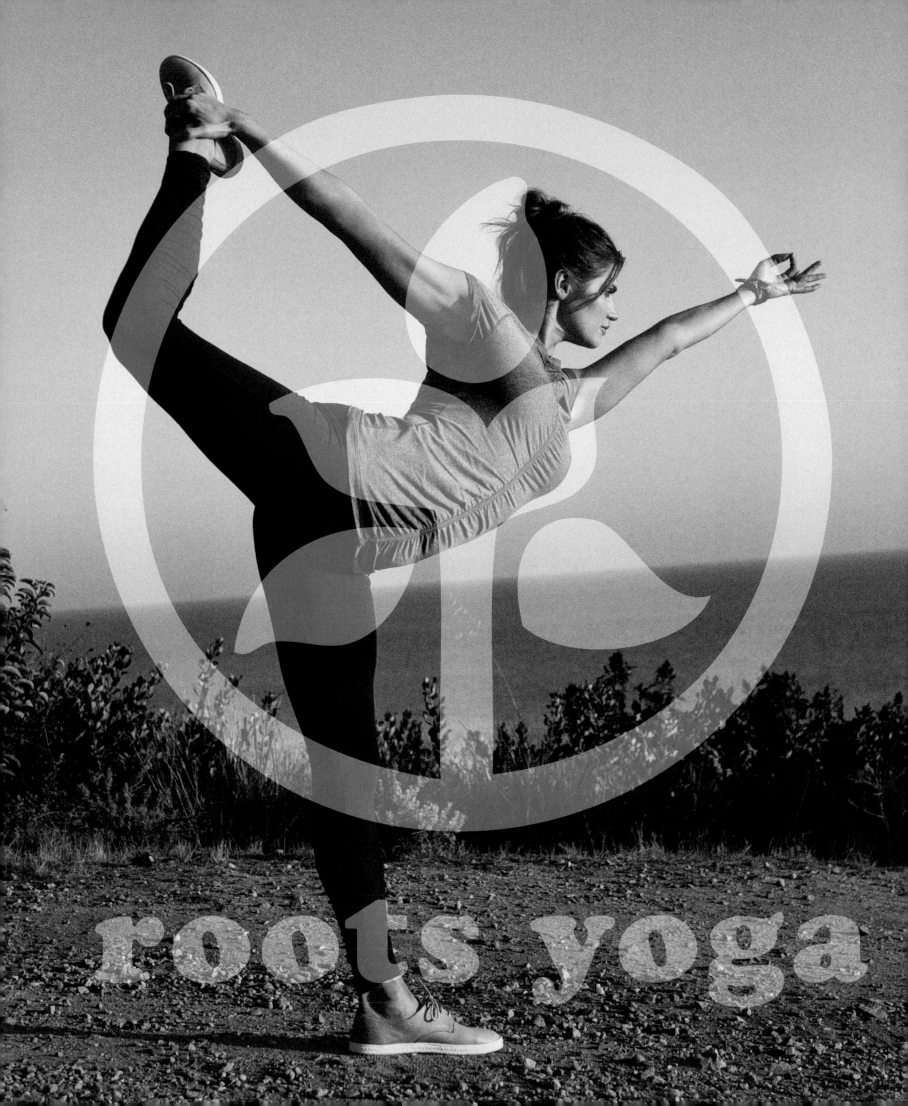

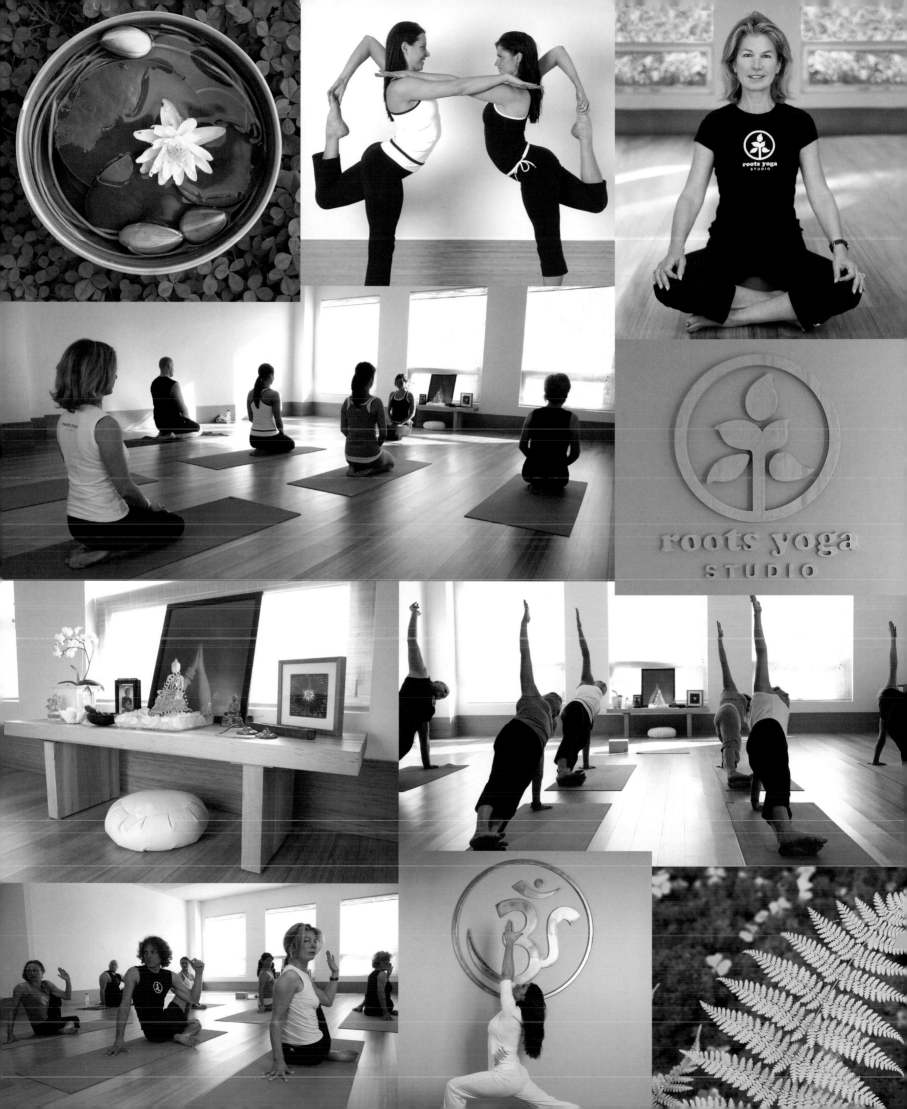

roots yoga
STUDIO

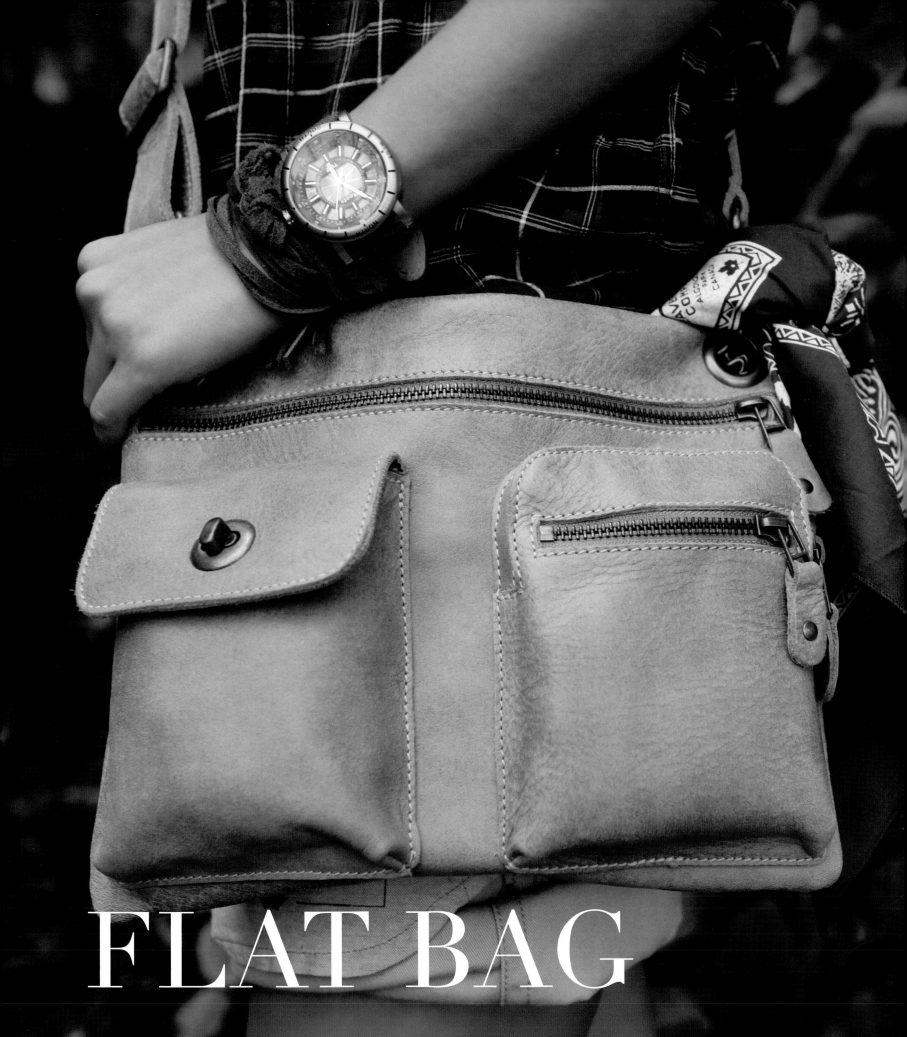

FLAT BAG

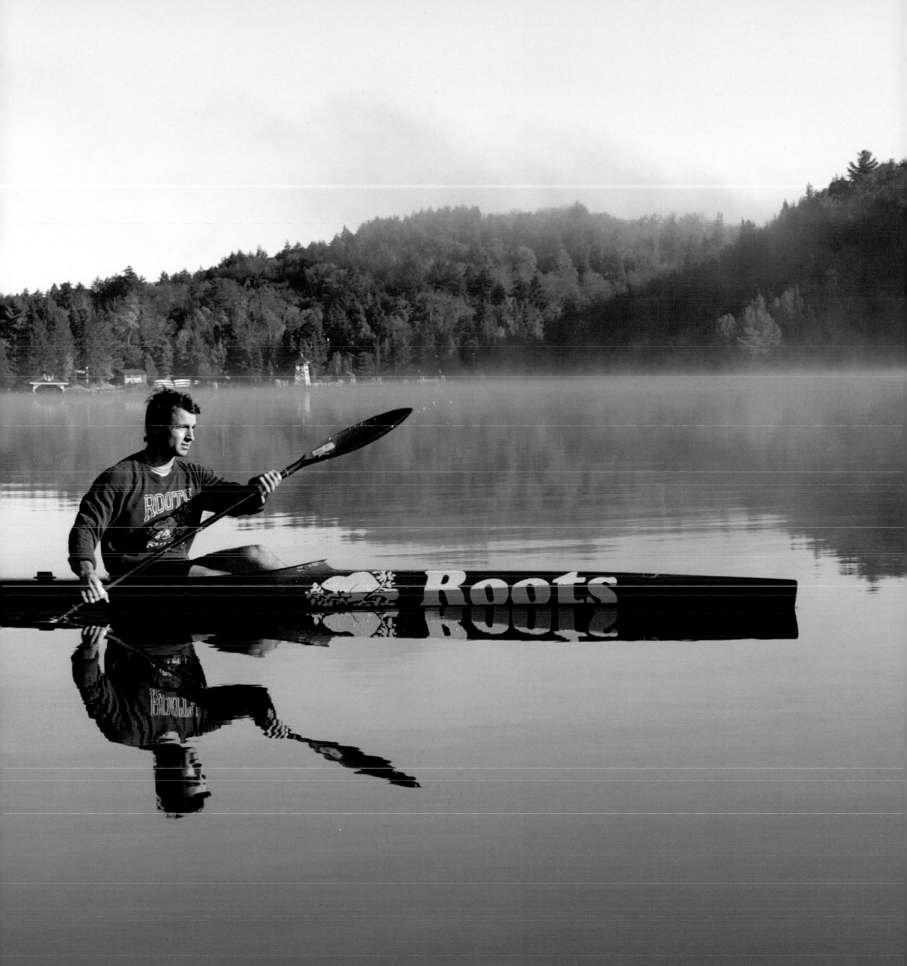

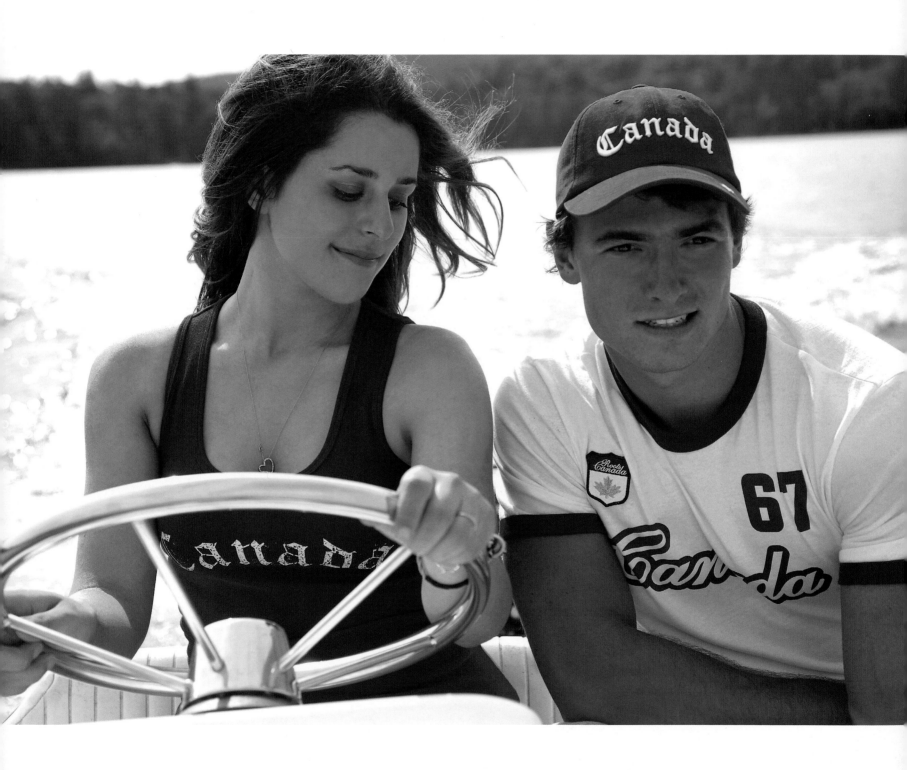

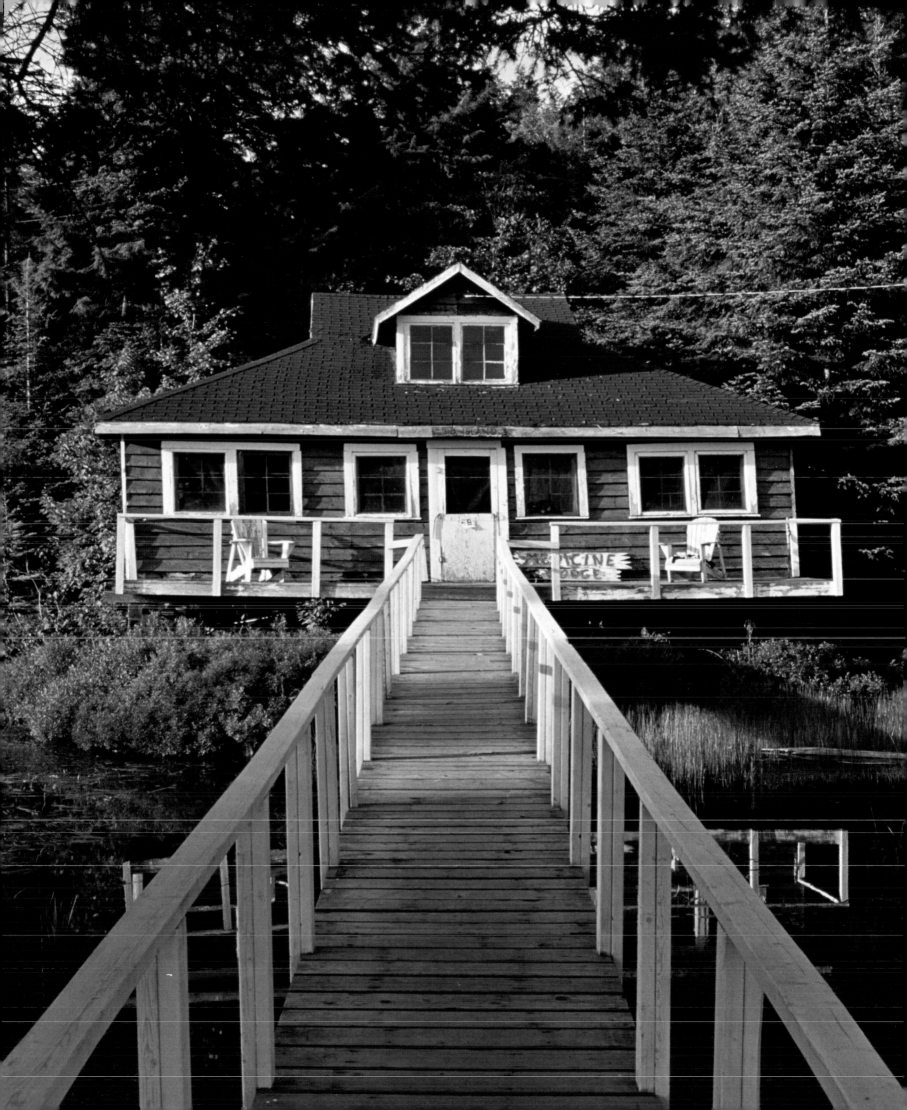

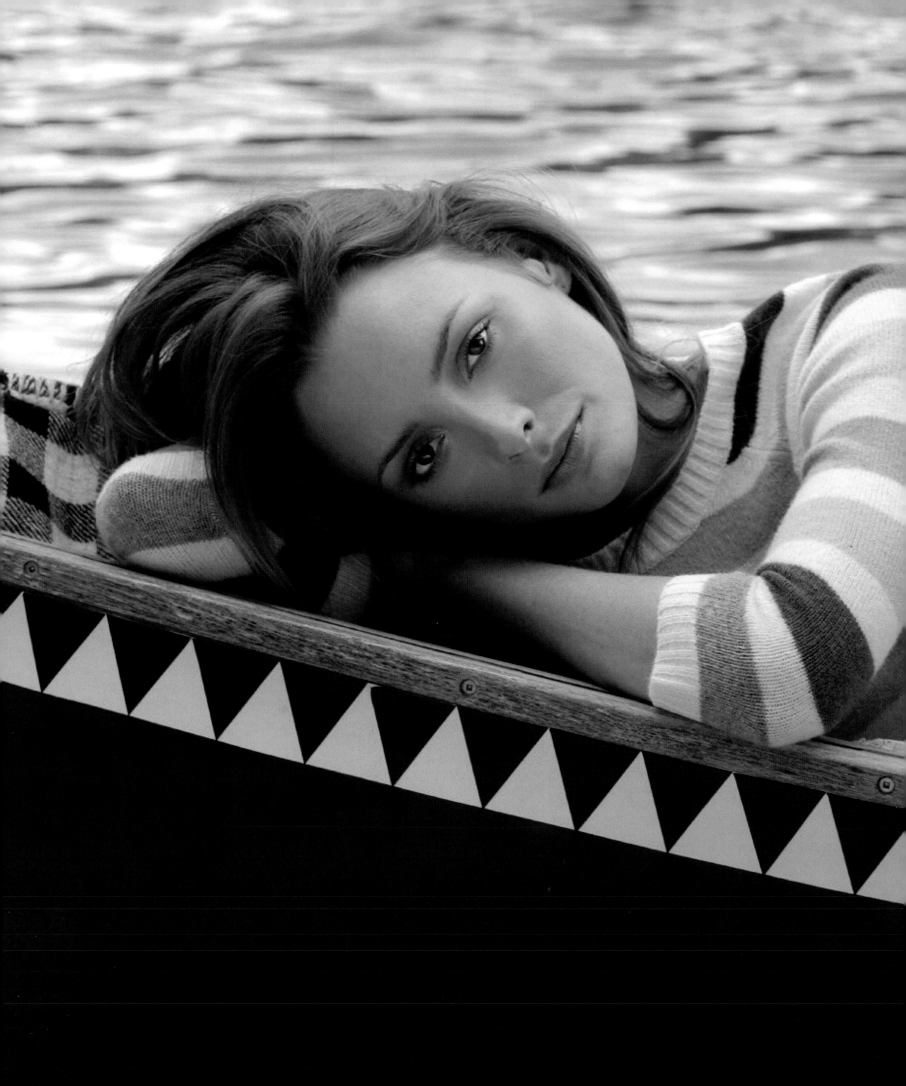

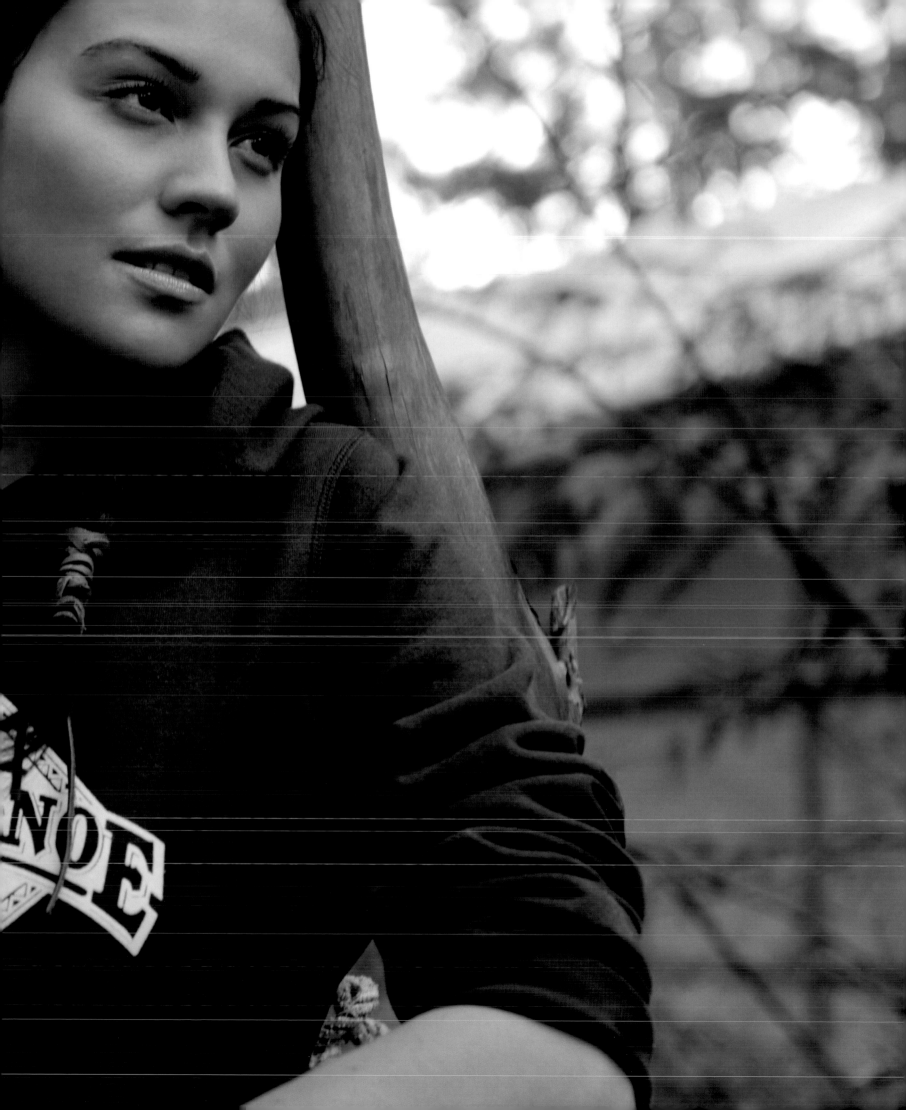

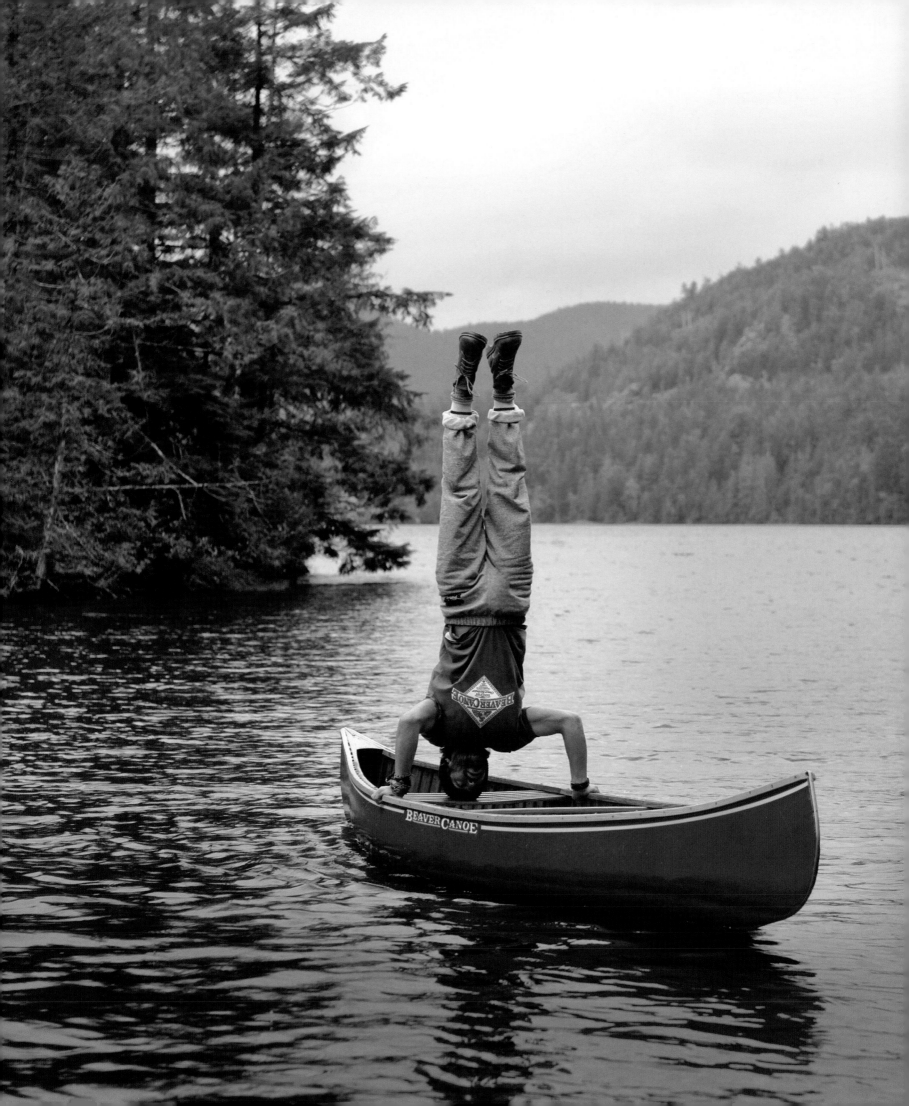

Heal the Planet

Positive Energy · Environmental Awareness · Hope & Peace

be OZONE friendly

it's a great atmosphere!

Roots cares

WATER Gives LIFE

KEEP OUR OCEANS CLEAN!

ROOTS CANADA

FRESH AIR · CLEAN WATER · HEALTHY LIVING

THINK GREEN

ROOTS CARES

POLLUTION-FREE

SAVE THE WORLD

RECYCLE

greenhouse effect *n* : warming of the lower layers of the atmosphere that tends to increase with increasing atmospheric carbon dioxide and that is caused by conversion of solar radiation into heat in a process involving selective transmission of short wave solar radiation by the atmosphere, its absorption by the earth's surface, and reradiation as infrared which is absorbed by carbon dioxide and water vapor in the air

it's a world problem

ENVIRONMENTAL AWARENESS

THE OZONE LAYER

NO DUMPING

Roots

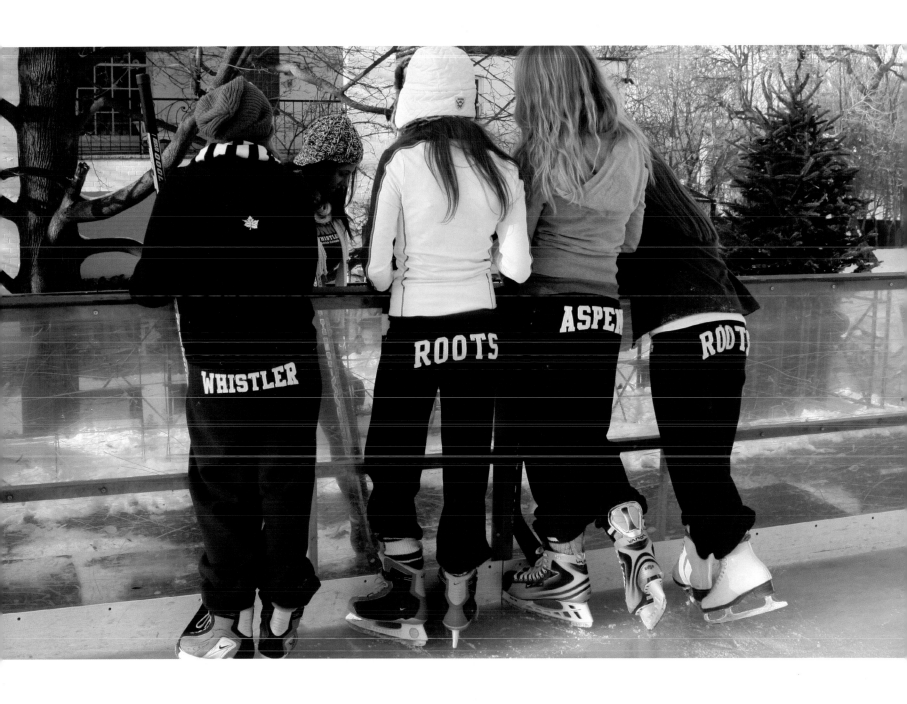

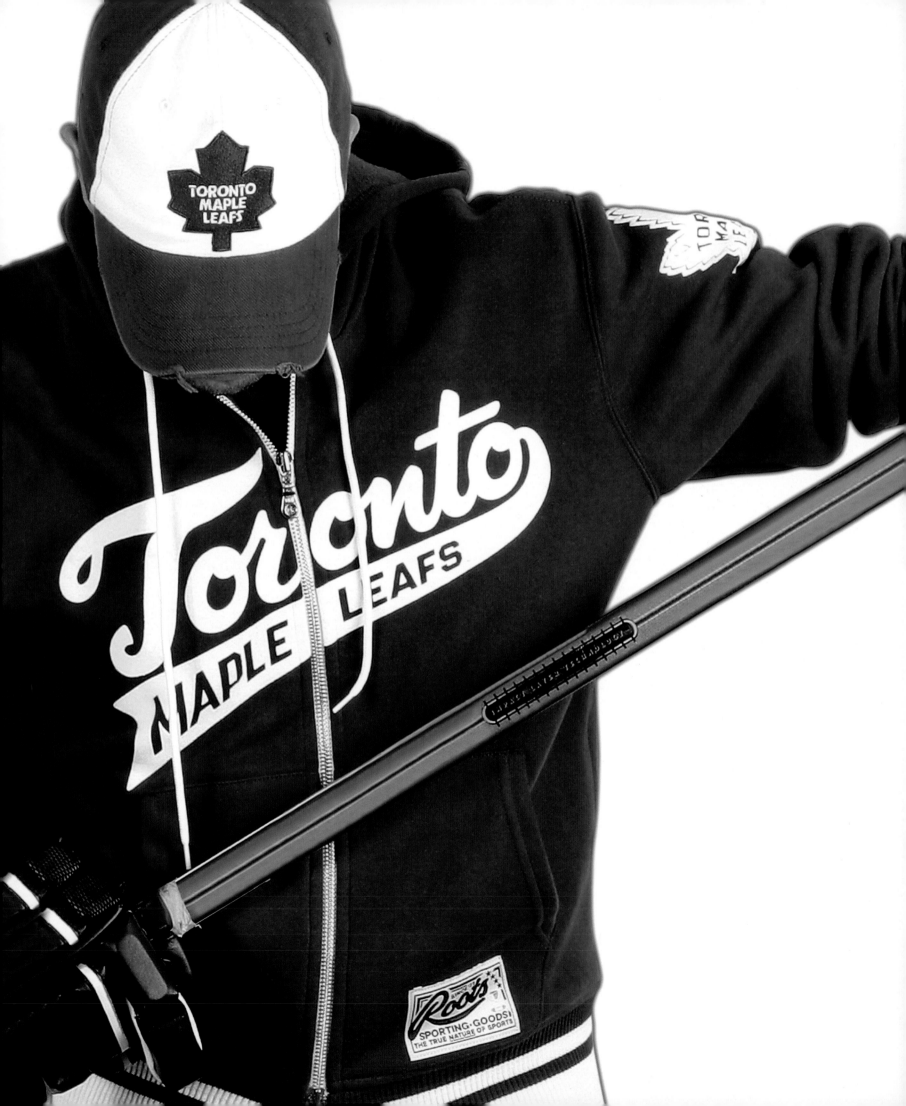

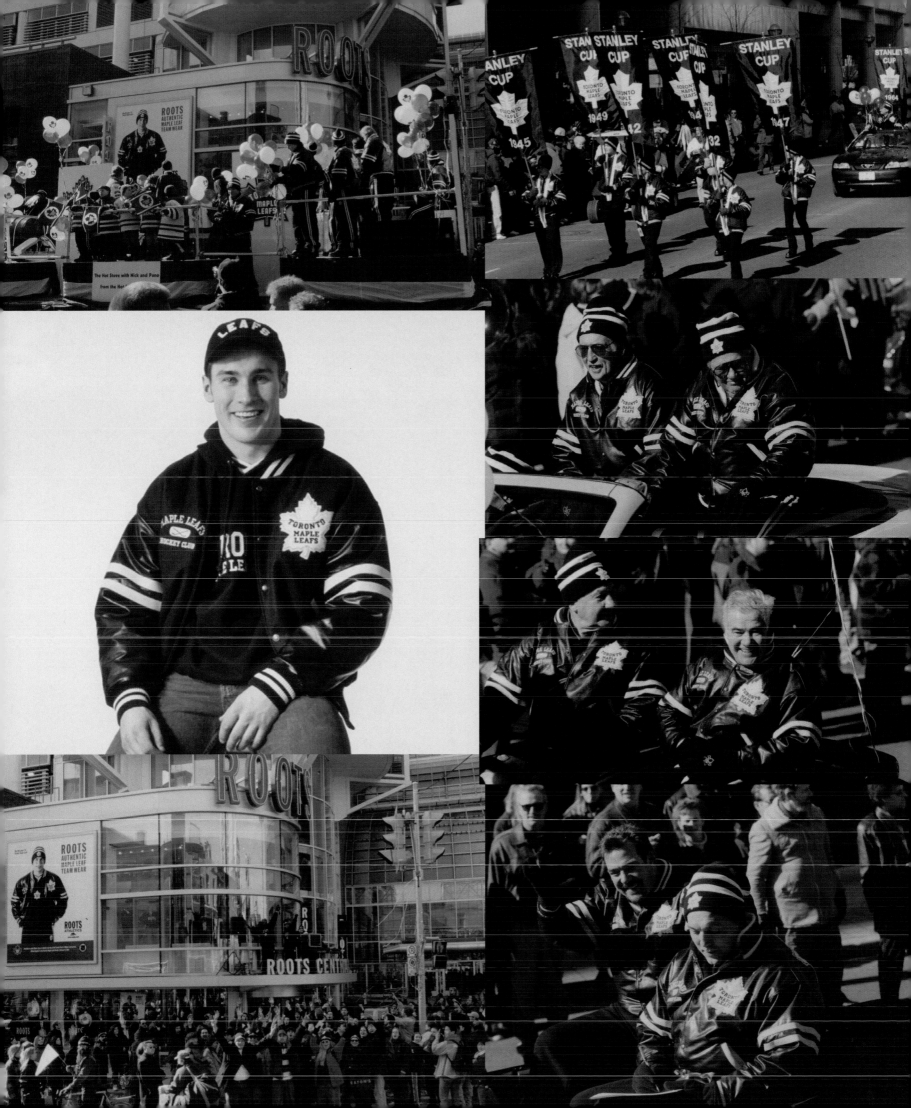

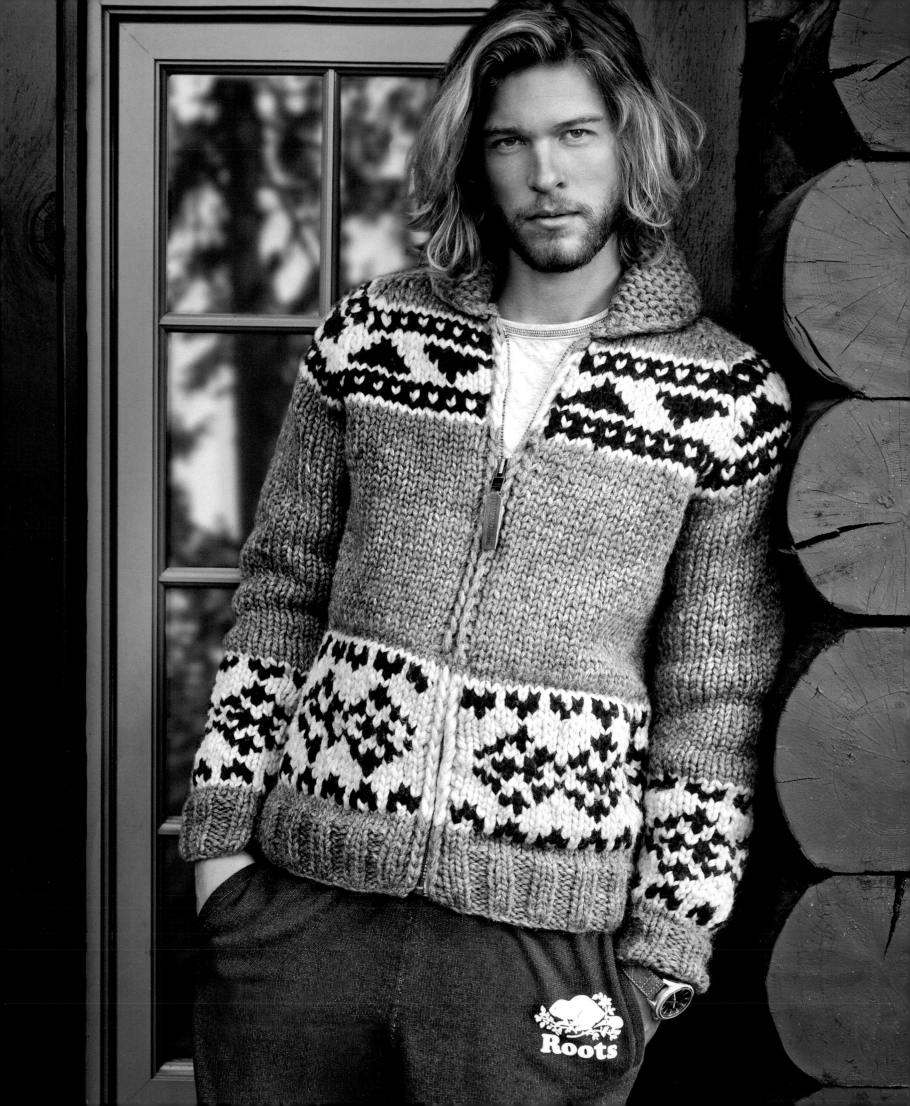

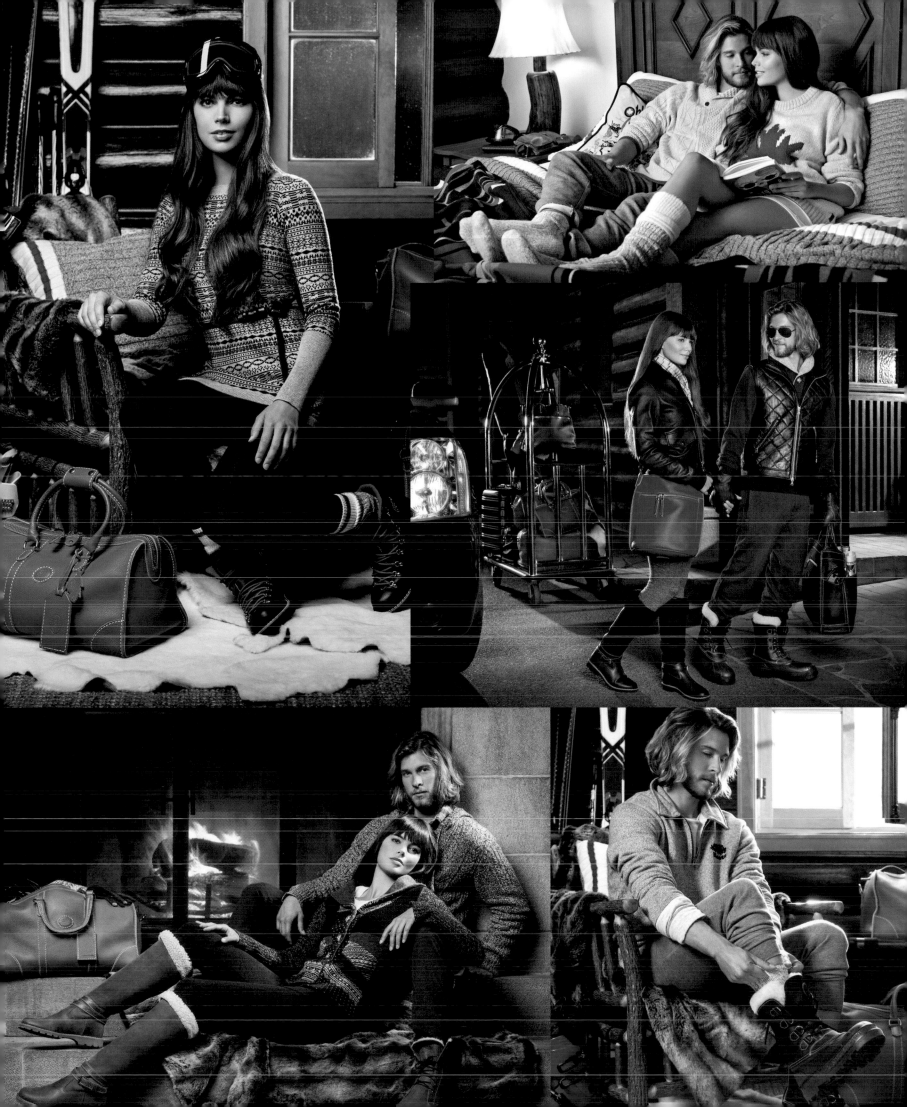

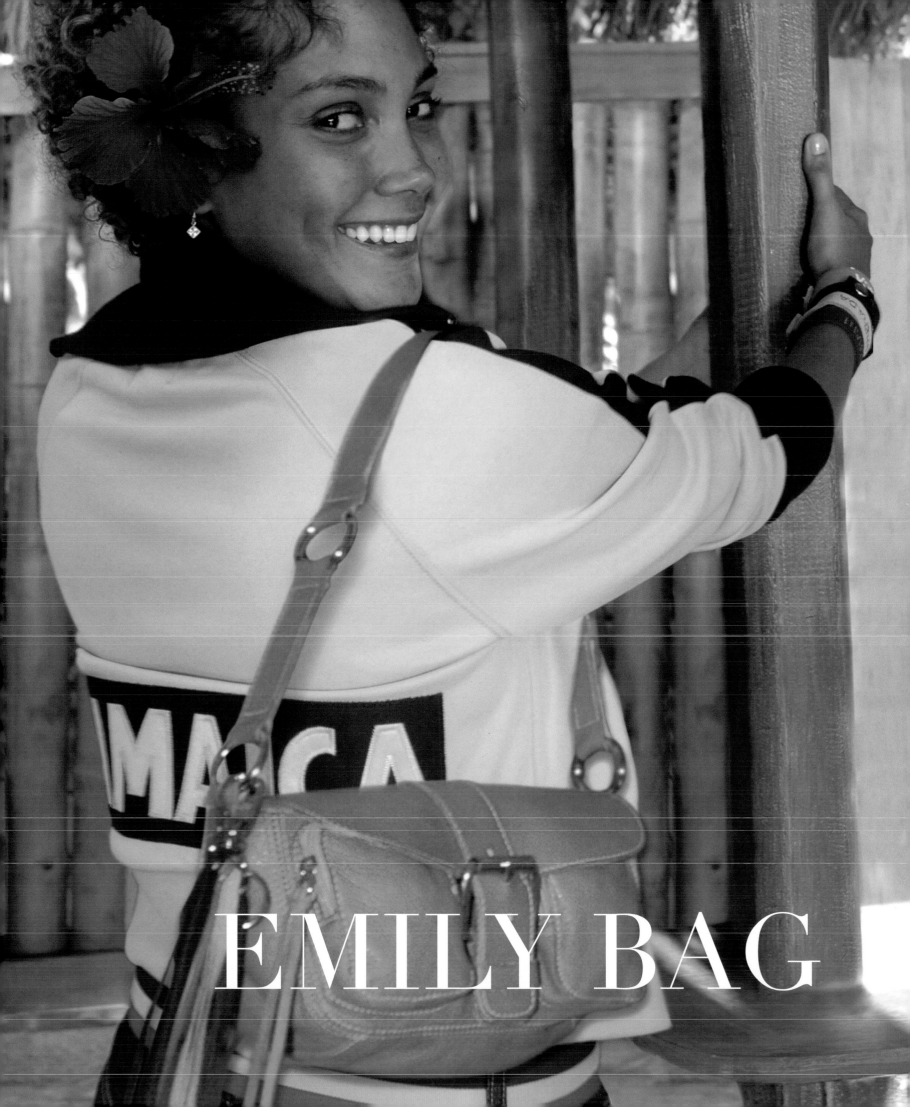

EMILY BAG

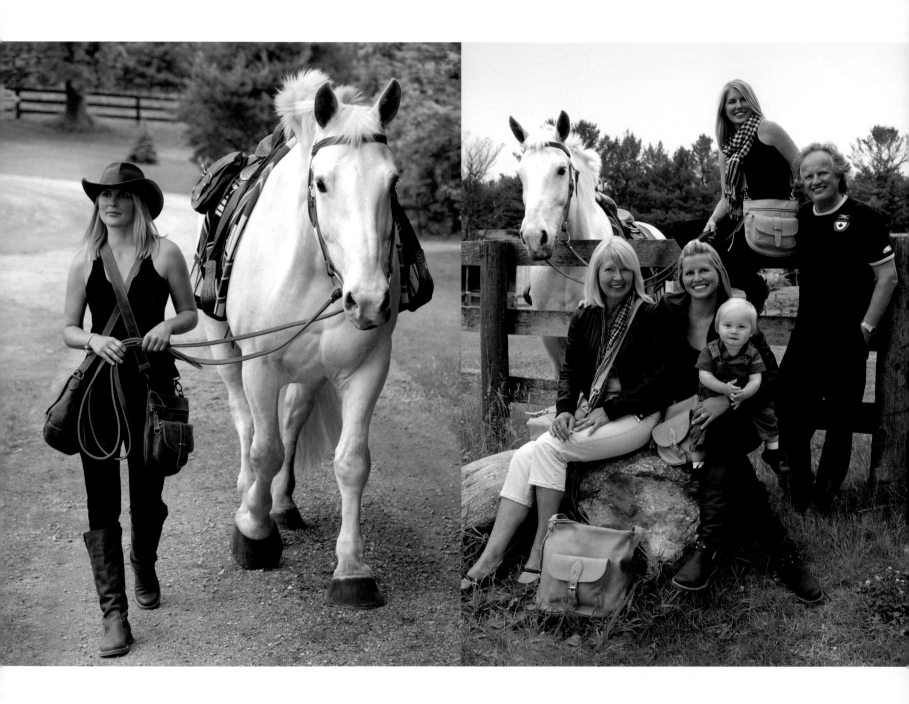

STUDENT
PACK

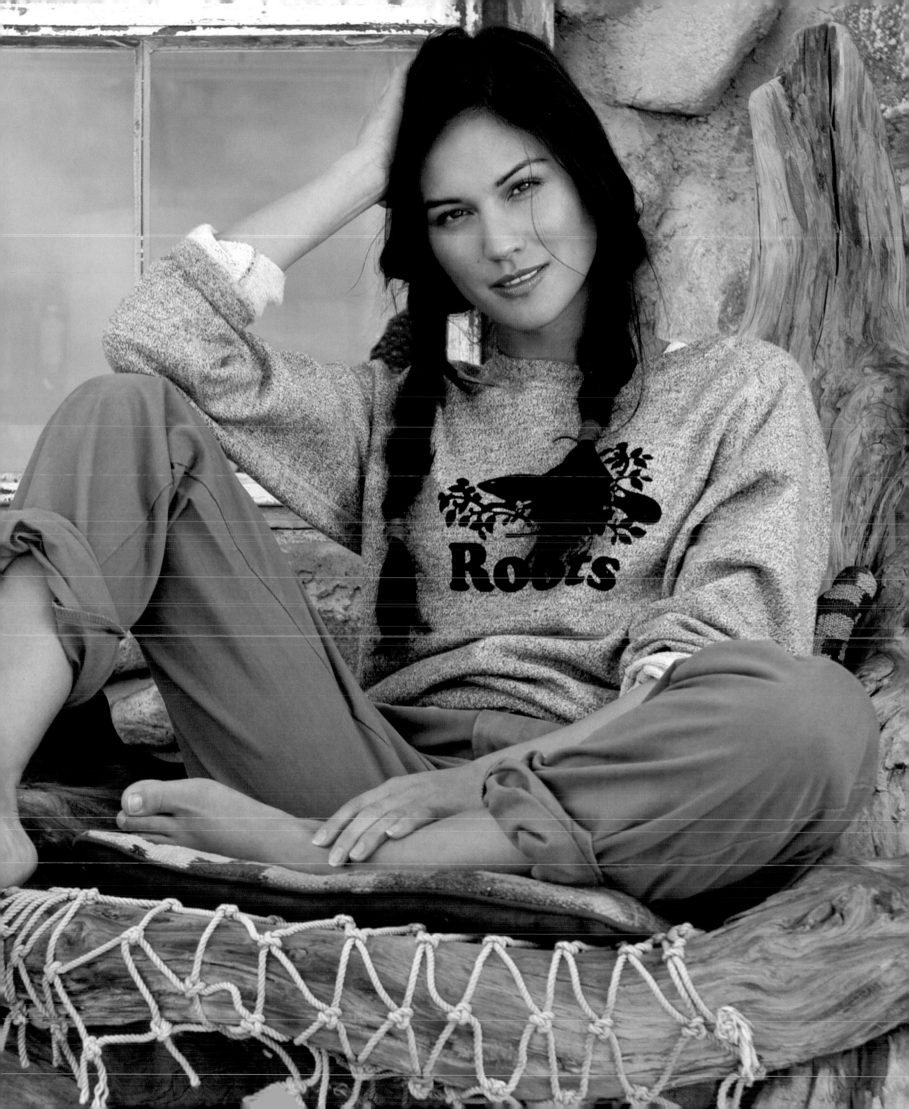

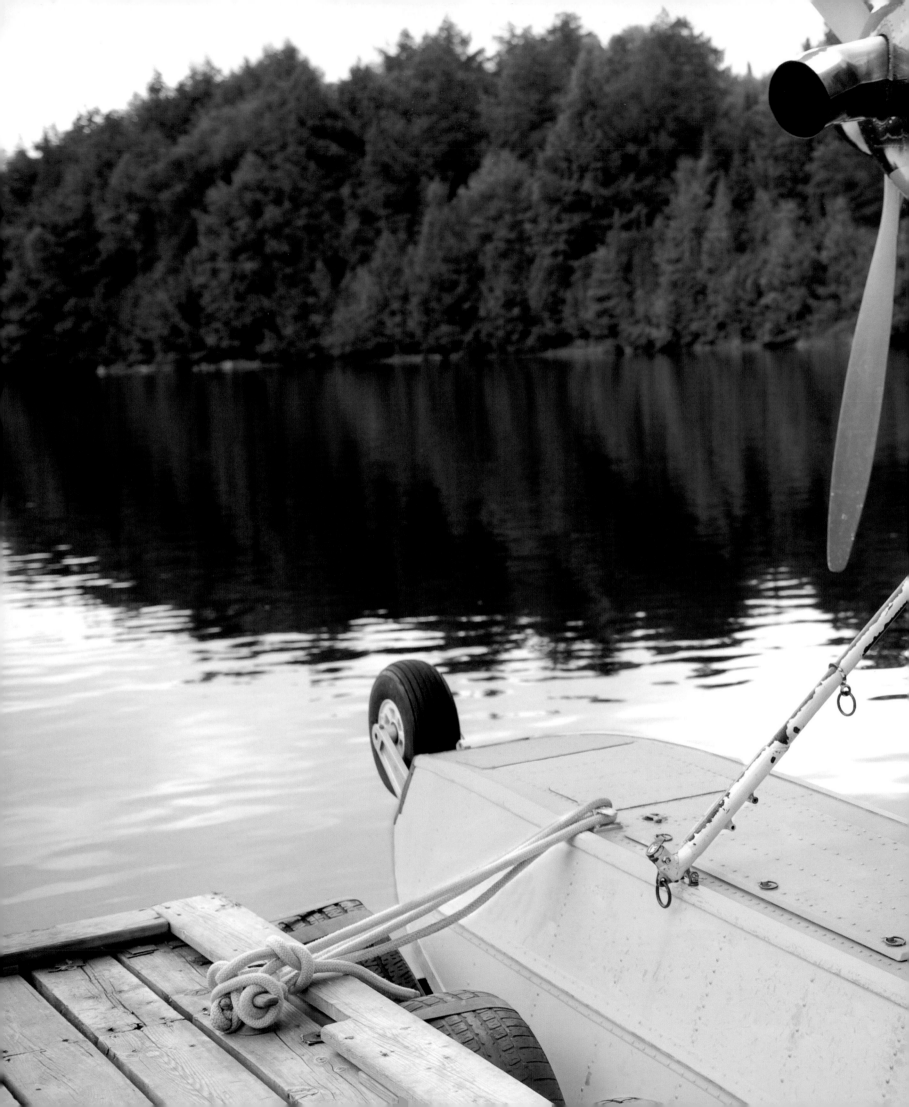

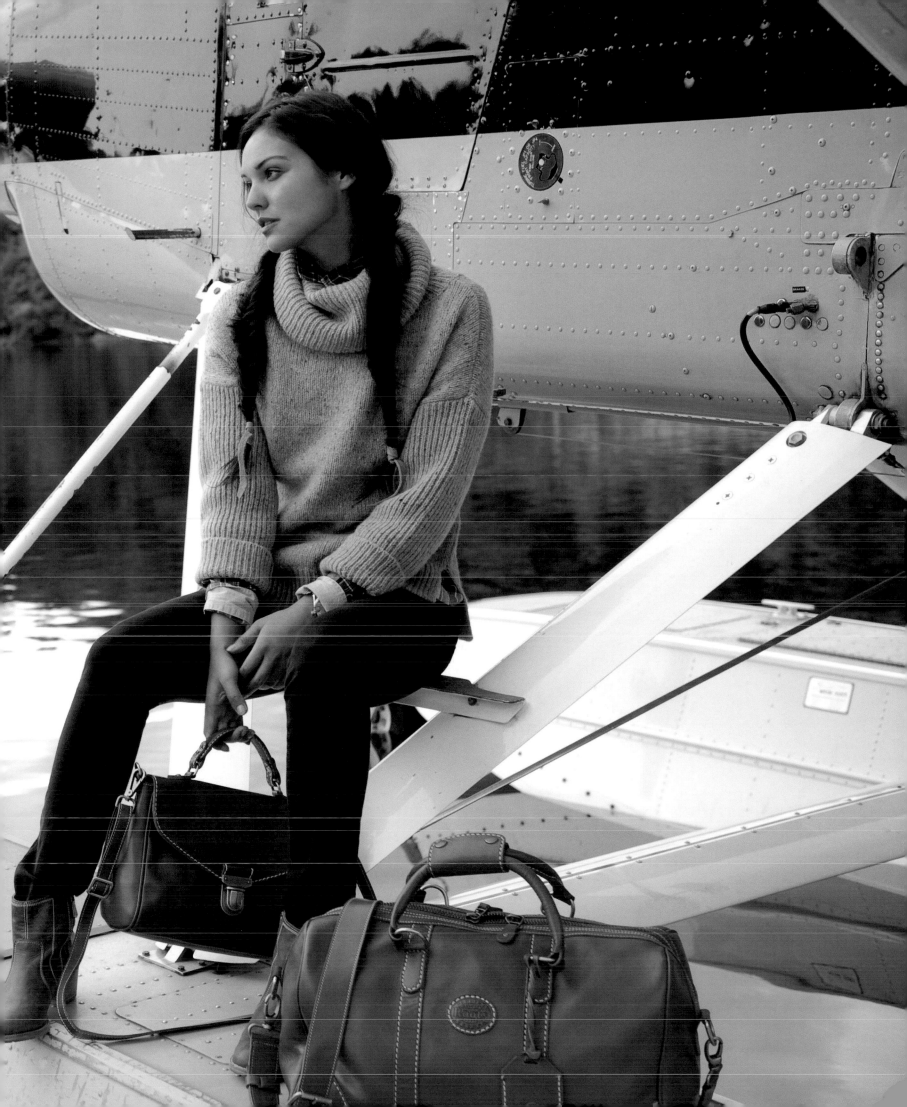

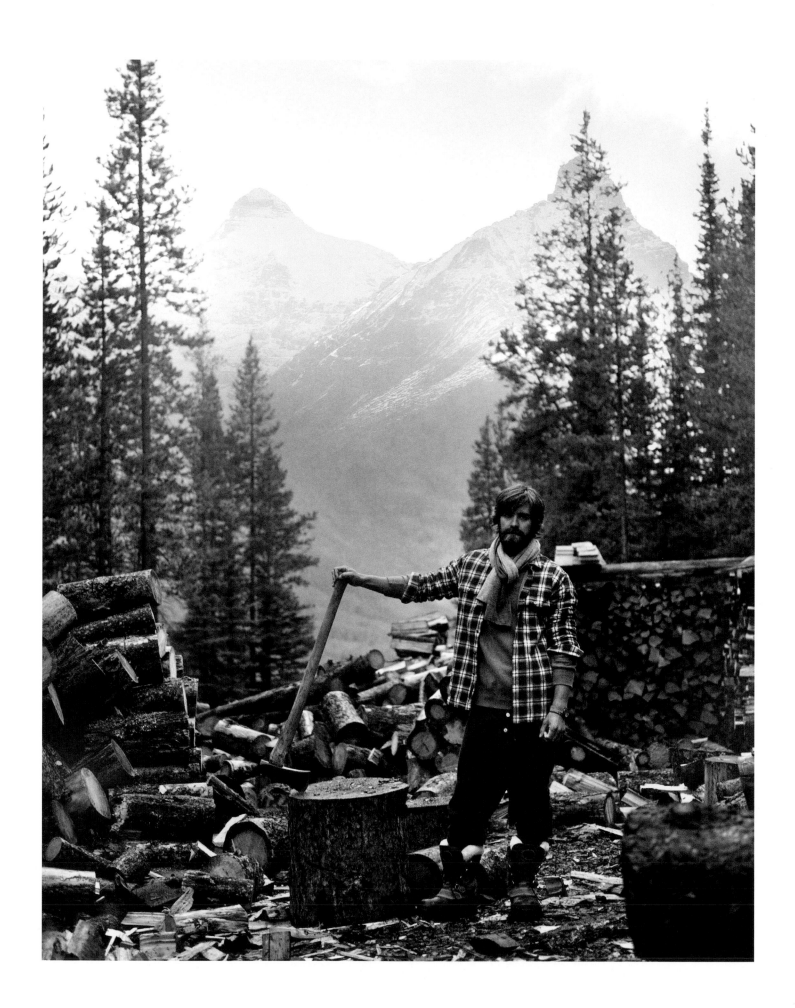

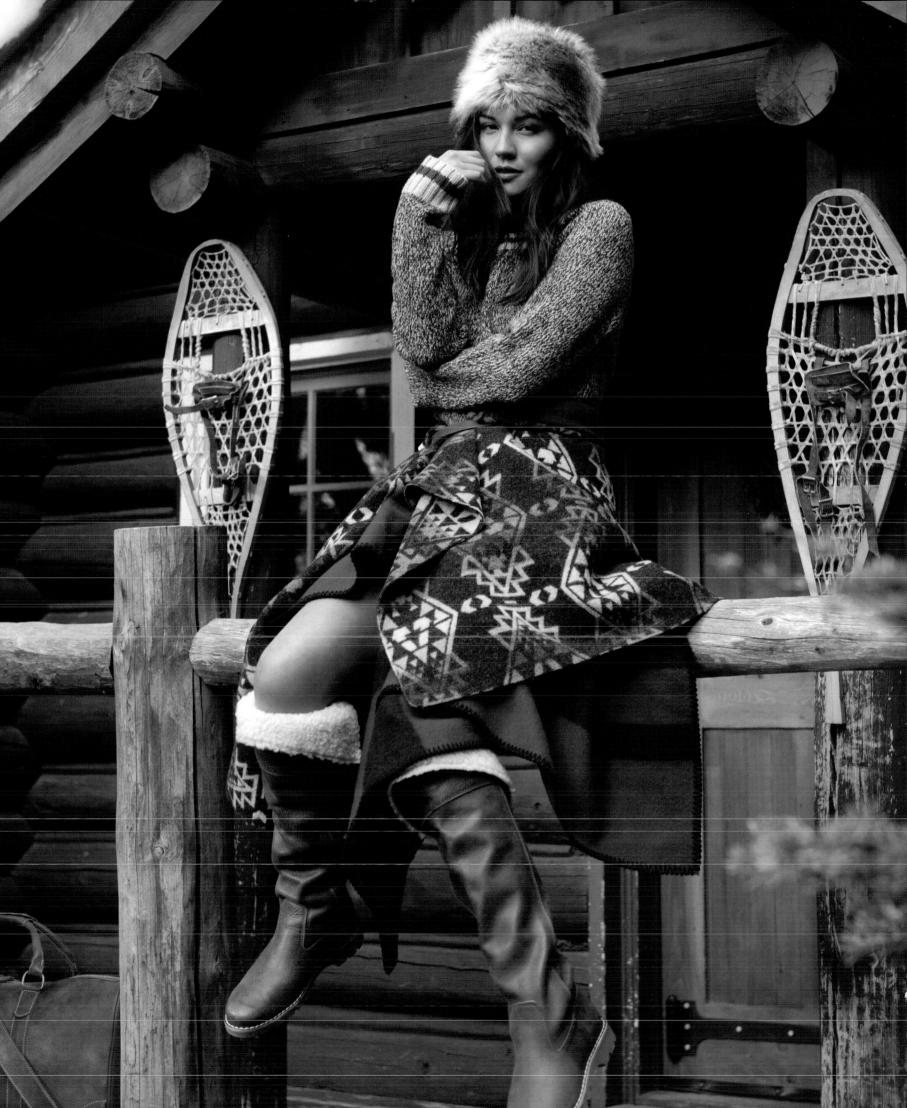

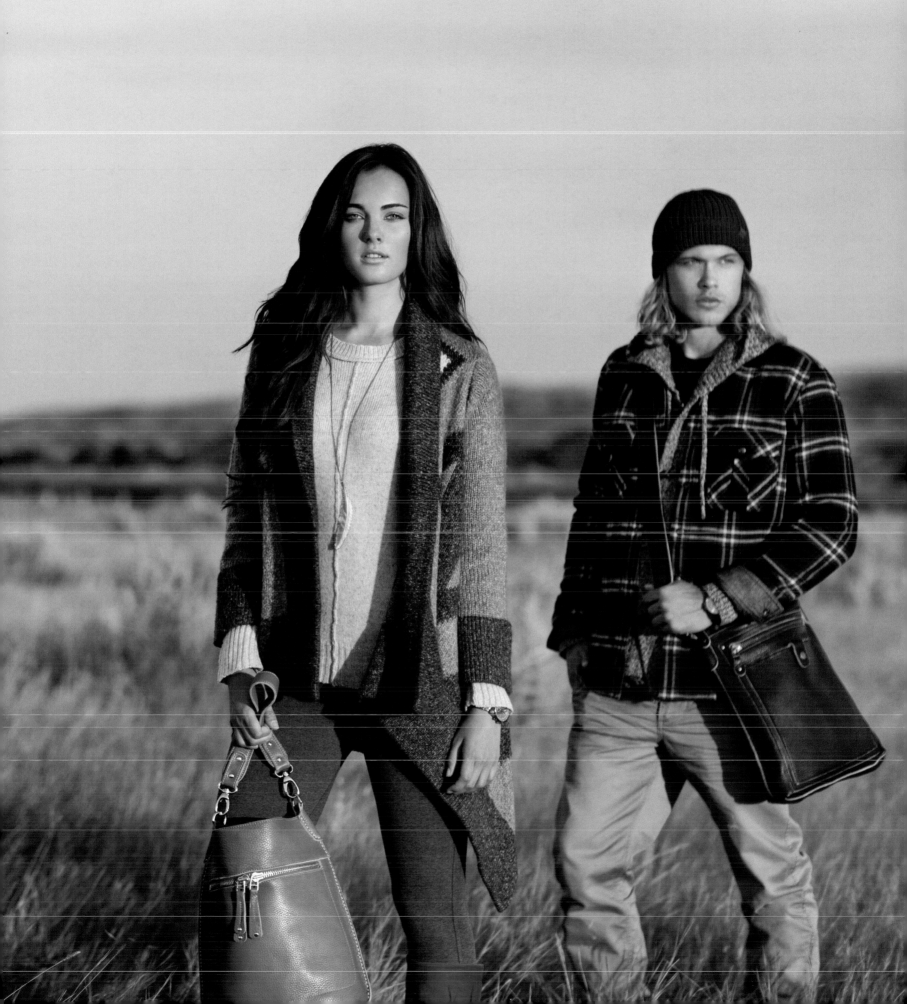

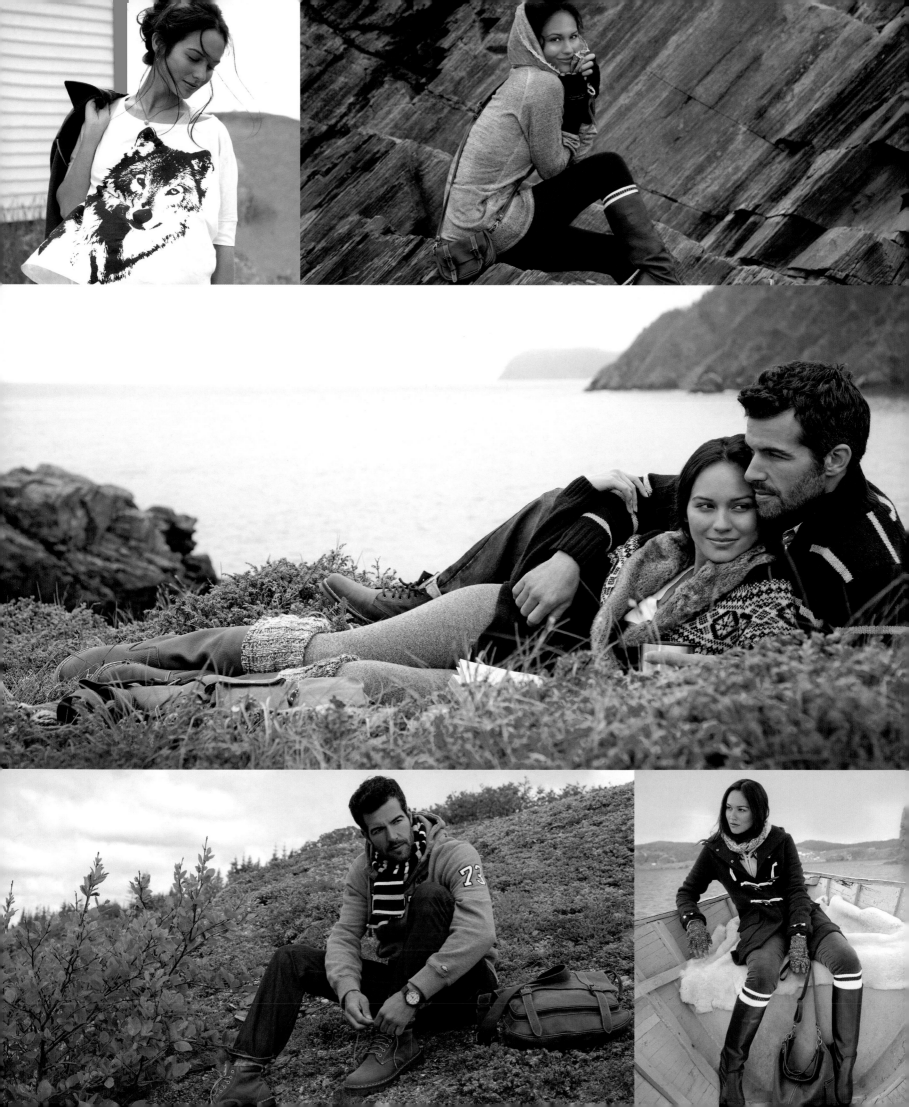

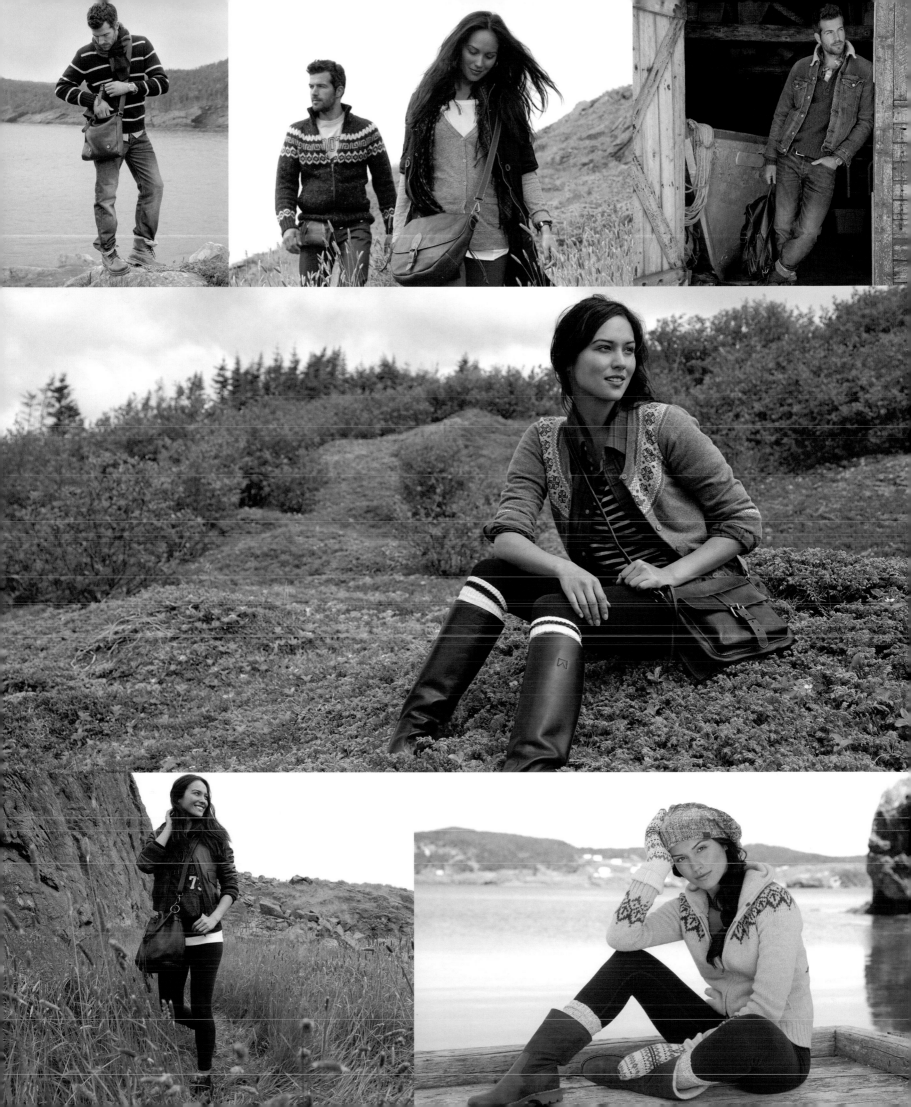

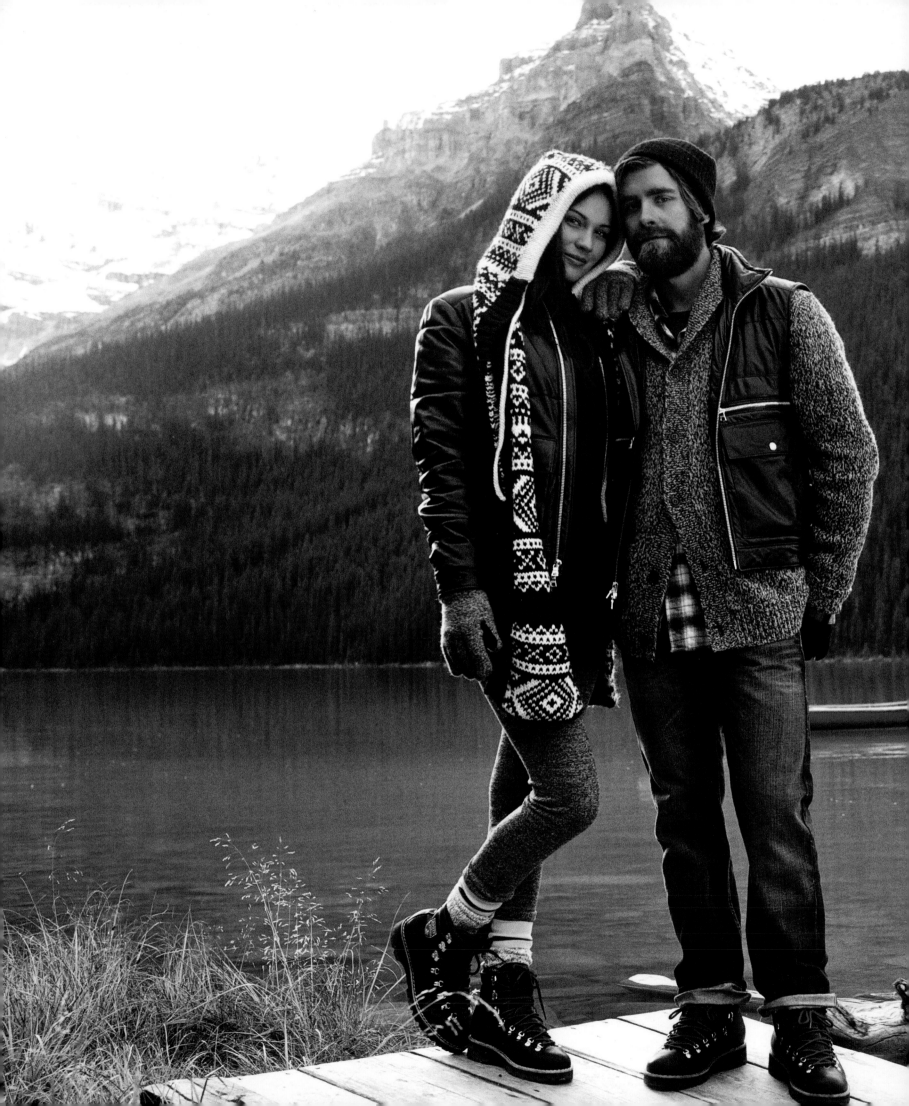

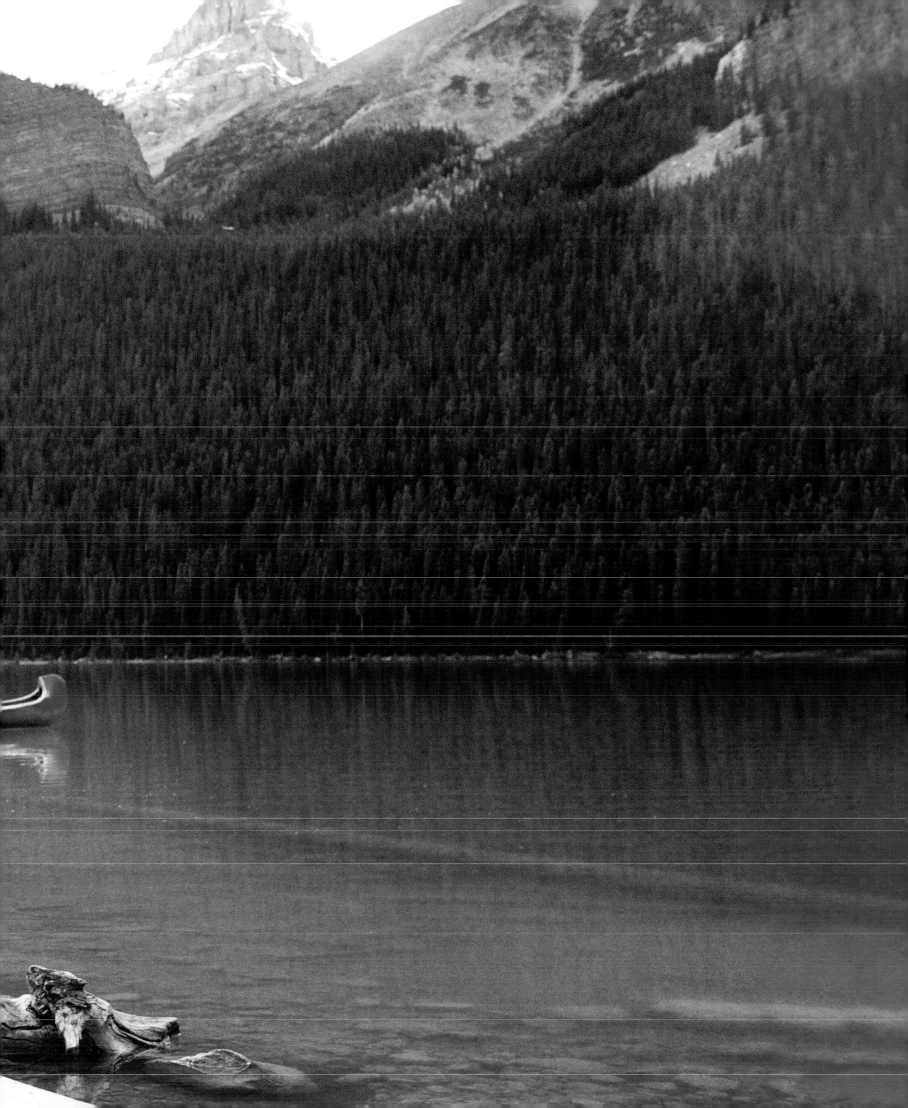

NOW

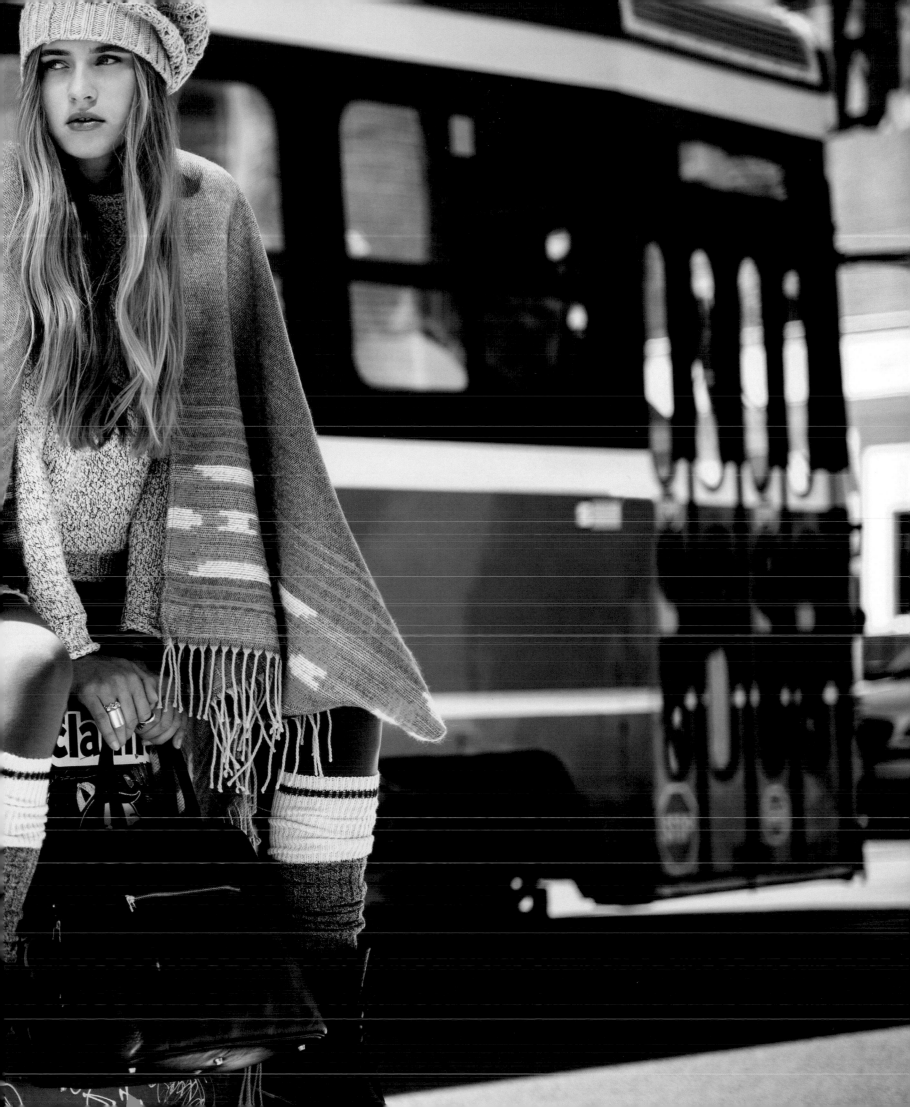

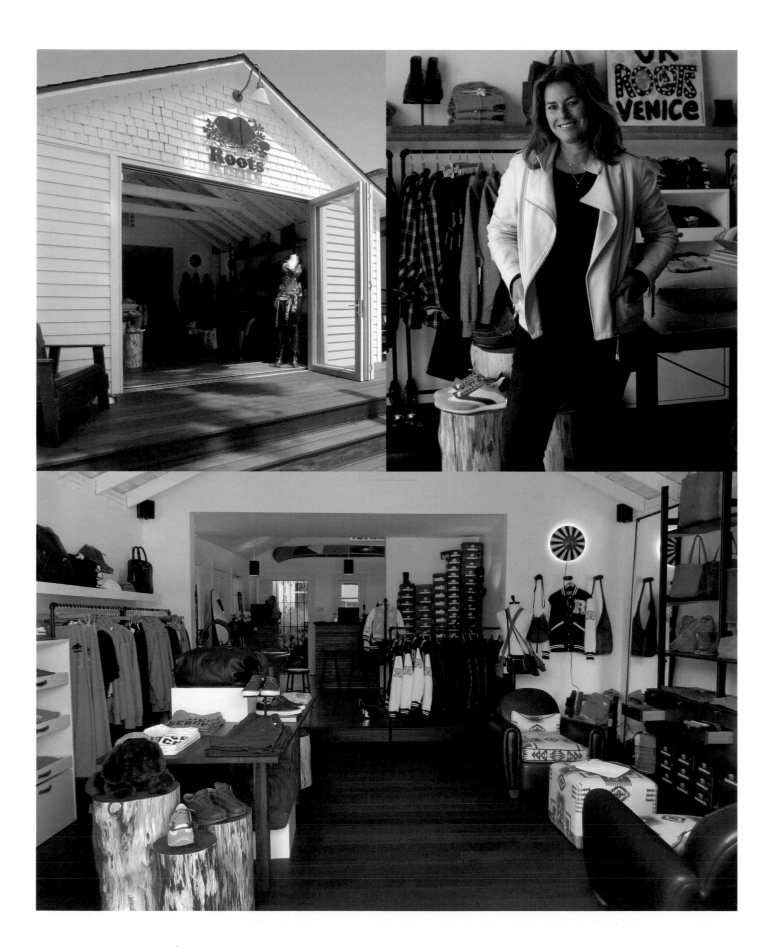

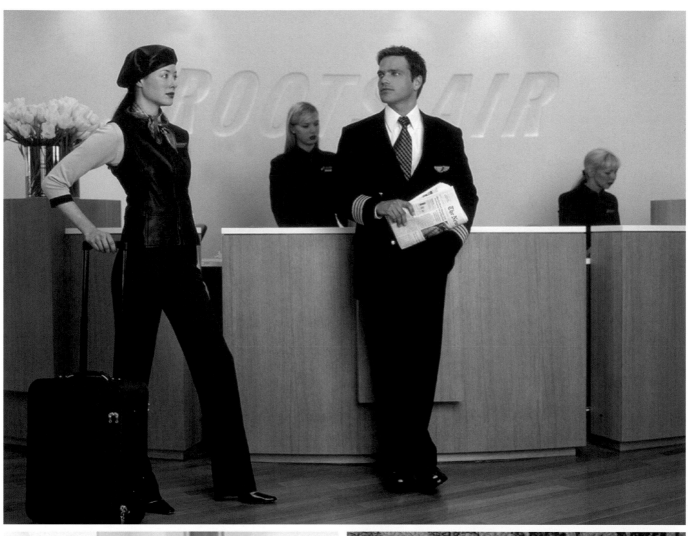

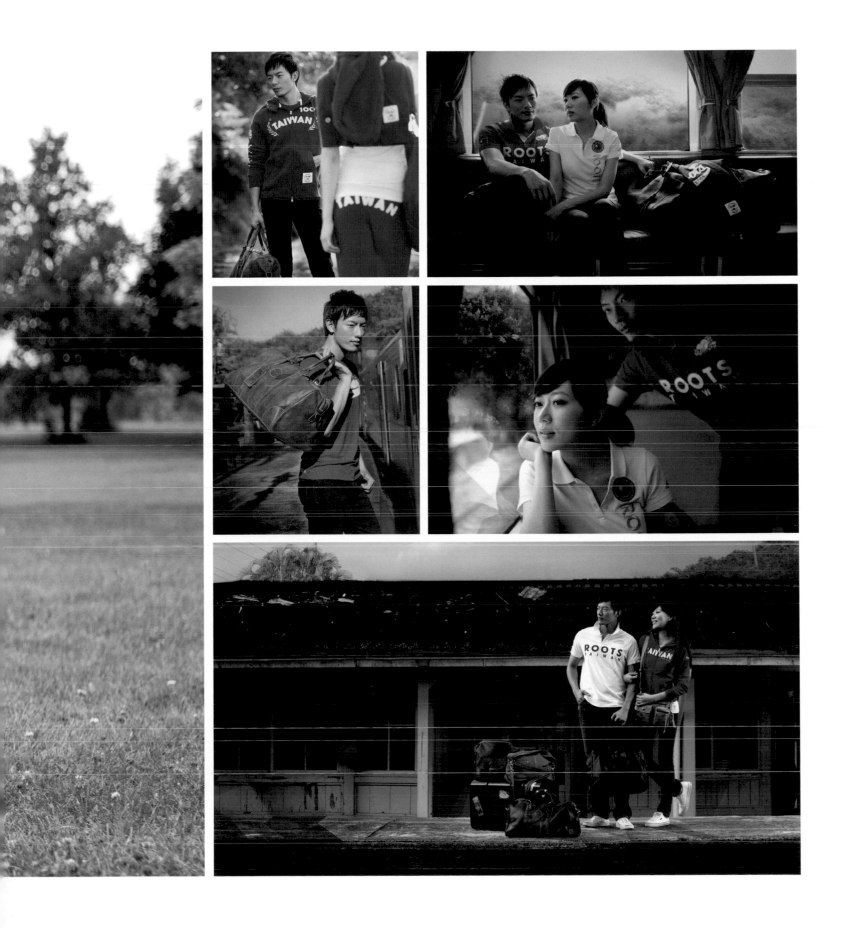

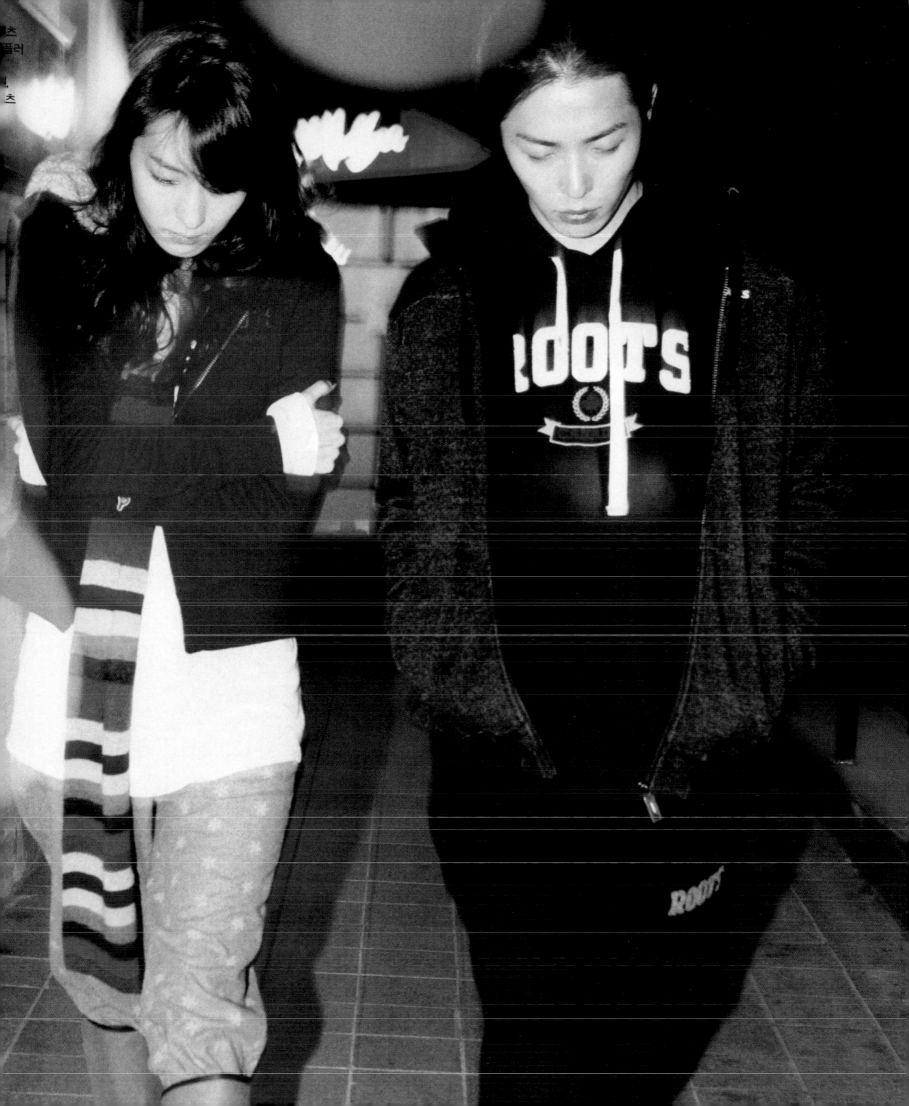

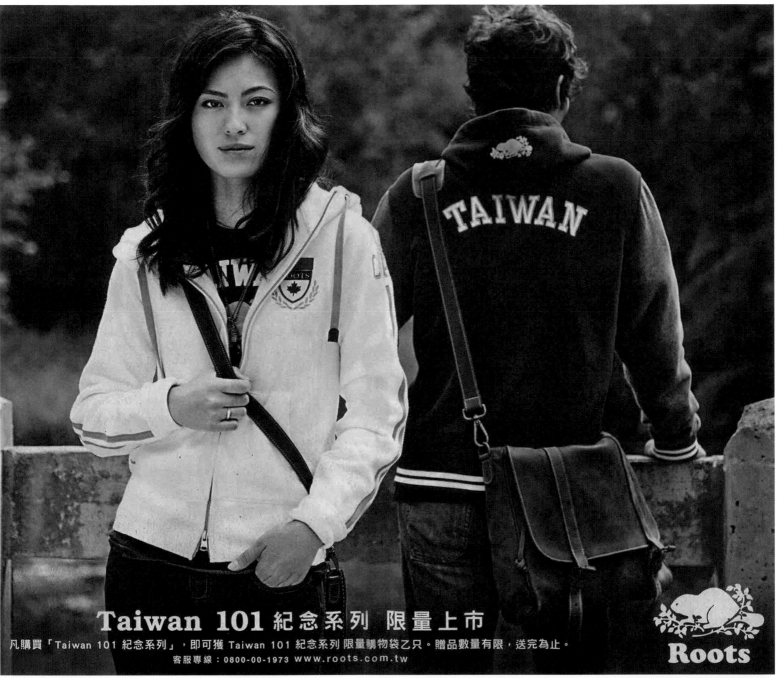

Taiwan 101 紀念系列 限量上市

凡購買「Taiwan 101 紀念系列」，即可獲 Taiwan 101 紀念系列 限量購物袋乙只。贈品數量有限，送完為止。
客服專線：0800-00-1973 www.roots.com.tw

Roots

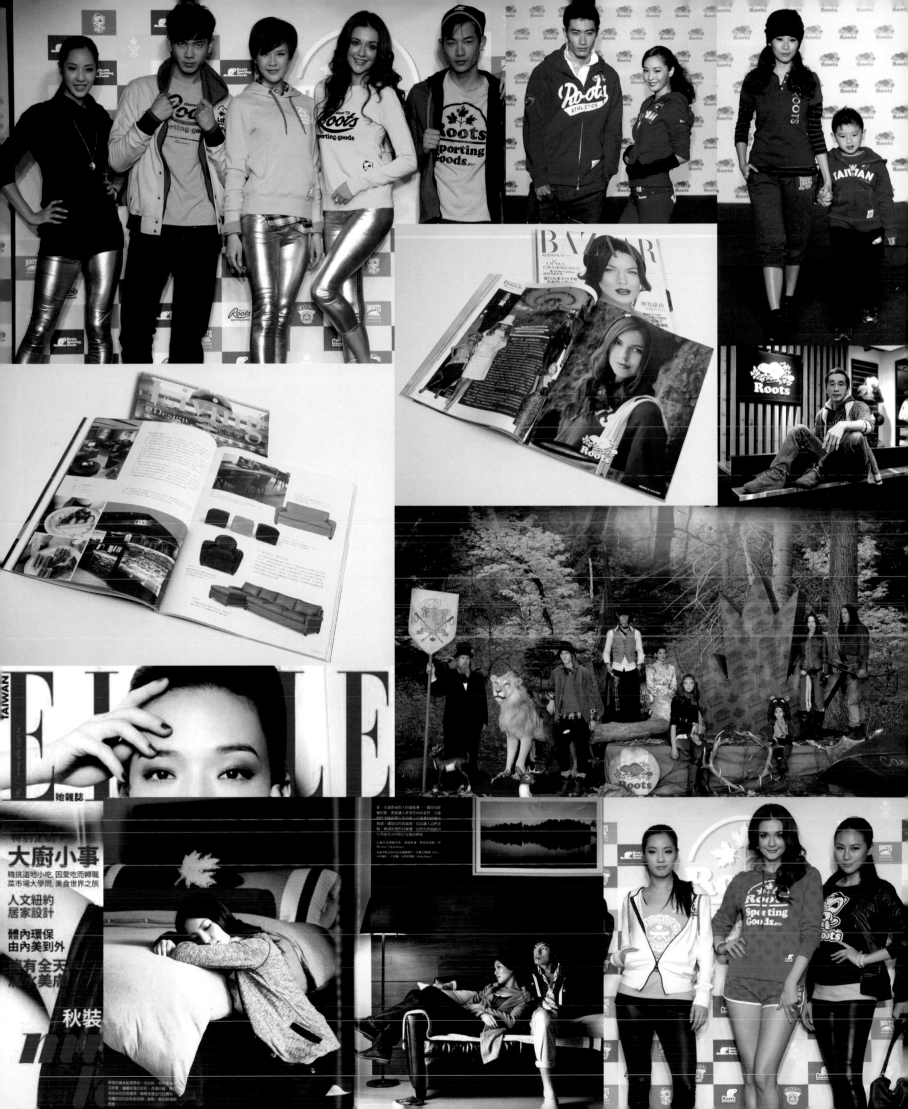

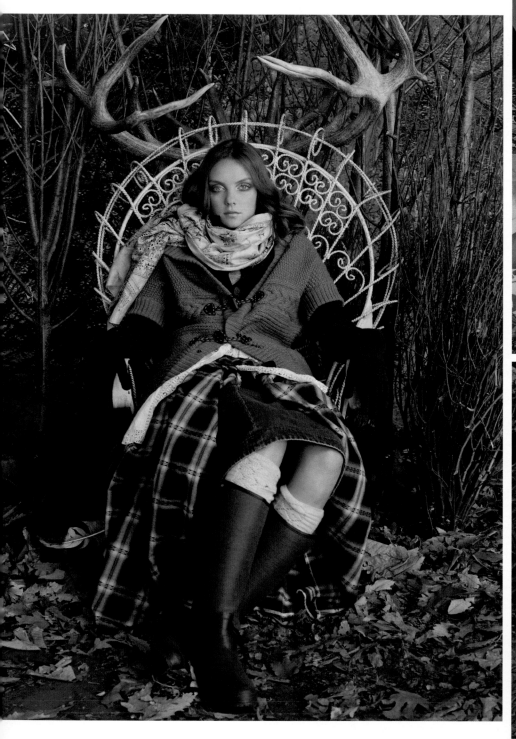
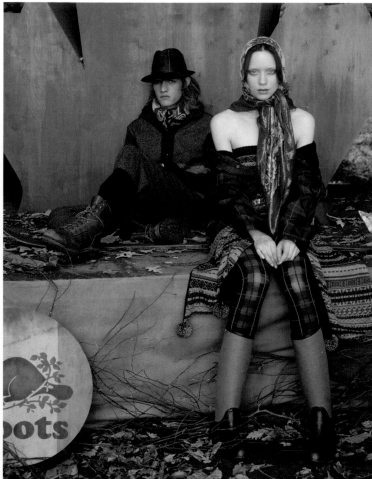
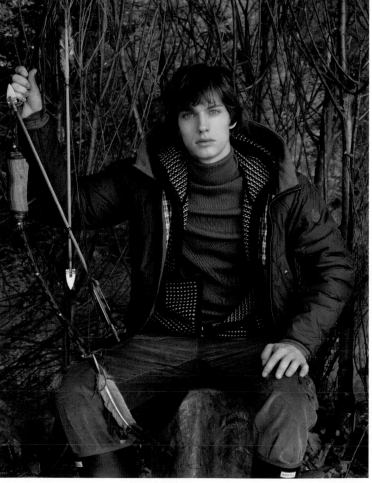

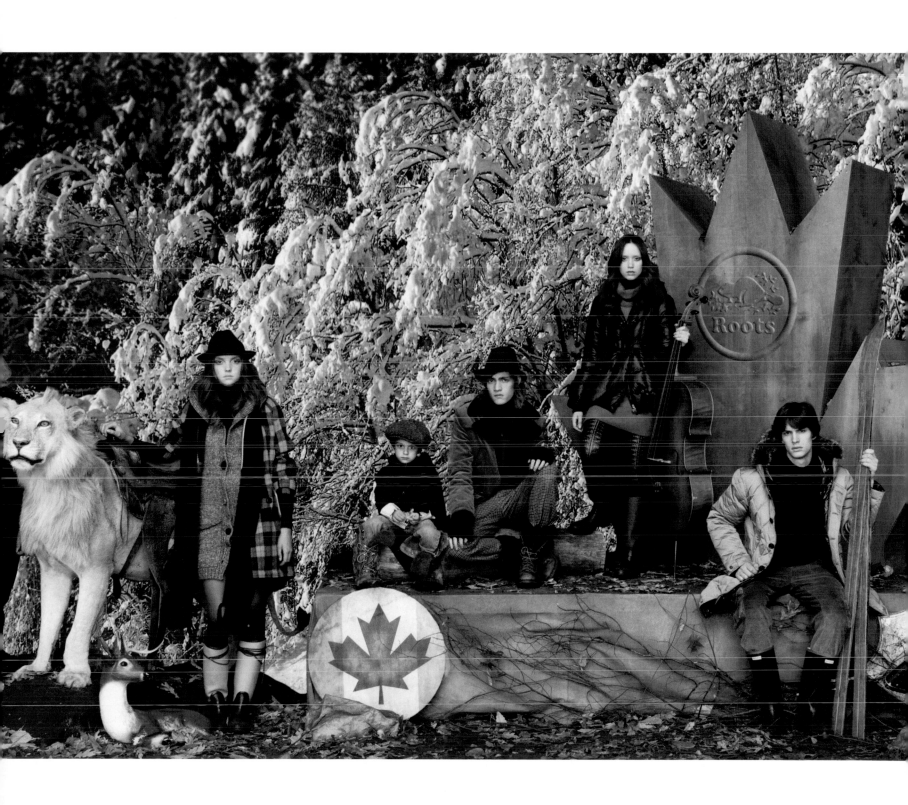

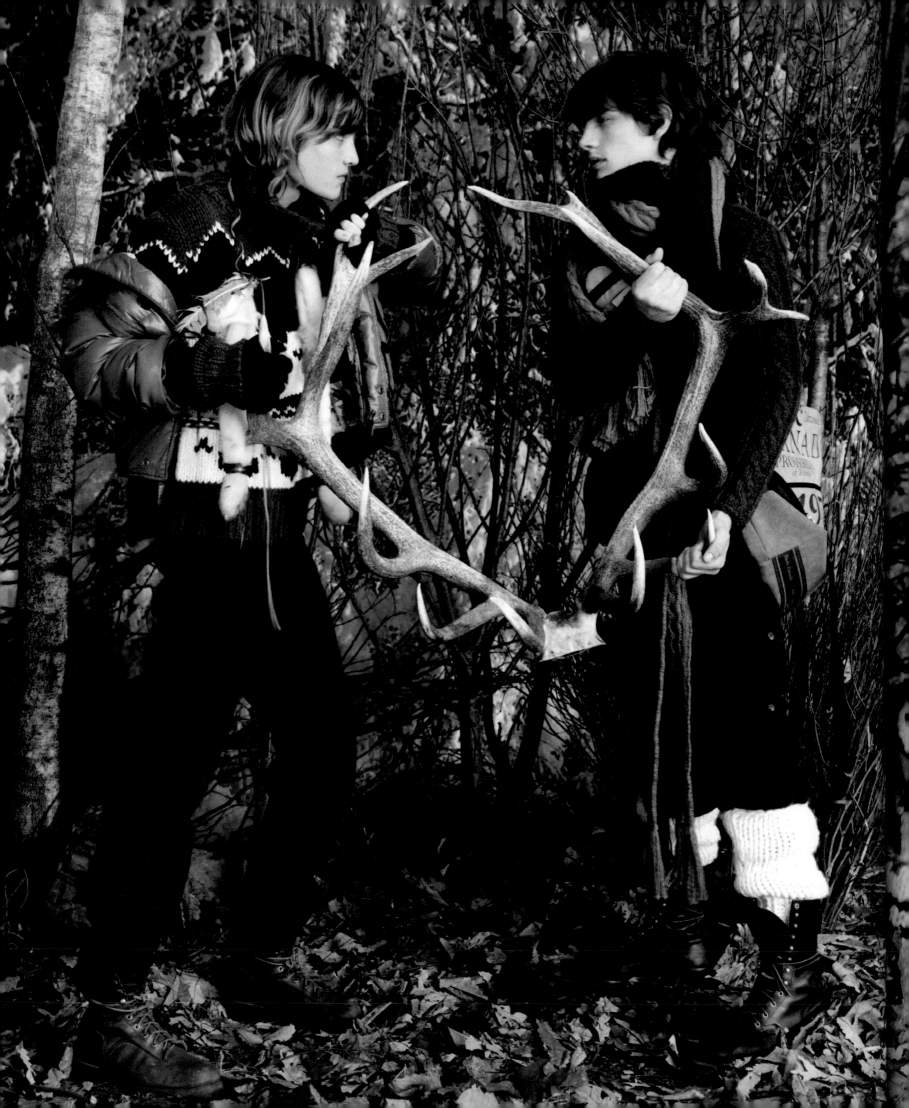

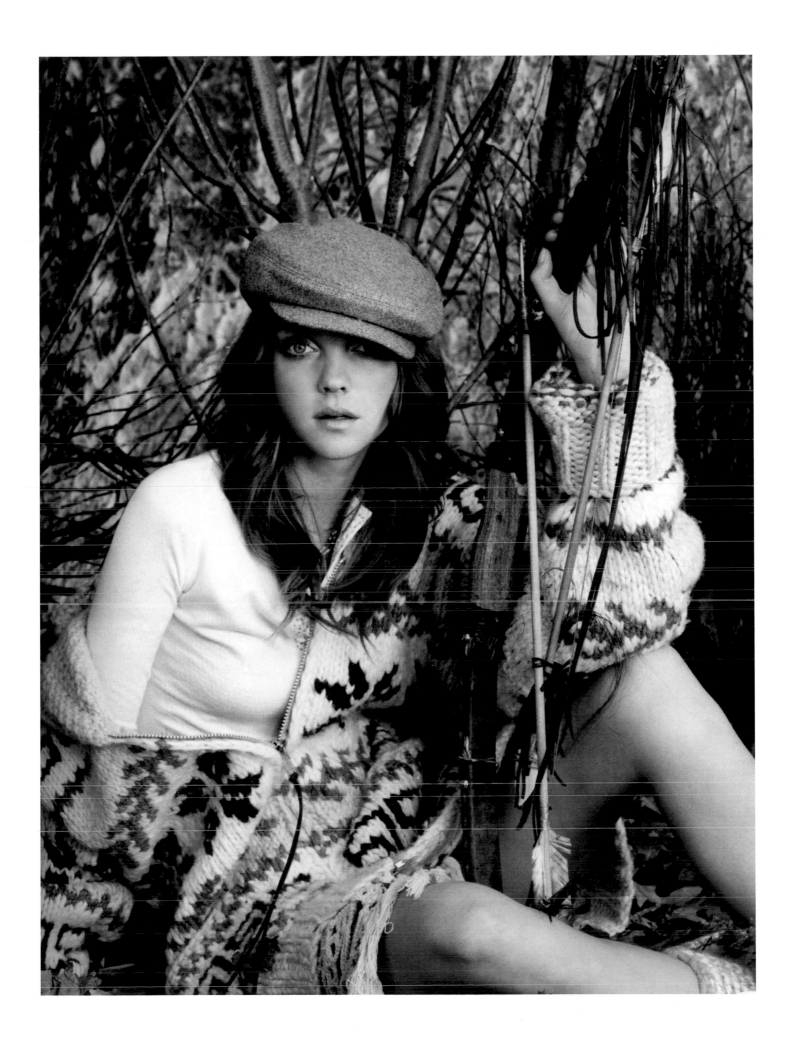

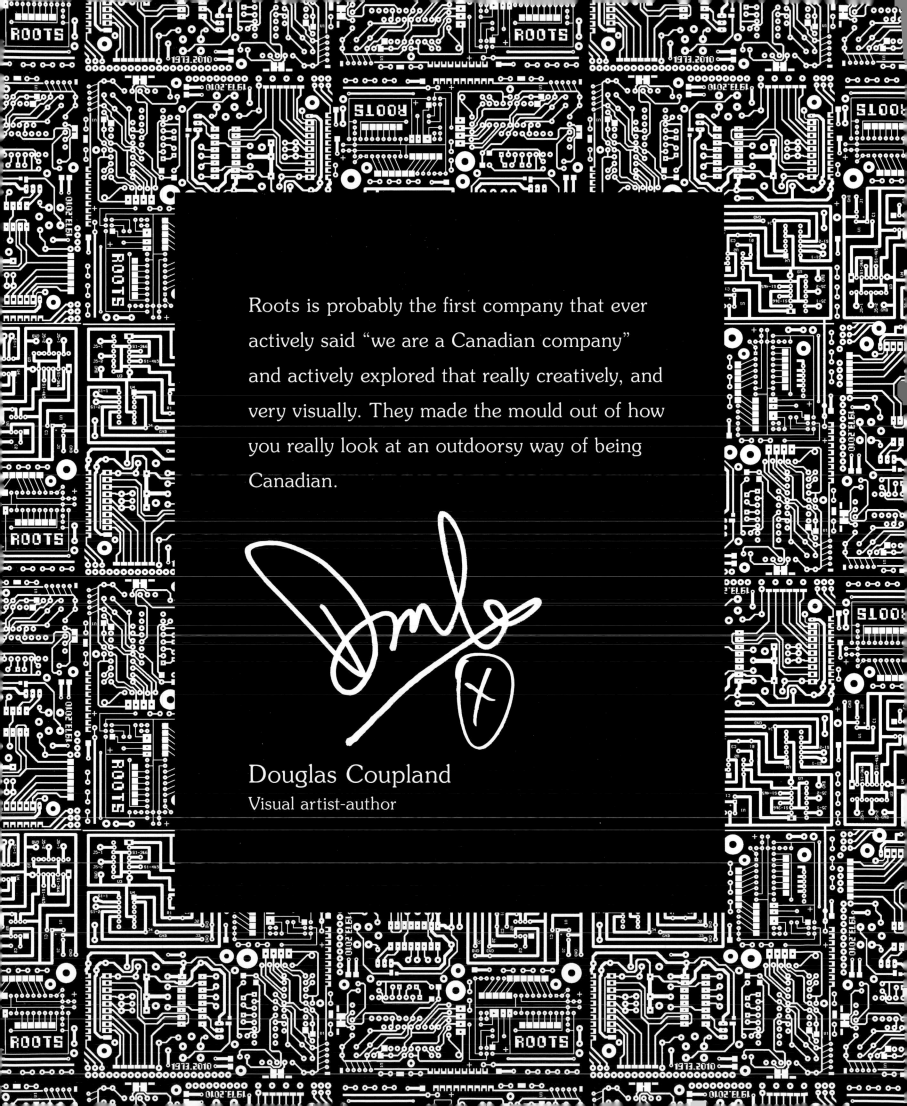

Roots is probably the first company that ever actively said "we are a Canadian company" and actively explored that really creatively, and very visually. They made the mould out of how you really look at an outdoorsy way of being Canadian.

Douglas Coupland
Visual artist-author

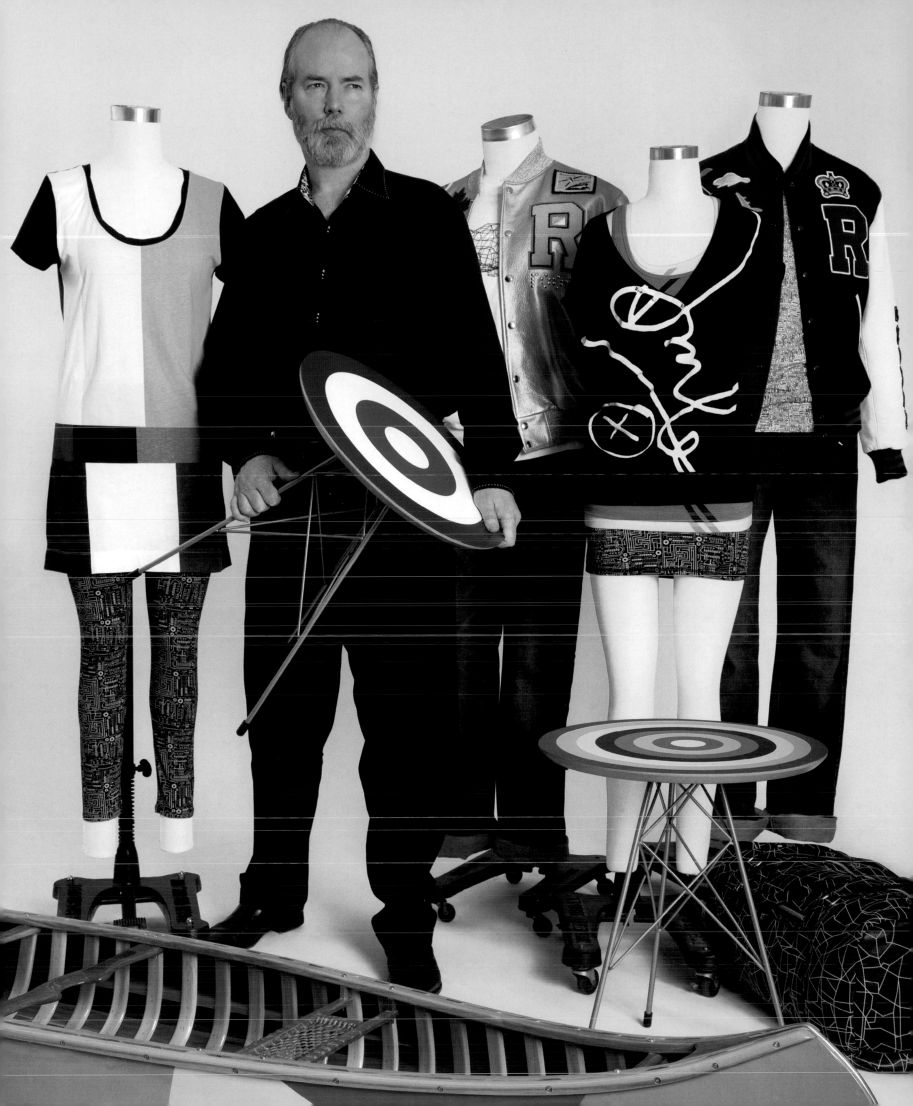

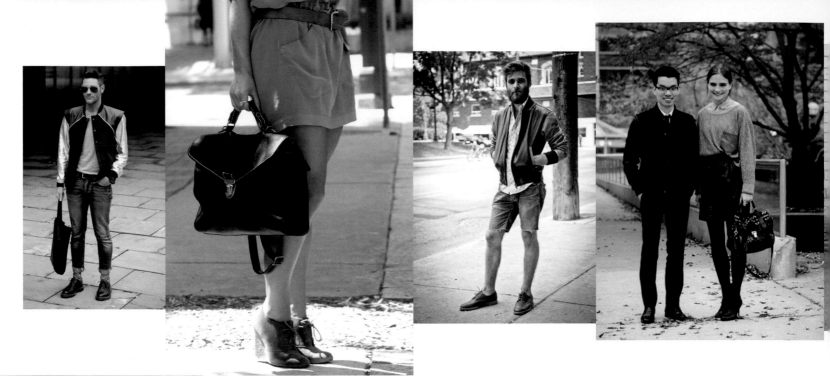

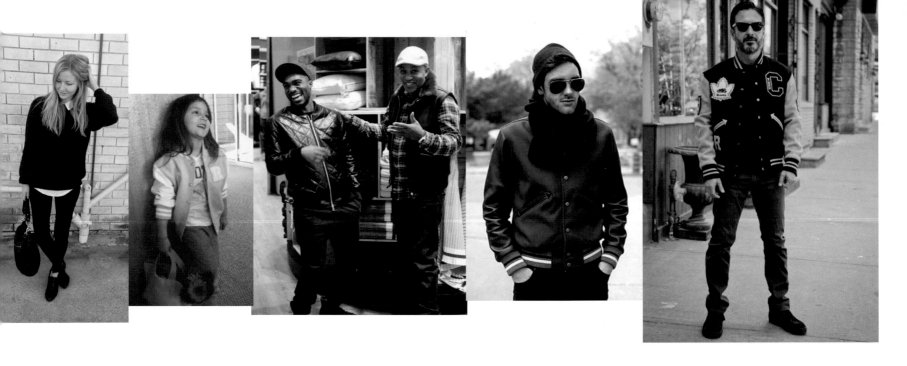
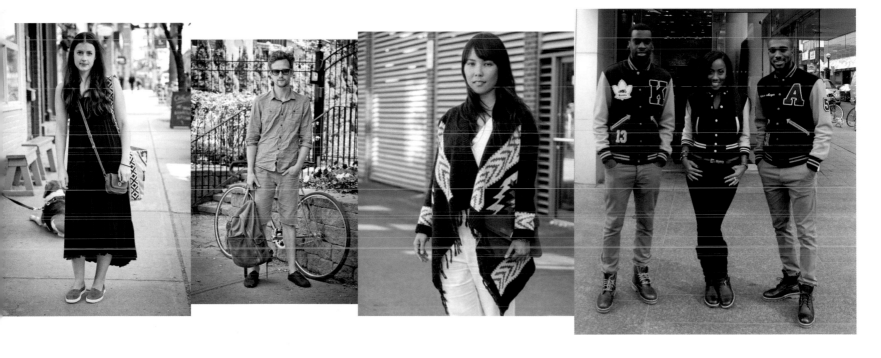
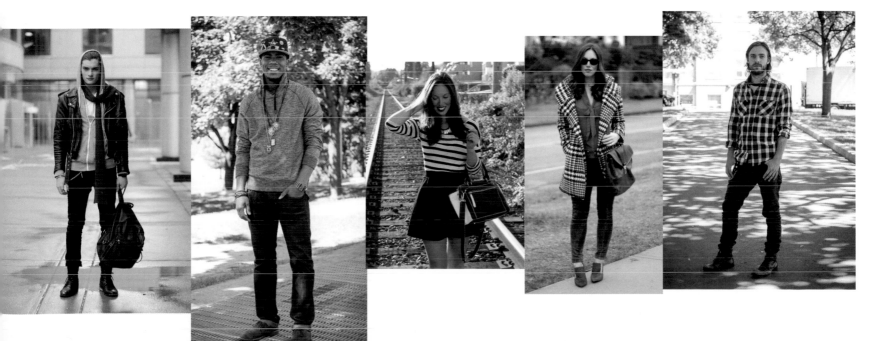

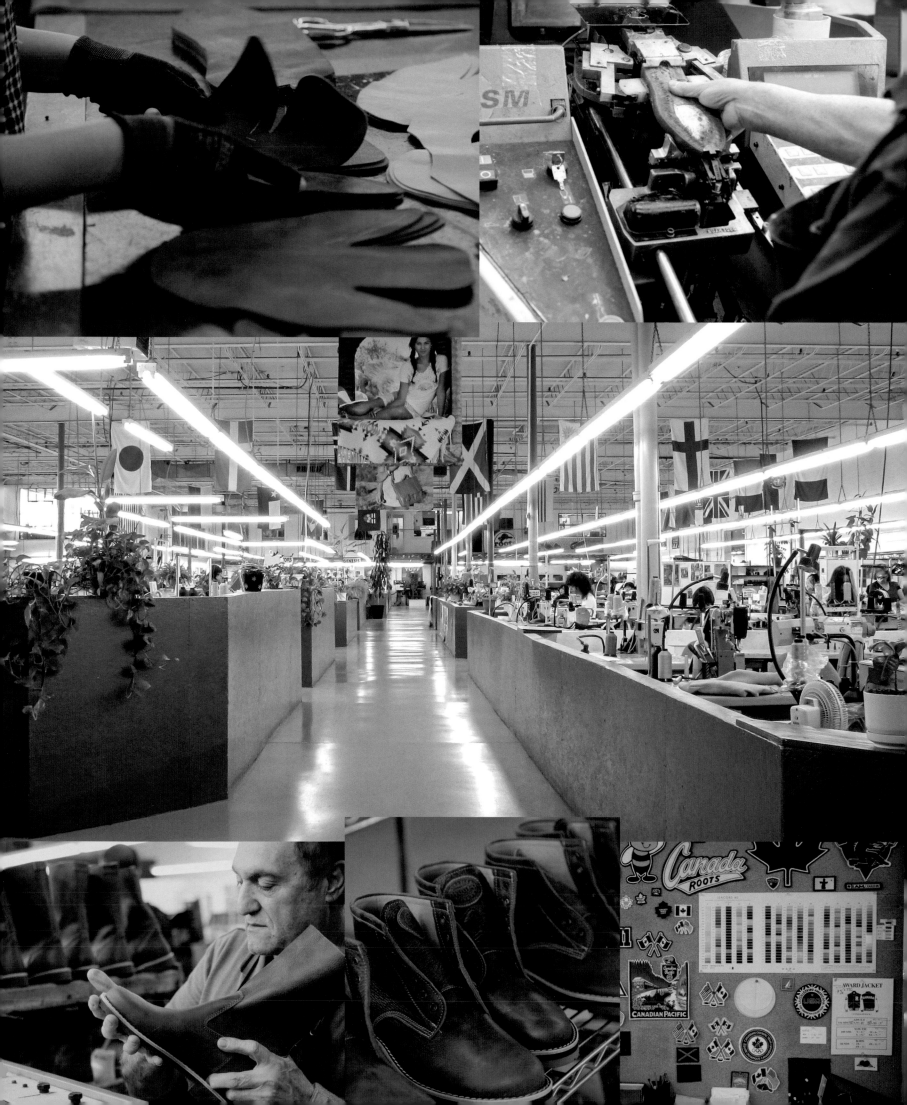

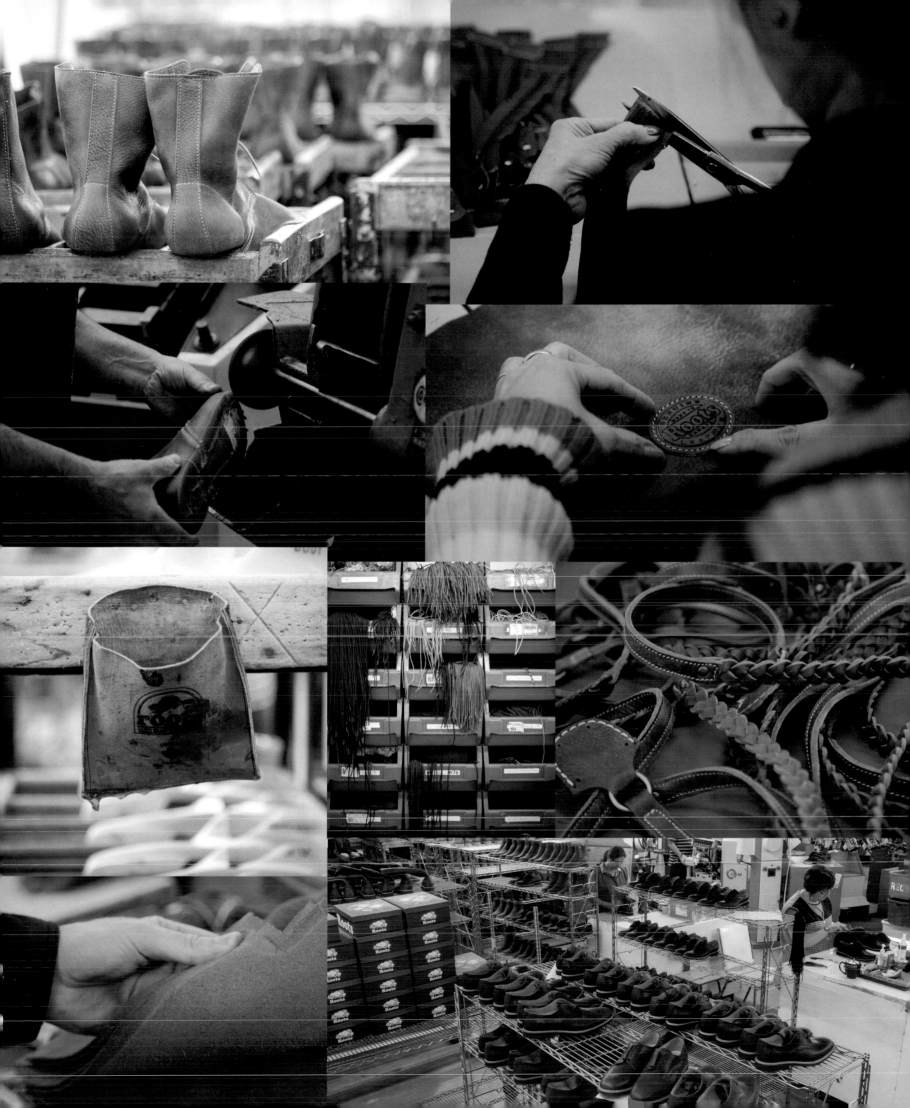

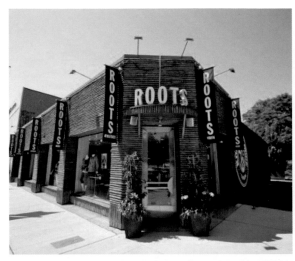

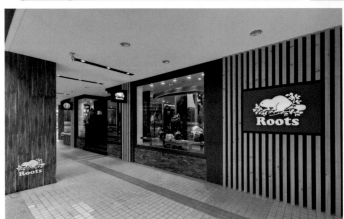
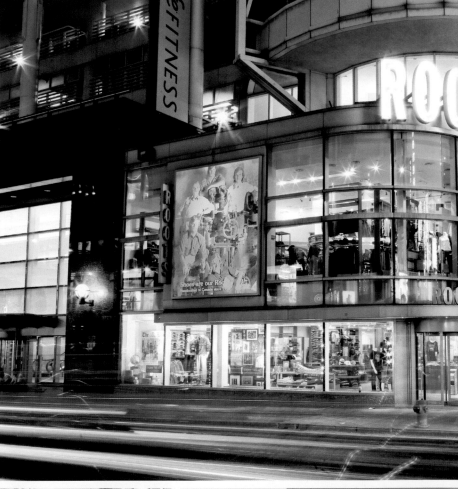

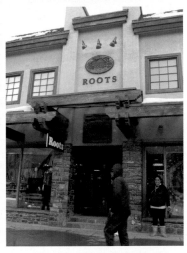

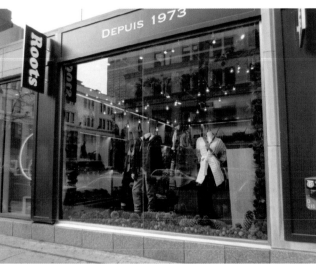

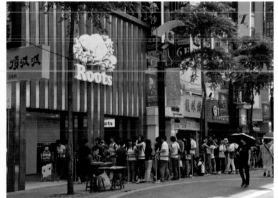

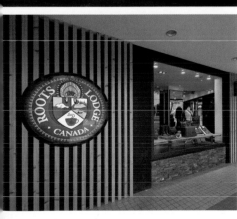
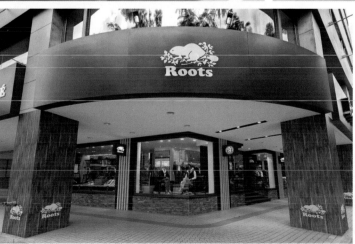

The True Essence of Roots

By Dan Aykroyd

In the forty years since Roots was founded, the company has established far more than its bestselling lines of personal apparel, products, housewares, and accessories. The Roots brand has succeeded in striking a nerve in consumers not only in Canada but in many places around the world. The essence of this stimulation goes beyond how people have embraced the company's fashions, recognized for their indisputable quality and unmistakable visual appeal.

The element that has most driven the success of Roots is the sense of personal identification that people have with the merchandise. For Canadians, taking home an item from Roots means owning a piece of their country in a very tangible way. For the global customer, it means owning a token from one of the planet's most respected and influential nations.

The American-born founders of Roots, Michael Budman and Don Green, perceived the unique and overwhelmingly appealing value of life in Canada when they came up from Michigan to its dark granite lakes and deep green forests as summer campers. Of course, Michigan has a historic kinship with its northern neighbour, rooted in common ties to the New France founders-explorers Champlain, La Salle, Marquette, and Cadillac. But it was golden days and star-strewn moonlit nights in Algonquin Park that infused the boys with the heart of the country where they would choose to settle, marry their magnificent Canadian women, Diane and Denyse, and together raise their respective families.

If I know one thing about success in any project it is that it must have heart. Be it a television sketch, a song, or a film, if its creators are able to connect to people in a genuine manner, success will always follow. Since its inception Roots has embodied Canada's heart in everything it manufactures and sells to consumers.

When you buy a Roots product for yourself or as a gift, you recognize that your purchase conveys the spirit of distinctly Canadian joy. This joy is embodied in wintery nights on a neighbourhood hockey rink, wearing a Roots hooded garment against the cold; by a smoky summer campfire near a lake or river with a Roots sweatshirt keeping you warm; in the texture and colour of a Roots-made varsity jacket when students go back to school on an autumn day. It is the satisfaction of taking home a leather bag or a pair of boots when the Canadian spring thaws the winter, and knowing you will have and use the item for years.

Roots now occupies a place in Canadian culture as iconic as the country's reputation in international peacekeeping and crime fighting, its accomplishments in industry and science, and its contributions to the arts and sport. Canadians verify this everyday when they walk into a Roots store; people from the rest of the world confirm it when they buy Roots products. It is this essence that truly distinguishes the company from all other manufacturers and retailers.

Congratulations, Roots, on forty years of successes and breakthroughs. Your existence has made our country all that more great.

Dan Aykroyd, CM, DLitt (h.c.)

Roots enthusiast and supporter since 1973

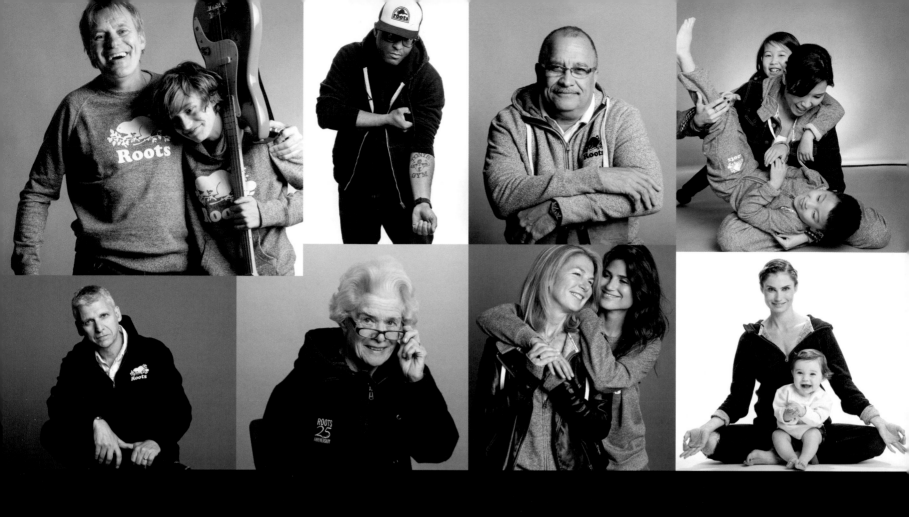

TEAM SPIRIT

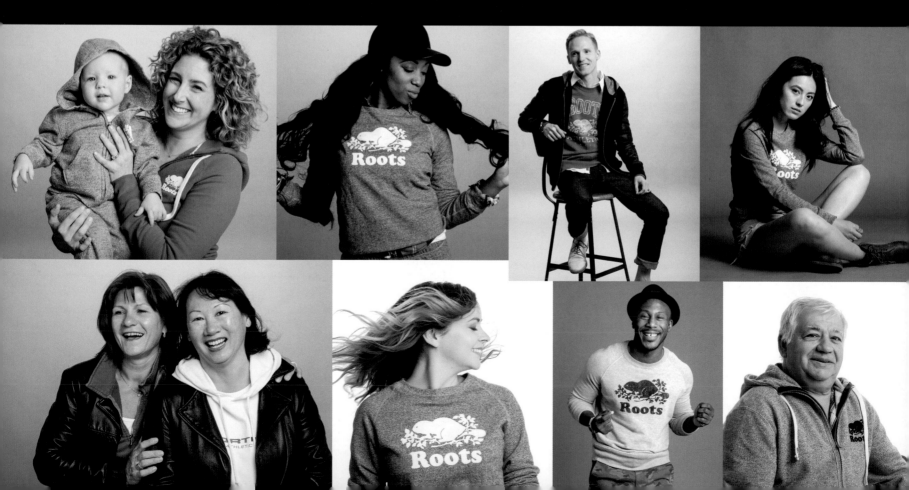

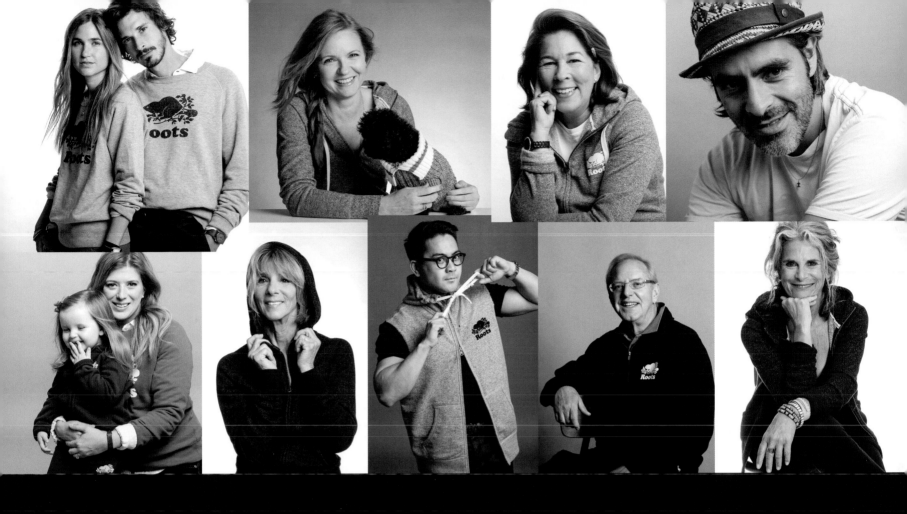

The evolution of Roots is based on a strong sense of collaboration. Since its inception in 1973, Roots has always attracted highly talented, dedicated men and women of diverse backgrounds who connect with the style and progressive ethos of the company — and have been vital to its success.

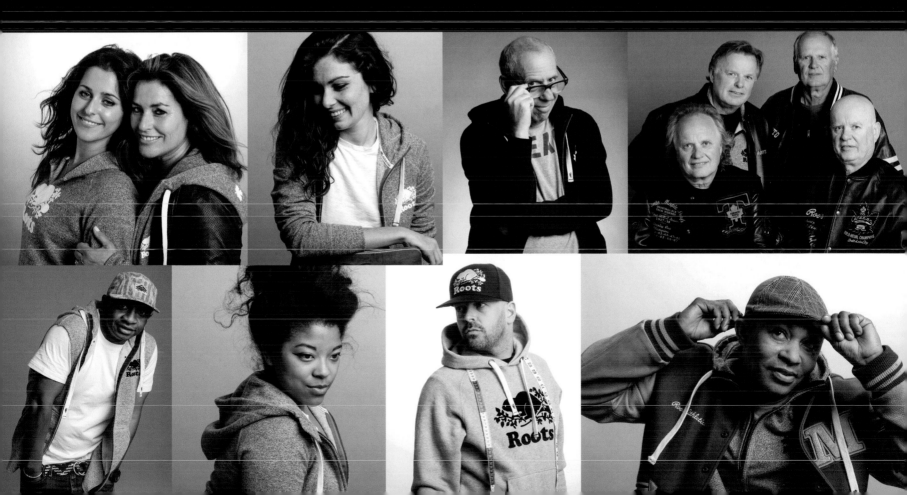

A Forty-Year Journey

Michael Budman and Don Green first met as teenagers in Detroit, and became close friends through summers spent together at Camp Tamakwa in Algonquin Park. Both decided to move to Toronto after attending university and wanted to develop a business partnership. In 1973, Roots was born. Here are some of the company's most memorable milestones.

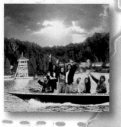

1976
The company introduces their now famous leather bags. Customers may be helped by future *Saturday Night Live* star Dan Aykroyd who is known to pitch in around the first store.

1981
Tamakwa co-founder Omer Stringer and Roots team up to create Beaver Canoe, a joint venture making canoes, clothing, and other outdoor items.

1988
After the Jamaican bobsled team arrives in Canada for the Calgary winter Olympics without any winter wear, Roots designs and makes their team jackets and clothing. The story is made famous by the 1993 hit movie *Cool Runnings*, starring John Candy.

1993
Roots designs and makes much of the clothing for *Indian Summer*, directed by former Tamakwa camper Mike Binder, and starring Alan Arkin, Bill Paxton, and Kevin Pollak. Much of the film is based on the Roots co-founders' experiences at Tamakwa.

1997
Roots expands into Asia, opening stores in South Korea, Taiwan, and Hong Kong, in addition to its existing presence in Japan.

1973
Roots bursts onto the fashion scene with the Negative Heel Shoe. Within a year, the company goes from producing 400 to 1,200 pairs of shoes per day.

1980
Richard Gere wears Roots Jazz Oxford shoes in *American Gigolo*, the company's first — but certainly not last — major foray into Hollywood.

1985
Roots Beaver Athletics sweatshirt launches. It becomes one of the bestselling garments ever made in Canada.

1992
The introduction of the Tuff Boot: a durable winter boot that becomes an instant sensation.

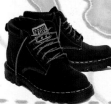
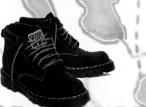

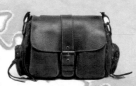

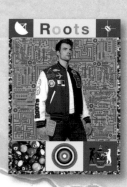

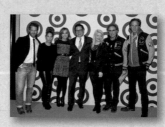

1998
The company begins its formal Olympic involvement, outfitting the Canadian team in items that become highly coveted for the Winter Games in Nagano, Japan. The red poorboy cap dominates Olympic coverage — even the princes of England (Charles, William, and Harry) can't resist owning one.

2001
In partnership with Skyservice, Roots launches Roots Air. The company designs the staff uniforms and departure lounges. Eventually Roots Air merges with Skyservice, which becomes a successful charter airline.

2005
The Emily Bag becomes the bestselling handbag in Roots history. Its success contributes to the huge resurgence of Roots leather goods.

2010
"Canada Goes Electric" as Roots and Douglas Coupland team up to launch a special line of clothing and furniture.

2013
American department store Target taps Roots as its first limited-time-offer partner for a sweatshirt line for their Canadian launch. A wider line of clothing and home items under the Beaver Canoe name quickly follows.

1999
Roots.com officially launches at a star-studded event at the Toronto Eaton Centre store, selling a wide selection of leather goods, sweats, and footwear. A grandmother from Nova Scotia places the first order on the site.

2002
The Roots beret worn by American athletes at the Salt Lake City Olympic Games takes the U.S. by storm. More than a million berets are sold.

2009
Zach Galifianakis's character Alan wears a Roots Village Bag in the monster hit *The Hangover* claiming, "It's not a man purse, it's called a satchel. Indiana Jones wears one." Sales take off.

2012
By year's end, Roots hits a total number of stores in Asia at 88, a lucky number in Chinese culture, with 14 stores in China and 74 stores in Taiwan.

.com

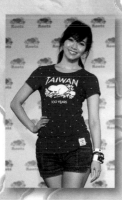

What began as one store in Toronto, Ontario, with one employee has grown into a 1,500-plus operation with more than two hundred stores in four countries. Michael Budman and Don Green never dreamed that their company would expand to sell quality leather goods, athletic wear, yoga wear, accessories, and home furnishings, and become an internationally recognized iconic Canadian brand.

Front jacket: Roots Co-founders Don Green and Michael Budman, University of Toronto, Ontario, 1979

Back jacket: *The Roots Beaver*, painting by Heather Cooper, 1976

Roots logo, originally designed by Heather Cooper and Robert Burns, 1976

Left: Potter Creek, Algonquin Park, Ontario, 1993

Right: Company mission at the Roots head office, Toronto, Ontario, 2013

(Background) Smoke Lake, Algonquin Park, Ontario, 2009

(Background) Smoke Lake, Algonquin Park, Ontario, 2009; (Foreground) Suzanne Boyd, Bonita Lake, Algonquin Park, Ontario, 1998

(Background) Molly's Island, Smoke Lake, Algonquin Park, Ontario, circa 1990

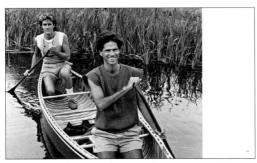

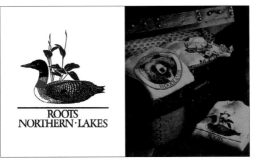

(Background) Matthew's Point, Smoke Lake, Algonquin Park, Ontario, circa 1993; (Foreground) Michael and Don, Toronto, Ontario, 2013

Michael and Don, Algonquin Park, Ontario, 1983

L: Northern Lakes logo designed in 1986

R: Sweatshirts from the Northern Lakes & Woodland collection, 1986

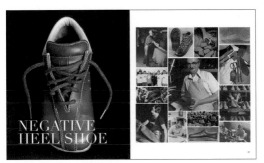

L: *The Roots Beaver*, painting by Heather Cooper, 1976. The image appeared in two different Roots posters, one in 1976 and the other in 1986

R: Roots Saddle Soap designed in 1976

L: Sport Root Negative Heel Shoes designed in 1973

R: (Clockwise from top left) drying hides, 1974; Algonquin Root Negative Heel Boots, 1974; Cutting the leather, 1974; Open Root Negative Heel Sandals designed in 1974; Designing a Roots shoe, 1974; Checking production, 1985; Henry Kowalewski at a sewing machine, 1973; (Top image) Roots leather factory, 1985; (Bottom image) Sport Root Negative Heel Shoes designed in 1973; Jan Kowalewski, master shoemaker, sketching, 1980; Buffing the hide, 1974; Stitched uppers, 1985; Jan's retirement party with Albert Budman and the Kowalewski brothers, 1985; (Centre image) Jan lasting a Roots shoe, 1974

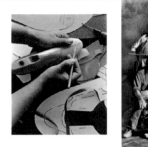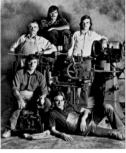

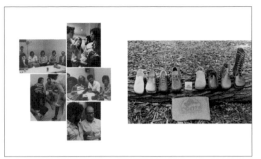

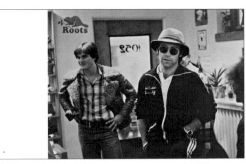

L: Designing a Roots shoe, 1979

R: (Clockwise from top left) Jan Kowalewski, master shoemaker, and his sons Richard, Henry, Karl, and Stanley, Toronto, Ontario, 1974

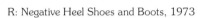

L: First Roots franchise meeting, circa 1975 (clockwise from top left): Jan Kowalewski and his sons; Don with franchisees; Michael and Don with franchisees; Michael with Irwin Green; Don modelling shoes

R: Negative Heel Shoes and Boots, 1973

Karl Kowalewski (left) with singer-songwriter Elton John at the original Roots store, 1052 Yonge Street, Toronto, Ontario, circa 1974

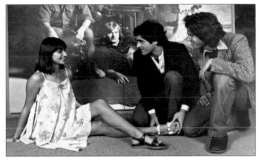

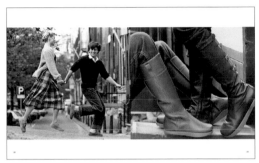

Model with Michael and Don at the Roots store in Amsterdam, the Netherlands, 1975

L: First Roots employee, Denyse Green, holding the Sport Root Negative Heel Shoe, Toronto, Ontario, 1974

R: "City Feet Need Roots," first Roots national advertising campaign in Canada, 1974

L: Negative Heel Shoe advertisement, Amsterdam, the Netherlands, circa 1975

R: Negative Heel Boots advertisement, circa 1975

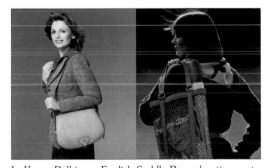

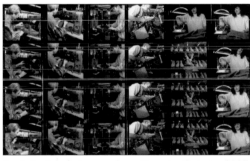

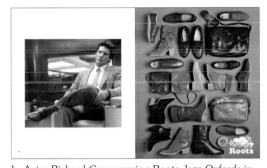

L: Karen Bell in an English Saddle Bag advertisement, 1976

R: Roots Net Bag advertisement, 1976

Roots leather factory workers, Toronto, Ontario, 1985

L: Actor Richard Gere wearing Roots Jazz Oxfords in the movie *American Gigolo*, 1980

R: Roots leather advertisement, circa 1980

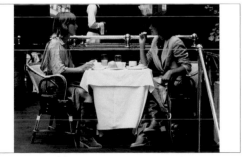

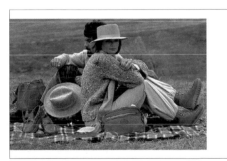

L: Canadian Prime Minister Pierre Trudeau with Michael and Don outside Parliament, Ottawa, Ontario, 1976

R: Actor-comedian John Belushi with Don at the Roots Beverly Hills store opening, California, 1979

Denyse Green (left) eating breakfast with a friend at the Courtyard Café in the Windsor Arms Hotel, Toronto, Ontario, circa 1979

Roots advertisement, circa 1976

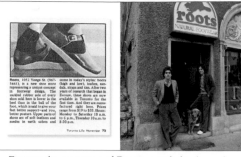

L: First media coverage of Roots; article by Anne Apor in *Toronto Life*, November 1973

R: Michael, Don and his dog, Philippe, at the original Roots store in Toronto, Ontario, 1973

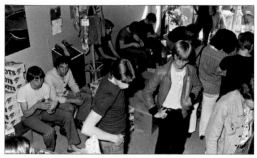

Roots store in Amsterdam, the Netherlands, circa 1976

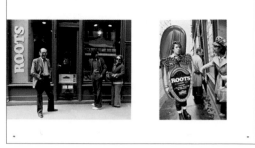

L: (From left to right) Irwin, Don, and Bethea Green in front of the Roots store in Paris, France, 1976

R: Man wearing a Roots sandwich board in front of the Roots store in Paris, France, 1976

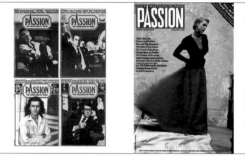

L: *Paris Passion* covers (clockwise from top left): Andrée Putman, 1982; Karl Lagerfeld, 1982; Yves Saint Laurent, 1983; Bernard-Henri Lévy, 1983

R: Model on the cover of *Paris Passion*, 1986

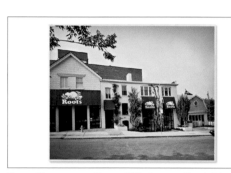

Roots Department Store, 195 Avenue Road, Toronto, Ontario, 1983

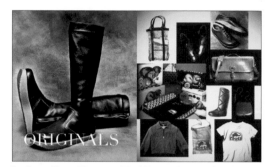

L: Snow Root Negative Heel Boots designed in 1974

R: (Clockwise from top left) Net Bag designed in 1976; Jazz Oxfords designed in 1976; Sport Root Negative Heel Shoes designed in 1973; School Bag designed in 1976; (Left) Puff Boot designed in 1974; (Right) English Saddle Bag designed in 1976; First T-shirt designed in 1974; Burlap bag designed in 1973; Fringe Jacket designed in 1987; Roots packaging, shoe care, and products, 1987

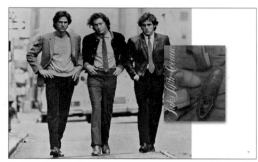

L: (From left to right) Don, Marcus O'Hara, and Michael pose for Saks Fifth Avenue advertisement, New York, New York, 1979

R: Saks Fifth Avenue advertisement for the *New York Times*, 1979

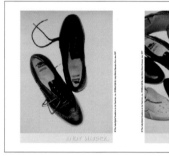

L: Andy Warhol, Spectator Root advertisement, *Interview* magazine, circa 1977

R: Andy Warhol, Roots Footwear advertisement, *Interview* magazine, circa 1977

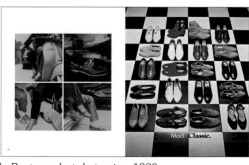

L: Roots product shots, circa 1980

R: Roots Mod Classic advertisement, 1980

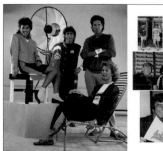

L: (From left) Diane Bald, Michael, Don, and Denyse Green in a photograph for a *Toronto Star* article, 1985

R: Top row: Don and Michael at work in a phone booth, Algonquin Park, Ontario, circa 1988; (From left) Diane Bald, Michael, artist-photographer Jean-Paul Goude, model Farida Khelfa, and friend, Paris, France, 1983; Albert Budman and Michael, circa 1984. Middle row: Actor-comedian John Candy with Michael at the Roots Beverly Hills opening, California, 1979; (From left) Michael, Don, president of the Montreal Canadiens Ronald Corey, with hockey players Aurèle Joliat, Guy Lafleur, Jean Béliveau, and Maurice "Rocket" Richard at the *Les Canadiens* film premiere, Toronto, Ontario, 1985. Bottom row: Singer Tony Bennett with Michael at the *Les Canadiens* screening, Toronto, Ontario, 1985; (Top image) Don and Michael, Paris, France, 1983; (Bottom image) Denyse Green, Lyn Frankel, and Diane Bald at the Roots Beverly Hills opening, California, 1979

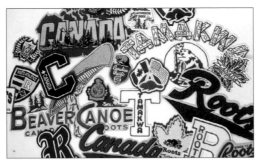

L: Advertisement for the launch of Baby Roots featuring Anthony Green, 1983

R: Norwegian Sweater designed in 1983

Assorted Roots Award Jacket crests, 1983–2013

(Background) Camp Tamakwa, South Tea Lake, Algonquin Park, Ontario, circa 1991; (Foreground) Don Standfield, Algonquin Park, Ontario, 2012

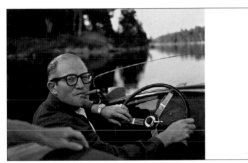

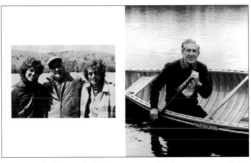

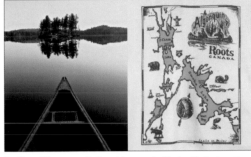

Lou Handler, co-founder of Camp Tamakwa, in Algonquin Park, Ontario, circa 1970

L: (From left to right) Don, master bush carpenter Felix Luckasavitch, and Michael in Algonquin Park, Ontario, circa 1990

R: Omer Stringer, legendary outdoorsman, canoeist, and co-founder of Camp Tamakwa, Algonquin Park, Ontario, 1983

L: Tom Thomson Lake, Algonquin Park, Ontario, circa 1985

R: Sweatshirt featuring a hand-drawn map of Algonquin Park by Omer Stringer designed in 1983

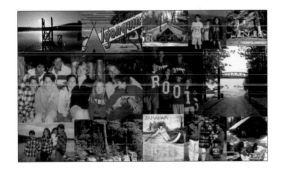

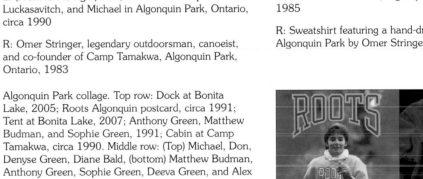

Algonquin Park collage. Top row: Dock at Bonita Lake, 2005; Roots Algonquin postcard, circa 1991; Tent at Bonita Lake, 2007; Anthony Green, Matthew Budman, and Sophie Green, 1991; Cabin at Camp Tamakwa, circa 1990. Middle row: (Top) Michael, Don, Denyse Green, Diane Bald, (bottom) Matthew Budman, Anthony Green, Sophie Green, Deeva Green, and Alex Anne Budman, 1994; (Top) Don and Michael, (bottom) Anthony Green, Sophie Green, Matthew Budman, Deeva Green, Alex Anne Budman, 1995; Camp Tamakwa, circa 1995. Bottom row: Matthew Budman, Sophie Green, Alex Anne Budman, and Anthony Green, 1994; Budman cabin, Smoke Lake, circa 1990; Camp Tamakwa plaque of Michael as a canoe instructor, 1966; (From left) David Bale, Vic Norris, Michael, Alex Anne Budman, (in Michael's arms), and Matthew Budman, 1990; Rec Hall at Bonita Lake in Algonquin Park, circa 1996

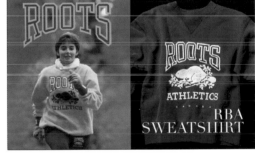

L: Postcard launching Roots Beaver Athletics (RBA), 1985

R: Roots 25th anniversary sweatshirt, designed in 1998

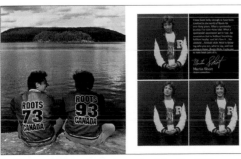

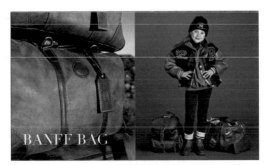

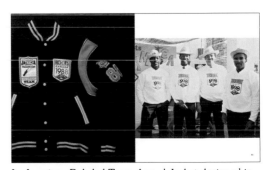

L: Don and Michael photographed for the 20th anniversary of Roots, Algonquin Park, Ontario, 1993

R: Actor-comedian Martin Short, 1986

L: Banff Bag designed in 1988. Photograph was part of the "Field Tested" campaign, Joshua Tree National Park, California, 2011

R: Sophie Green in a Roots advertisement, 1993

L: Jamaican Bobsled Team Award Jacket designed in 1988

R: Jamaican Bobsled Team at the Roots Department Store, Toronto, Ontario, 1988

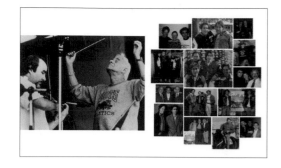

L: New York Philharmonic concertmaster and first violinist Glenn Dicterow (left) with conductor-composer Leonard Bernstein at the Concerts in the Park series, New York, New York, 1986

R: Top row: (From left) Don, Detroit Red Wings hockey legend Ted Lindsay, and Michael, circa 1999; Film directors Mike Binder (left) and Sam Raimi, 1993; Michael with Microsoft co-founder Paul Allen at the Superbowl, Detroit, Michigan, 2006. Second row: Ashley and Mary-Kate Olsen, Toronto, Ontario, 1993; (Clockwise from top left) *Indian Summer* actors Kevin Pollak and Vincent Spano with Don and Michael at the Roots Leather Factory, Toronto, Ontario, 1993; (Top image) Dan Aykroyd in Israel, circa 1994; (Bottom image, from left) Michael, Martin Short, and environmental activist David Suzuki, Roots 20th anniversary party, Toronto, Ontario, 1993. Third row: (From left) music producer Clive Davis, Michael, and *Saturday Night Live* producer Lorne Michaels, New York, New York, 1998; Don, Mike Binder, and Michael at the screening of *Indian Summer*, Toronto, Ontario, 1993; Actors Vincent Spano (left) and Bill Paxton at an *Indian Summer* event at the Roots Department Store, Toronto, Ontario, 1993. Bottom row: Don and Michael, 1996; (From left) Michael, Vincent Spano, and Jim Budman at the screening of *Indian Summer*, 1993; Olympic equestrian Eric Lamaze riding Cagney, Bromont International Horse Show, Quebec, 1995; (From left) Matthew Budman, with Michael and diplomat David Hermelin, Algonquin Park, Ontario, circa 1989

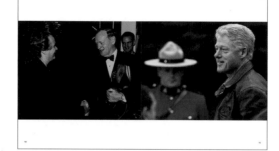

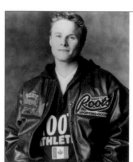

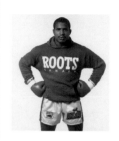

L: Neville Staple of the Specials, 1996

R: Singer-songwriter David Bowie holding *The Idiot* by Fyodor Dostoyevsky in an American Library Association reading campaign, 1987

L: Canadian Prime Minister Jean Chrétien receiving a jacket from Karl Kowalewski at the opening of the Design Exchange, Toronto, Ontario, 1994

R: American President Bill Clinton wearing a Roots jacket at the APEC Summit, Vancouver, British Columbia, 1997

L: Olympic snowboarder Ross Rebagliati in a Roots advertisement, Toronto, Ontario, 1998

R: Canadian heavyweight champion Donovan "Razor" Ruddock in a Roots advertisement, New York, New York, 1990

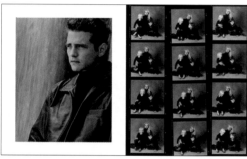

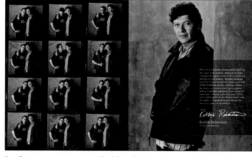

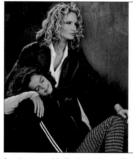

L: Actor Jason Priestley in a Roots advertisement, Los Angeles, California, 1996

R: Actor Donna Dixon with her daughters Danielle, Belle, and Stella in a Roots advertisement, Los Angeles, California, 1996

L: Singer-songwriter Robbie Robertson with son Sebastian in a Roots advertisement, Los Angeles, California, 1996

R: Robbie Robertson in a Roots advertisement, Los Angeles, California, 1996

L: Actress Kelly Lynch with daughter Shane in a Roots advertisement, Los Angeles, California, 1996

R: Actor John Hurt, Los Angeles, California, 1996

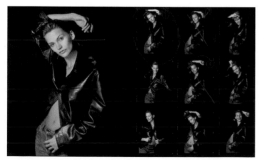

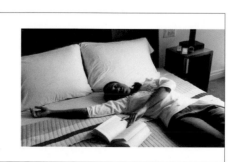

L: Actress Natasha Henstridge in a Roots advertisement, Toronto, Ontario, 1996

R: Natasha Henstridge contact sheet for Roots advertisement, Toronto, Ontario, 1996

Singer-actress Deborah Cox in the "Stick to Your Roots" campaign, Toronto, Ontario, 1999

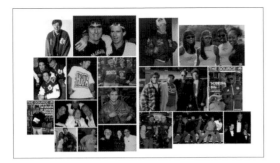

Top row: Actor-comedian Mike Myers in a Roots advertisement, circa 1992; Michael with Keith Richards of the Rolling Stones, Toronto, Ontario, circa 1993; Actor Sylvester Stallone, Apsen, Colorado, 1991; Destiny's Child, 1999. Second row: the Backstreet Boys, 1999; Actor-singer Mark Wahlberg, circa 1990; David Suzuki with Michael, 1994; (From left) Michael, actor Chris Farley, Dan Aykroyd, and Don, Toronto, Ontario, 1994; Singer Haydain Neale on the cover of *The Source,* 2006. Bottom row: Author Noah Richler on the cover of *The Source,* 2006; Michael with (from left) actor Adrien Brody, Helen Budman, and actor Michael Douglas, at the Spoke Club, Toronto, Ontario, 2005; (Bottom left image) Deborah Cox and Don, Toronto, Ontario, 1999; (Bottom right image) actor-film director Arnold Schwarzenegger, 1996; (Top image) Actor Jonathan Taylor Thomas, circa 1994; (Bottom image, from left) film director-producer Norman Jewison with wife, Lynne St. David, and Michael, circa 2005; Hockey players Ted Lindsay and Maurice "Rocket" Richard, Montreal, Quebec, 1999; 'N Sync at the Olympic Games, Salt Lake City, Utah, 2002; (From left) Anthony Green, hockey player Guy Lafleur, and Matthew Budman, Toronto, circa 1991

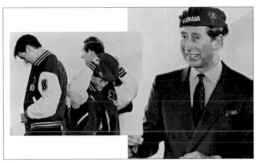

Prince William and Prince Harry with their father Charles, Prince of Wales, in Canadian Olympic wear, Vancouver, British Columbia, 1998

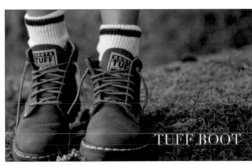

Roots Tuff Boot designed in 1992

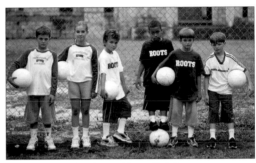

Advertisement for the "Athletics Kids" campaign, Montreal, Quebec, circa 2005

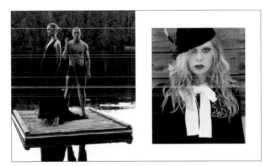

Models in the "Prêt-à-Portage" *Flare* magazine shoot, Bonita Lake, Algonquin Park, Ontario, 2002

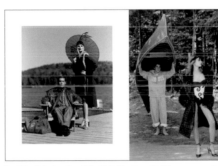

L: Models in the "Prêt-à-Portage" *Flare* magazine shoot, Bonita Lake, Algonquin Park, 2002

R: Matthew Budman and model in the "Prêt-à-Portage" *Flare* magazine shoot, Bonita Lake, Algonquin Park, 2002

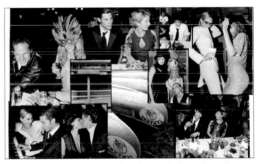

The Green and Budman families with friends and models in the "Prêt-à-Portage" *Flare* magazine shoot, Bonita Lake, Algonquin Park, 2002

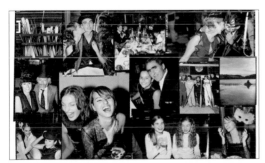

The Green and Budman families with friends and models in the "Prêt-à-Portage" *Flare* magazine shoot, Bonita Lake, Algonquin Park, 2002

L: Advertisement for "Roots Athletics" campaign, circa 2005

R: Kayaker Adam van Koeverden, Las Vegas, Nevada, 2013

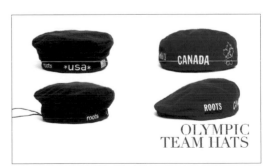

L: Roots beret made for the United States Olympic Team in Salt Lake City, Utah, 2002

R: Roots poorboy hat made for the Canadian Olympic Team in Nagano, Japan, 1998

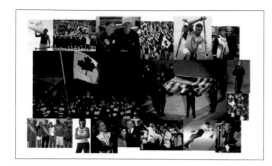

Top row: Canadian canoeist Attila Buday in a Roots advertisement for the Sydney Olympic Games, 2000; British Olympic Team at the opening ceremony, Salt Lake City, Utah, 2002; Canadian figure skaters Jamie Sale and David Pelletier, 1999; Canadian Olympic Team at the opening ceremony, Sydney, Australia, 2000; Canadian canoeists Attila Buday (front) and Tamas Buday Jr. in a Roots advertisement for the Sydney Olympic Games, 2000; Helen Budman (right) with NBC's Katie Couric, Turin, 2006. Second row: Canadian Olympic Team at the opening ceremony, Salt Lake City, Utah, 2002; United States Olympic Team carrying a tattered flag recovered from the Twin Towers after 9/11 at the opening ceremony, Salt Lake City, Utah, 2002; (Top image) Canadian figure skater Elvis Stojko, 1998; (Bottom image) Canadian Olympic Team at the opening ceremony, Athens, Greece, 2004. Bottom row: Barbadian Olympic Team, Athens, Greece, 2004; Team Canada village wear, Athens, Greece, 2004; Singer Kelly Clarkson performing at a medal ceremony, Turin, Italy, 2006; Figure skater Michelle Kwan with President George W. Bush, Salt Lake City, Utah, 2002; American Olympic Team at the opening ceremony, Turin, Italy, 2006; Canadian snowboarder Jasey-Jay Anderson in a Roots advertisement, 2002; Wayne Gretzky at the Vancouver Olympics, British Columbia, 2010

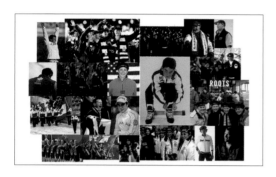

Top row: Adam van Koeverden after winning the gold medal in the Men's K-1 500 metre kayak, Athens, Greece, 2004; Canadian Olympic Team at the opening ceremony, Salt Lake City, Utah, 2002; American Olympic Team at the opening ceremony, Salt Lake City, Utah, 2002; Ross Rebagliati celebrates his gold medal win in snowboarding, Nagano, Japan, 1998; Roots Toronto 2008 Olympic Bid uniform, 2001. Second row: Roots advertisement for the Sydney Olympic Games, 2000; American Olympic Team at the Parade of Nations, Athens, Greece, 2004; Rachel Steer wears the Team USA outfit at the opening ceremony, Salt Lake City, Utah, 2002; Matthew Budman in a Roots advertisement, 1998; (Top left image) American Olympic Team at the opening ceremony, Athens, Greece, 2004; (Top right image) Olympic ski legend Stein Eriksen with Michael at the Lillehammer Olympics, Norway, 1994. Third row: Canadian Olympic Team at the opening ceremony, Nagano, Japan, 1998; Walter Gretzky, Salt Lake City, Utah, 2002; Diver Alexandre Despatie, Athens, Greece, 2004; (From left) Customers Gretchen Devine, Anne Miller, Whitney Clark, and Kimberlee Sirstins posing with their newly purchased berets outside a Roots store, Salt Lake City, United States, 2002. Bottom row: Canadian synchronized swim team, Nagano, Japan, 1998; Barbadian Olympic Team at the opening ceremony, Athens, Greece, 2004; Matthew Budman and Wayne Gretzky, Nagano, Japan, 1998; The U.S. figure skating team with First Lady Laura Bush, Turin, Italy, 2006; Model wearing British Olympic Team village wear, Athens, Greece, 2004; Roots advertisement for the Salt Lake City Olympic Games, 2002

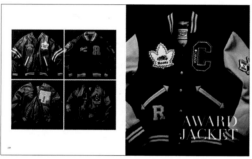

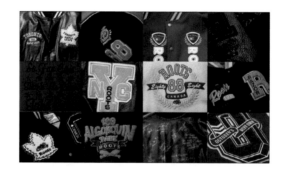

Roots Award Jackets (top row from left): Toronto Maple Leaf, 2000; Jamaican Bobsled Team, 1988; Roots Taiwan 100th anniversary, 2011; Roots x Drake's O.V.O., 2011. Second row: Roots x Drake's O.V.O., 2011; New York City Roots, 1998; Roots '88, 1988; Donovan "Razor" Ruddock, 1991. Bottom row: Gretzky, 2010; Algonquin Park, 1993; New York City Roots, 1998; Roots x Drake's O.V.O., 2011.

L: Roots Award Jackets (clockwise from top left): Toronto Maple Leafs, 2000; Donovan "Razor" Ruddock, 1991; Canadian Hockey Team Gold Medal, 2002; New York City Roots, 1998

R: Gretzky Award Jacket, 2010

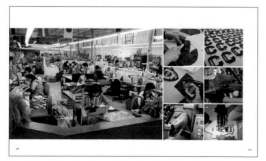

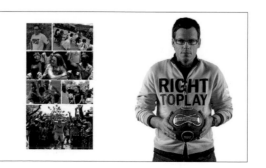

L: Right to Play. First row: Founder Johann Koss, Toronto, Ontario, 2013; Rower Adam Kreek in Peru, 2009. Second row: Speed skater and cyclist Clara Hughes in Liberia, 2012. Third row: Boys with ball; Clara Hughes in Mali, 2011. Bottom row: Kayaker Adam van Koeverden in Mali, 2011.

R: Founder of Right To Play Johann Koss, Toronto, Ontario, 2009

Roots Leather Factory, Toronto, Ontario, 2012

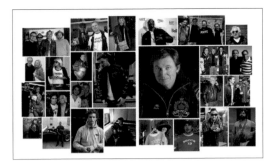

Top row (from left): The Barenaked Ladies at the Toronto International Film Festival, Ontario, 2006; Roots regional leather specialist Andrew McCurbin (left) and Roots DJ Davin Bujalski, 2011; Natasha Henstridge at Roots Bloor, Toronto, 2006; Snoop Dogg a.k.a. Snoop Lion, Toronto Film Festival, Ontario, 2012; (From left) film writer-producer Jeff Kline, film producer John Goldwyn, actor Dan Aykroyd, and Michael at the Roots store, Grand Prairie, Alberta, 2011; Artist Jim Budman, circa 2012. Second row: *Sex and the City* star Kim Cattrall with artist Clifford Ross, Frieze Art Fair, New York, 2012; Singer Carrie Underwood, Toronto Pearson Airport, Ontario, 2012; Talk show host–comedian Jimmy Fallon at Roots Bloor, Toronto, 2009; Drake in O.V.O. x Roots Award Jacket, 2011; Hockey superstar Wayne Gretzky in Roots advertisement, 2006; (From left)

Michael, hockey legend Bobby Orr, and Don, 2010; Film producer Mitch Glazer and Michael, Martha's Vineyard, Cape Cod, Massachusetts, 1997. Third row: Singer Rihanna (right) and friend in Montreal, 2013; Michael and Jim Budman, 1999; Matthew Budman and soccer player David Beckham, 2007; Film director Pedro Almodóvar at Roots, Toronto, Ontario, circa 1997; Dragonette at Roots Bloor, Toronto, 2012. Bottom row: Singer-songwriter Serena Ryder, circa 2012; Singer-songwriter Justin Bieber and Director X, Los Angeles, 2012; Actor Eddie Redmayne, 2013; Singer-songwriter David Bowie, 2013; Editor Suzanne Boyd at Roots Bloor, Toronto, Ontario, 2013; Film director Jason Reitman, circa 2007; Singer Miguel wearing Roots quilted baseball jacket at Roots Bloor, Toronto, 2013; Actor Zach Galifianakis wearing the Roots Satchel in *The Hangover*, 2006

"Roots Canada" campaign, Toronto, Ontario, 2012

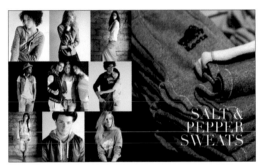

L: "Sweats with History" campaign, 2012

R: Salt and Pepper sweatpants designed in 1979

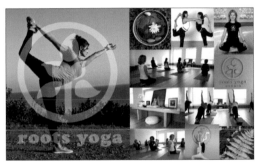

L: Laurie Campbell for Roots Yoga, Malibu, California, 2011

R: Roots Yoga Studio photo shoot featuring Denyse Green (top right), Toronto, Ontario, 2006

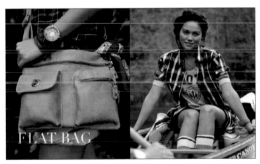

L: Flat bag designed in 2006. Photograph part of "Roots Outfitters" campaign, Sunshine Coast, British Columbia, 2011

R: "Roots Outfitters" campaign, Algonquin Park, Ontario, 2011

Adam van Koeverden in Algonquin Park, Ontario, 2012

L: Alex Anne Budman and Adam van Koeverden in the "Canada Day Collection" campaign, Algonquin Park, Ontario, 2008

R: *Camper Cabin*, Camp Tamakwa, Algonquin Park, Ontario, 1993

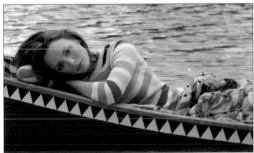

"Roots Fall" campaign, Algonquin Park, Ontario, 2004

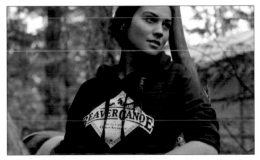

"Roots Outfitters" campaign, Sunshine Coast, British Columbia, 2011

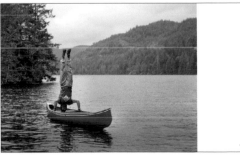

Homage to Omer Stringer, part of the "Roots Outfitters" campaign, Sunshine Coast, British Columbia, 2011

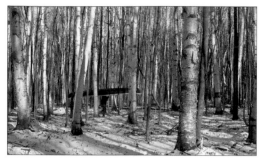

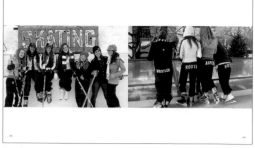

L: Roots environmental logos, 1990–91

R: (Background) *Red Maple Leaf and Pine Needles*, Algonquin Park, Ontario, 1991; (Foreground) Roots environmental logo, 1990

Portaging Early Spring, Rock Lake, Algonquin Park, Ontario, 1993

L: Skating at Budman Gardens (from left): Maddie Dalkie, Lucie Pivnick, Emily Wright, Allie Hawkey, Molly Merkley, Alex Anne Budman, and Aidan Wienrib, Toronto, Ontario, 2009

R: Skating at Budman Gardens, Toronto, Ontario, 2009

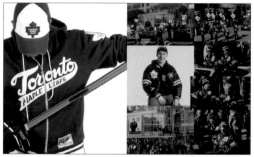

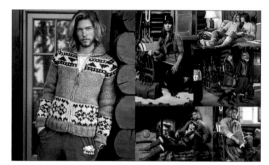

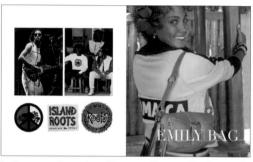

L: Toronto Maple Leafs for Roots advertisement, 2007

R: Various Toronto Maple Leafs alumni participate in the Maple Leaf Gardens closing/Air Canada Centre opening parade, Toronto, Ontario, 1999. (Centre image) former Toronto Maple Leaf Alyn McCauley, circa 1999

"Le Chalet" campaign, Fairmont Le Château Montebello, Montebello, Quebec, 2012

L: Reggae ambassadors. Top row: Guitarist Cat Coore of Third World, circa 1983; (From left) model with William "Bunny Rugs" Clarke and Stephen "Cat" Coore of Third World, 1983. Bottom row: Roots Jamaica logos, 1990

R: Emily Bag designed in 2004. Photo was part of the "Roots Visits the Caves" campaign, Negril, Jamaica, 2005

L: "Saddle Up" campaign. Karoline Kowalewski, Tottenham, Ontario, 2010; (From left) Kris, Kasia, Tanner, Karoline, and Karl Kowalewski, Tottenham, Ontario, 2010

R: Student Pack designed in 1988

"Field Tested" campaign, Joshua Tree National Park, California, 2011

"Into The Woods" campaign, Algonquin Park, Ontario, 2011

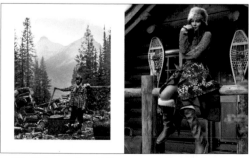

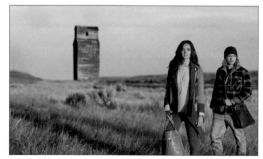

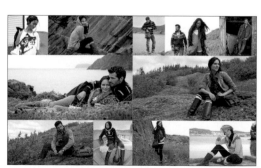

L: "My Cabin in Canada" campaign, Storm Mountain Lodge, Banff National Park, Alberta, 2011

R: "My Cabin in Canada" campaign, Storm Mountain Lodge, Banff National Park, Alberta, 2011

"Globe and Field" campaign, the Badlands, Drumheller, Alberta, 2012

"Exploring Our Roots" campaign, Trinity Bight, Newfoundland, 2010

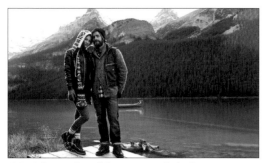

"My Cabin in Canada" campaign, Lake Louise, Alberta, 2011

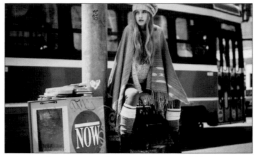

"Grunge" campaign, Toronto, Ontario, 2013

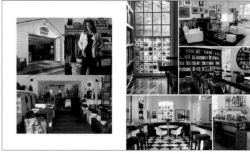

L: Roots in Venice Beach, California, 2013 (clockwise from top left); Venice Beach storefront; Diane Bald at the Venice Beach store; Venice Beach interior

R: Home of Michael Budman and Diane Bald, Toronto, Ontario, 2013

L: (Top image) Roots Air, Toronto Pearson International Airport, Ontario, 2001; (Bottom left image) Roots Air Lounge, Toronto Pearson International Airport, 2001; (Bottom right image) Roots Air Messenger Bag, 2001

R: Roots Air graphic, 2001

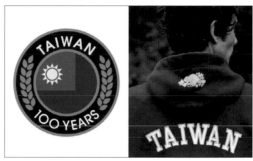

L: Roots Taiwan 100th anniversary logo, 2011

R: "Roots Taiwan 101st Anniversary" campaign, 2012

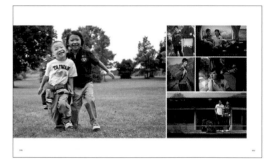

L: "Roots Taiwan 101st Anniversary" campaign, 2012

R: "Roots Taiwan 100th Anniversary" campaign, 2011

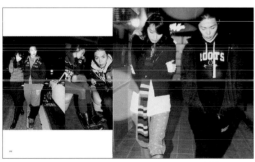

Roots Korea in *CéCi* magazine, November 2008

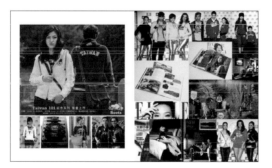

Top row: "Roots Taiwan 101st Anniversary" campaign, magazine advertisement, 2012. Bottom row: Roots Taiwan 100th anniversary fashion show, 2011; Roots Korea advertising, 2007; Multistore franchisee Shirley Ding from Chengdu, China, 2013: Taiwan country manager Matt Meng and Michael at Roots Taiwan 100th anniversary opening, 2011

Roots Asia. Top row: Modern Sporting Goods launch, Taiwan, 2013; Roots Taiwan 100th anniversary collection fashion show, 2011; Roots Taiwan 100th anniversary collection fashion show, 2011. Second row: Roots Taiwan article in *Living*, March 2012; Roots Taiwan advertising in *Bazaar*, April 2008; Matt Meng, Taiwan, 2013. Third row: Roots advertising in Korea, 2008; Roots Korea advertisement, 2008. Last row: Roots Taiwan "as seen in" *Elle*, 2012; Modern Sporting Goods launch, Taiwan, 2013

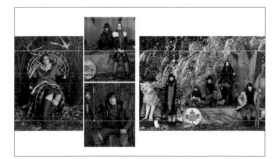

Roots Korea advertisement, 2008

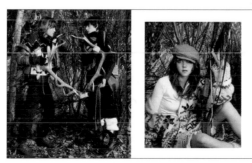

Roots Korea advertisement, 2008

L: Roots x Douglas Coupland Award Jacket, "Canada Goes Electric" campaign, 2010

R: Roots x Douglas Coupland graphic, "Canada Goes Electric" campaign, 2010

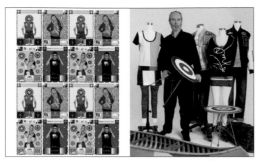

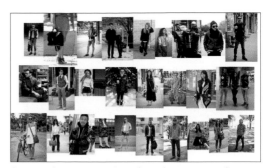

L: Roots x Douglas Coupland wild posters, "Canada Goes Electric" campaign, 2010

R: Douglas Coupland with Roots x Douglas Coupland furniture, canoe, luggage, and clothing, "Canada Goes Electric" campaign, 2010

Roots x Douglas Coupland beaver logo, "Canada Goes Electric" campaign, 2010

Street style in various Canadian, American, and Australian cities, 2012–13

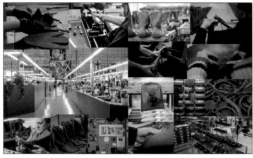

Roots Leather Factory, Toronto, Ontario, 2013

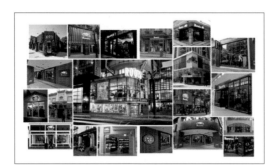

Roots stores. Top row: Roots Lodge, Toronto, Ontario; Ximen, Taipei, Taiwan; Don Mills, Toronto, Ontario; Westmount, Montreal, Quebec; St. Laurent, Ottawa, Ontario; Centreville, Montreal, Quebec. Second row: (Top image) Jen-Ai, Taiwan; (Bottom left image) Venice Beach, California; (Bottom right image) Banff, Alberta; Roots Central, Toronto, Ontario; (Top left image) Bloor Street, Toronto, Ontario; (Bottom left image) Ximen, Taipai, Taiwan; (Bottom right image) Upper Canada Mall, Newmarket, Ontario. Bottom row: Spring Garden, Halifax; Whistler, British Columbia; Market Mall, Calgary, Alberta; Roots Lodge Café in Taipei, Taiwan; Jen Ai, Taipei, Taiwan; (Top image) Brookfield Place, Toronto, Ontario; (Bottom image) Markville Mall, Markham, Ontario

(Background) Banff, circa 2011; (Foreground) Dan Aykroyd, Antarctica, 2007

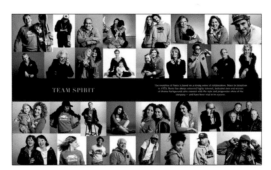

Some of the Roots family, 2013. Top row: Raymond and Liam Perkins; Adrian Aitcheson; Bob Baker; Senna and Christian, with Victoria Lee; Deeva Green and Lee Reitelman; Melinda McDonald and Zoe; Pauline Landriault; Ilich Mejia. Second row: Robert Sarner; Judy Hurlburt; Denyse and Sophie Green; Laurie Campbell and Sophia; Hannah and Kim Court-Hampton; Rima Biback; Oliver Capistrano; Ed Cox; Lyn Frankel. Third row: Noa and Liz Doggett; Jilliann Grant; James Connell; Sisi Jiang; Alex Anne Budman and Diane Bald; Halla Koudsi; Syd Beder; Stanley, Richard, Karl, and Henry Kowalewski. Bottom row: Karen Fernes and Ling Chow; Alice Mallinson; Patrick Davis; Tony Bettencourt; Michael Kerr; Marissa Engels; David Young; Andy McCurbin

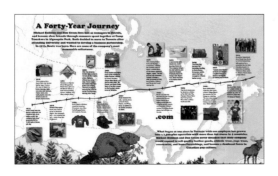

Top row: English Saddle Bag; Beaver Canoe logo; Jamaican Bobsled Award Jacket crest; *Indian Summer* film poster; Prince William, Prince Harry, and Prince Charles; Roots Air; Emily Bag; Roots x Douglas Coupland; Roots x Target. Bottom row: Sport Root Negative Heel Shoes; Richard Gere in *American Gigolo*; RBA sweatshirt; Tuff Boot; Roots in Ximen, Taipei, Taiwan; Roots.com logo; Team USA at the Salt Lake City Olympics; The Satchel; Roots Taiwan 100th anniversary fashion show

This edition published in 2013 by
House of Anansi Press Inc.
110 Spadina Avenue, Suite 801
Toronto, ON, M5V 2K4
Tel. 416-363-4343
Fax 416-363-1017
www.houseofanansi.com

This is a work of history. The reproduction of advertisements in this book is purely for editorial purposes.

Distributed in Canada by
HarperCollins Canada Ltd.
1995 Markham Road
Scarborough, ON, M1B 5M8
Toll free tel. 1-800-387-0117

Distributed in the United States by
Publishers Group West
1700 Fourth Street
Berkeley, CA 94710
Toll free tel. 1-800-788-3123

House of Anansi Press is committed to protecting our natural environment.
As part of our efforts, the interior of this book is printed on paper that contains 100% post-consumer recycled fibres, is acid-free, and is processed chlorine-free.

17 16 15 14 13 1 2 3 4 5

Library and Archives Canada Cataloguing in Publication

Roots (Company) [Photographs. Selections]
Roots : 40 years of style / introduction by Michael Budman, Don Green ; preface by Suzanne Boyd ; afterword by Dan Aykroyd.
Includes a curated collection of photographs from the Roots archives.
ISBN: 978-1-77089-419-8 (bound). ISBN: 978-1-77089-420-4 (html).

1. Roots (Company) — History — Pictorial works. 2. Fashion merchandising — Canada — History —20th century — Pictorial works. 3. Clothing trade — Canada — History — 20th century — Pictorial works. 4. Display of merchandise — Canada — History— 20th century — Pictorial works.

I. Budman, Michael, writer of introduction II. Green, Don, writer of introduction
III. Boyd, Suzanne, writer of added commentary IV. Aykroyd, Dan, writer of added commentary V. Title.

HD9940.C254R66 2013 338.7'6870971 C2013-903781-0

Library of Congress Control Number: 2013941772

Book Designer: R. Maricar Dionisio
Contributions from James Connell, Evangeline Lee, Raymond Perkins, and Robert Sarner

Canada Council for the Arts
Conseil des Arts du Canada

ONTARIO ARTS COUNCIL
CONSEIL DES ARTS DE L'ONTARIO

We acknowledge for their financial support of our publishing program the Canada Council for the Arts, the Ontario Arts Council, and the Government of Canada through the Canada Book Fund.

Printed and bound in Canada

Photography Credits

Every reasonable effort has been made to trace ownership of copyright materials. The publisher will gladly rectify any inadvertent errors or omissions in the credits of future editions.

Roots Archive

19, 20, 21, 22, 23, 24–5, 26–7, 28, 29, 30, 31, 32, 33, 34–5, 37, 38, 39, 40–1, 42–3, 45, 46–7, 48, 49, 50, 51, 52–3, 54, 56, 57, 60, 61, 63 (top row, middle), 63 (top row, right), 63 (middle row), 63 (bottom row), 70–1, 72, 75, 76–7 (top row, second from left), 76–7 (second row, left), 76–7 (second row, right), 78, 80, 81, 85, 86, 87 (top row, middle), 87 (top row, right), 87 (second row, left), 87 (second row, middle), 87 (second row, bottom right), 87 (third row, middle), 87 (third row, right), 87 (bottom row, second from left), 87 (bottom row, second from right), 87 (bottom row, right), 90, 102–3, 104–5 (top row, left), 104–5 (top row, second from left), 104–5 (top row, right), 104–5 (second row, second from left), 104–5 (second row, second from right), 104–5 (bottom row, left), 104–5 (bottom row, second from left, bottom), 104–5 (bottom row, third from left, bottom), 104–5 (bottom row, third from right), 104–5 (bottom row, right), 110–1, 120, 124–5 (top row, left), 124–5 (top row, third from left), 124–5 (top row, second from right), 124–5 (bottom row, left), 124–5 (bottom row, second from left), 124–5 (bottom row, second from right), 126–7 (top row, right), 126–7 (second row, left), 126–7 (second row, third from left), 126–7 (second row, top right), 126–7 (third row, third from left), 126–7 (bottom row, third from left), 126–7 (bottom row, second from right), 136–7 (top row, left), 136–7 (top row, left), 136–7 (top row, second from left), 136–7 (top row, third from left), 136–7 (top row, third from right), 136–7 (second row, left), 136–7 (second row, second from left), 136–7 (second row, third from left), 136–7 (second row, fourth from left), 136–7 (second row, third from right), 136–7 (third row, left), 136–7 (third row, second from right), 136–7 (third row, right), 136–7 (bottom row, left), 136–7 (bottom row, second from left), 136–7 (bottom row, fourth from right), 136–7 (bottom row, third from right), 136–7 (bottom row, right), 156, 157 (foreground), 163, 166 (top row, left), 166 (bottom row), 178–9, 191, 192–3, 194, 195, 196, 197, 198, 199, 206–7 (top row, left), 206–7 (top row, second from left), 206–7 (top row, third from left), 206–7 (top row, fourth from left), 206–7 (top row, fifth from right), 206–7 (top row, fourth from right), 206–7 (top row, third from right), 206–7 (top row, second from right), 206–7 (second row, fourth from left), 206–7 (second row, right), 206–7 (third row, third from left), 206–7 (third row, fourth from left), 206–7 (third row, fifth from right), 206–7 (third row, third from right), 206–7 (third row, second from right), 210–11 (top row), 210–11 (second row, left), 210–11 (second row, bottom left), 210–11 (second row, bottom right), 210–11 (second row, second from right, bottom), 210–11 (second row, right, bottom), 210–11 (second row, top right), 210–11 (third row), 216–7 (top row, left), 216–7 (top row, second from left), 216–7 (top row, third from left), 216–7 (top row, third from right), 216–7 (top row, second from right), 216–7 (bottom row, left), 216–7 (bottom row, third from left), 216–7 (bottom row, fourth from left), 216–7 (bottom row, fifth from left), 216–7 (bottom row, fourth from right), 216–7 (bottom row, third from right), 216–7 (bottom row, second from right), 216–7 (bottom row, right)

Diane Bald, 7 (foreground), 63 (top row, left), 69 (foreground), 76–7 (top row, left), 76–7 (top row, third from right), 76–7 (top row, second from right), 76–7 (top row, right), 76–7 (second row, second from right), 76–7 (bottom row), 87 (top row, left), 87 (second row, top right), 87 (third row, left), 104–5 (second row, third from left), 104–5 (second row, second from right), 104–5

(bottom row, second from left), 104–5 (bottom row, third from left, bottom), 124–5 (top row, right), 134 (top row, left), 136–7 (top row, second from right), 136–7 (second row, second from right), 136–7 (second row, right), 136 (third row, second from left), 160, 161

Illich Mejia, 4–5 (background), 6–7 (background), 11 (foreground), 17, 18, 55 (top row, second from left), 55 (top row, right), 55 (second row, right), 55 (second row, bottom right), 55 (bottom row), 65, 79, 84, 104–5 (second row, right), 104–5 (third row, left), 128, 129, 130–1, 132, 133, 135, 136–7 (third row,

Rylan Perry, 82, 108–9, 138–9, 142, 144, 145, 152–3, 154–5,

Jim Budman, 104–5 (top row, second from right), 104–5 (bottom row, second from left), 184

Maricar Dionisio, 55 (top left), 55 (second row, second from right, bottom), 66–7, 186 (bottom row,

third from left), 136–7 (bottom row, second from right), 143, 148, 162, 164, 165, 168, 169, 178–9, 182–3, 185, 188, 189, 190, 200, 202, 203, 206–7 (top row, right), 206–7 (second row, left), 206–7 (second row, second from left), 206–7 (second row, third from left), 206–7 (second row, fourth from right), 206–7

170–1, 172–3, 174, 175, 180–1, 202, 212–3 (background)

right), 210–1 (second row, second from right, top)

Francisco Garcia, 176–7

Marlee Maclean, 122, 123, 140, 141, 208–9

(second row, third from right), 206–7 (second row, second from right), 206–7 (third row, left), 206–7 (third row, second from left), 206–7 (third row, fifth from left), 206–7 (third row, fourth from right), 206–7 (third row, right), 208–9, 210–11 (second row, third from left), 214–5

Storm Saulter, 167

Nigel Scott, 166 (top row, right)

AP Images

J. Scott Applewhite, 124–5 (bottom row, fourth from left)

Hans Deryk, 126–7 (third row, second from left)

Charles Dharapak, 126–7 (bottom row, third from right)

Mark Duncan, 124–5 (top row, third from right)

Douglas C. Pizac, 126–7 (second row, second from right, top)

Laurent Rebours, 126–7 (bottom row, second from left)

CP Images

COC, 126–7 (top row, second from right), 126–7 (third row, left)

Nathan Denette, 124–5 (bottom row, right)

Tom Hanson, 104–5 (second row, right, bottom)

Chuck Stoody, 91, 106, 107, 216–7 (top row, fourth from right)

Getty Images

Hulton Archives / Moviepix, 216–7 (top row, fourth from left)

Elsa, 124–5 (bottom row, third from left)

Ryan Bahr, 124–5 (bottom row, third from right)

Al Bello, 126–7 (top row, third from right)

Jonathan Ferry, 126–7 (top row, left)

Clive Mason, 124–5 (second row, left)

Doug Pensinger, 124 (top row, second from left)